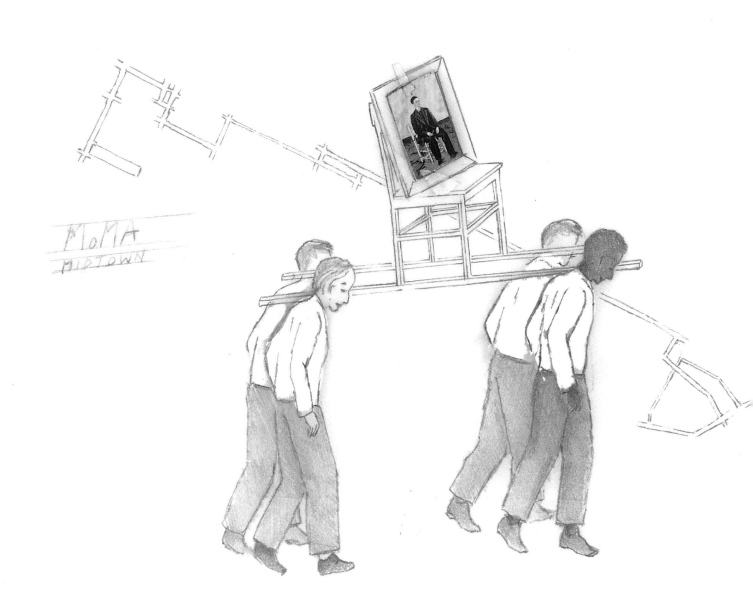

FRANCIS ALŸS

The Modern Procession

MoMAQNS

PUBLIC ART FUND

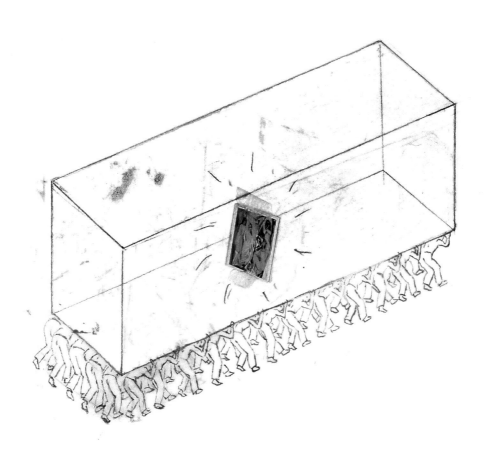

TABLE OF CONTENTS

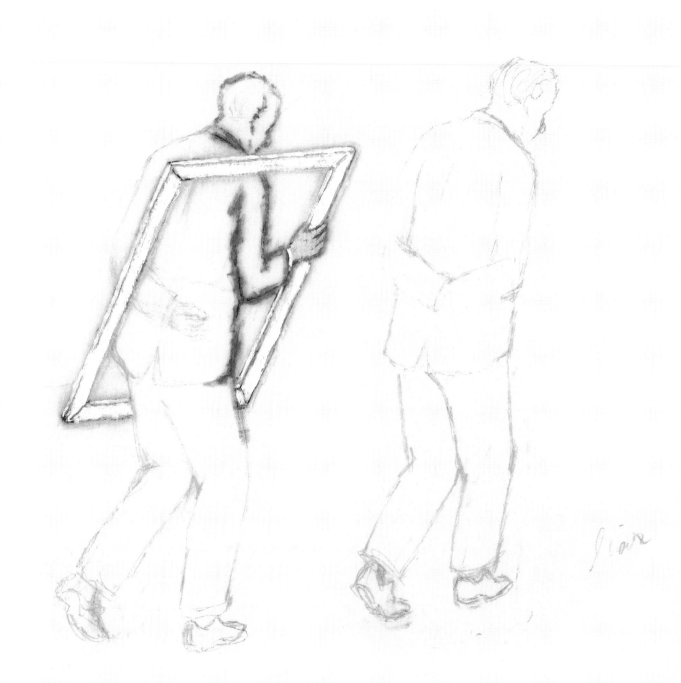

To celebrate the moving of The Museum of Modern Art from its midtown Manhattan location to MoMA QNS, to welcome MoMA's most sacred icons to the Periphery, come and revere The Modern Procession *on its journey to Queens on June 23. For they bring us pleasure, peace, and sometimes redemption....*

—FRANCIS ALŸS
New York City, 2002

NYC 2 June 2002

Claire
708 9690

→ 2

NO

+ DOLLYS

+ 2 stools → (4)

max height (paleuqui/gurney)

? max w./ Giacometti ?

- BANNERS ——→ (2)
- precursors/Precursors —→ (2)
- PUNCH ——————→ (3)
 (c/horseman)
- Fireworks ——→ (2)
- Camera ——→ (3)
- T.B.D. ——→ (1)
- Petal Rots ——→ (4)

59~60

+ Dog walker

BAND ——— +12
Police/horse ——
living icon ——— 1

72

3

x punch

Skibi Smith
Bruce Nauman
Meme Cunningham
Yoko Ono

ORQUETA

x 2

16.600
41.000
20.600
11.400
32.000
3.200
40.200
3.000
43.200 /8000

notes for
The Modern Procession
Francis Alÿs
NYC June 2002

+ pair for 2 sticks / measure
w/ wheel
horse? → horse guard
- hands for stools

FOREWORD

The fact that Francis Alÿs's *Modern Procession* took place at all is remarkable. This singular event, simple in conception yet posing myriad logistical challenges, demonstrated how an artist's individual vision can provide a powerful collective experience. *The Modern Procession* ultimately occurred at a symbolic moment of transition: the move of The Museum of Modern Art to Long Island City in Queens took place in the first days of the New York summer, after the long winter months that followed September 11, 2001. I am particularly proud that a relatively small organization the size of the Public Art Fund provided the institutional support that enabled Francis Alÿs to lead the Museum through the streets of Manhattan to its temporary home at MoMA QNS.

I am very grateful to Francis Alÿs for his enduring commitment to this project and its resulting publication, and to all those who gave their time, energy, and ingenuity to make *The Modern Procession* possible. The project was coordinated by Tom Eccles of the Public Art Fund with Harper Montgomery of The Museum of Modern Art and Miki García of the Public Art Fund, alongside our entire staff and the studio of Francis Alÿs. Francis's colleague Rafael Ortega was a constant source of support and inspiration as he organized the logistics of the film accompanying and documenting the procession. As the event was a collaboration with The Museum of Modern Art and its Projects series, I would also like to recognize the support of Glenn D. Lowry, the museum's director and Laurence Kardish, senior curator of film and video. Permitting the procession to proceed through midtown and across the Queensboro Bridge was a bold and courageous act by the city's government, demonstrating the Bloomberg administration's belief that the arts are central to New York's identity.

Throughout the planning process and, ultimately, on the day itself, the New York City Police Department facilitated the procession's passage through the city. None who participated in *The Modern Procession* will ever forget it. This publication records the complex issues raised by the project, and we are grateful to Anne Wehr, who has diligently co-edited this book with Francis Alÿs, and to its authors—Francesco Pellizzi, Dario Gamboni, RoseLee Goldberg, Lynne Cooke, Harper Montgomery, Laurence Kardish, and Alejandro Diaz—who have collaborated with Francis on its realization.

– SUSAN K. FREEDMAN
President, Public Art Fund

9

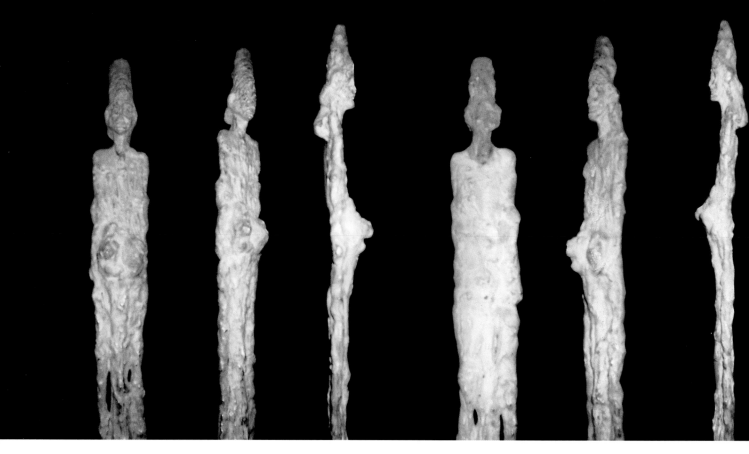

OUTSIDE INTERVENTION: THE MAKING OF THE MODERN PROCESSION

Tom Eccles

There was always a lot of confusion surrounding Francis Alÿs's procession. For starters, many people, including many of those involved, continued to call this project "the parade," a natural mistake given New Yorkers' almost instinctual habit of marking every season with a march up or down the avenues of Manhattan. St. Patrick's Day, Columbus Day, Puerto Rican Day, Israel Day, Veterans Day, Thanksgiving, Gay Pride and, of course, those historic moments signaled by the city's ultimate gift, a ticker-tape parade up the "canyon of heroes," lower Broadway, reserved for returning soldiers, astronauts, Olympic athletes, and the New York Yankees. What distinguished Alÿs's project from these exuberant celebrations was that Alÿs wasn't celebrating.

The Museum of Modern Art is, for Alÿs, an institution of almost religious significance, and the invitation to participate in its Projects series afforded a unique but fleeting opportunity for a personal homage not to the institution itself but to the works that it houses. For Alÿs, the procession that he envisaged was a pilgrimage, certainly not a party.

In June 2002, The Museum of Modern Art was moving out, leaving midtown for Long Island City in Queens. The four most stressful times in the life of any family are birth, marriage, death, and moving house. In New York, you might add a fifth: moving from Manhattan to an outer borough. MoMA at least was only temporarily relocating while rebuilding a bigger, better home on 53rd Street, but nevertheless the prospect of a daily commute on the 7 train into the decidedly unglamorous environs of 33rd Street in Queens was, to say the least, a challenge. Alÿs seized upon this moment as the core event upon which to build his project, to create a procession carrying the icons of modern art through the streets and over the Queensboro Bridge, from MoMA's midtown building to MoMA QNS; a public display of a public institution in the act of transition.

Alÿs has spoken of his interventions as "another fragment of the story that I am inventing, of the city I

am mapping." In his drawings for the project, the procession was, in fact, literally written over the map of New York. They were just lines drawn on a page, but they proposed a long march up Sixth Avenue, across 57th Street, up Park Avenue, along 59th Street, over the Queensboro Bridge, through the intersection of Queens Plaza, and finally through the long curve of Queens Boulevard (under the steel girders of the 7-train overpass) to MoMA's new home. On paper, simple enough.

At the suggestion of Robert Storr and Norton Batkin, Francis called me at home on Sunday, December 16, 2001, and insisted on coming over that night with his colleague, the filmmaker Rafael Ortega. They explained the project and how, after over one year of negotiations with the museum, it appeared *The Modern Procession* was not going to happen without outside intervention. Francis can be persuasive. It became apparent, in subsequent conversations with everyone at MoMA, that while the museum was intrigued by the possibility of a procession, they would simply never agree to the artist's requests to use their works in the manner proposed, nor were they cut out to organize such an event at the time of the "great move." Francis's project was simply stalled. There were also certain questions as to what exactly the project was. Was it a procession or a film of a procession? Was it a tribute to the collection or an elaborate send-up? Was it a celebration or a funeral? Museums are often better with objects than with artists, and while the Modern has expended considerable efforts to collaborate with artists, its focus remains deeply rooted in the predominance of its collection. And, in the United States, it has beyond a doubt the best collection.

The Modern Procession proposed one of the first live, sanctioned performance works at the museum to use the collection as its centerpiece, a focus that would indeed prove to be the cornerstone of an internal debate that took place within the museum as the project progressed. Francis wanted to carry representations of Pablo Picasso's *Les Demoiselles d'Avignon*, Alberto Giacometti's *Standing Woman*, and Marcel Duchamp's *Bicycle Wheel*, and perhaps also a living figure of

contemporary art—as though carrying the icons of a church through the streets of New York. Francis already had the route mapped out, which would involve closing the streets in a fairly large swath of midtown. And his proposal called for all the trappings of a traditional procession. A horse, of course. Some dogs. Rose petals (from a thousand long-stemmed roses). Police escorts. A Latin American (preferably Mexican or Peruvian) band that could play processional music. About 50 volunteers, no more. Everyone would be given a specific shirt illustrating his or her role within the procession. We cautiously agreed to collaborate.

At the time Francis and I first spoke about the project, it was but two months after September 11, and the bridges and tunnels of New York were guarded as never before. The police were burdened by every imaginable task. But, surprisingly, out of the tempest and with

1. Mexico City, March 2002

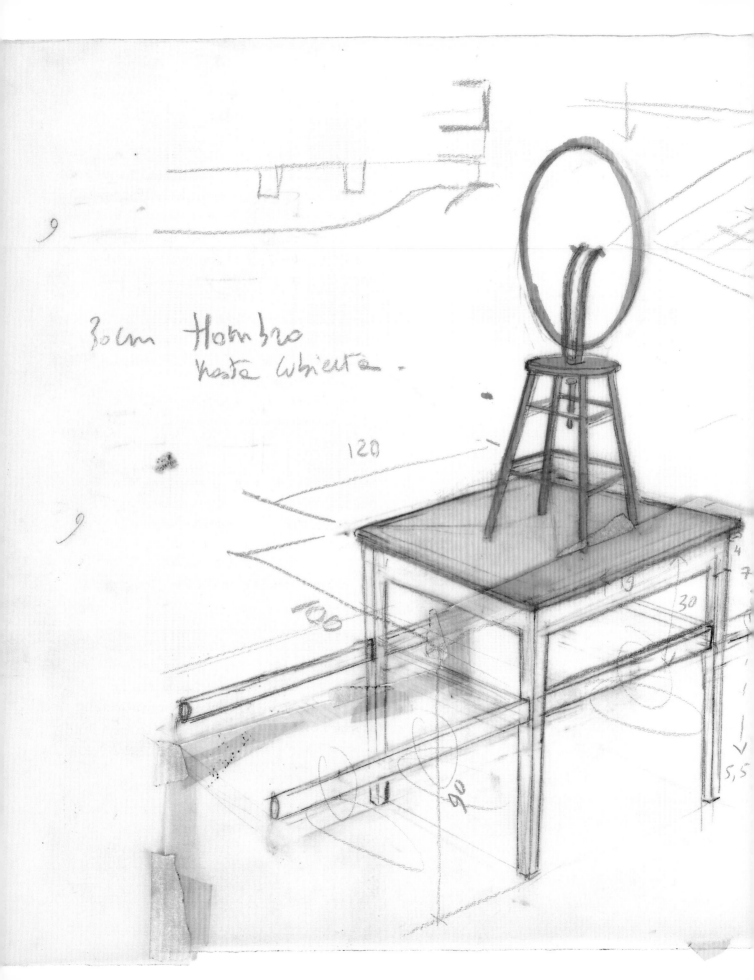

30 cm Hombro
hasta cubierta -

120

100

30

90

5,5

a change in municipal government came a desire to permit activities that under previous city administrations would have been unthinkable. *The Modern Procession* was one such project, and the Public Art Fund became engaged in our first collaboration with the New York City Police Department. Sunday, June 23, at 9 A.M., was the moment we chose for the procession to leave the museum's front door on 53rd Street, the last moment before MoMA handed over their headquarters to AMEC Construction Management and the weekend before the opening of MoMA QNS.

We anticipated that the entire block from Fifth Avenue to Sixth Avenue would be taken up by the participants and were granted a street closing from 8:15 A.M. onward. Once on the move, the police leapfrogged the procession with their cars, closing the two intersections ahead in order to clear a way through the city streets while minimizing the obstruction caused. We calculated that, given the somewhat casual pace of the march, it would take about an hour and a half for the procession to arrive at the Queensboro Bridge, where the midtown police escort would lead us onto the pedestrian overpass. We would be met on the other side by a division of Queens police to carry us through the intersection of Queens Boulevard and on to MoMA QNS.

Francis returned to Mexico to supervise the creation of the icons, still an area of major contention within the museum. A maquette of a small section of *Les Demoiselles* made of colored seeds arrived at the offices of the Public Art Fund. Shown to the museum curators, this exquisite rendering did nothing to lessen their concerns about the problems of re-presenting the museum's collection, issues that were eloquently (and historically) explored by the recent exhibition "Museum as Muse: Artists Reflect," curated by Kynaston McShine in 1999, and perhaps less so, though certainly to great effect, in 1998 by Maurizio Cattelan's hilarious Picasso prancing around outside the museum's front door. In fact, I often wondered if Cattelan's lack of decorum was the specter that haunted our discussions with the museum regarding *The Modern Procession*.

While *The Modern Procession* was a collaborative project, it was continually fraught with questions of diverging programs. Art institutions' burgeoning practice of commissioning artists to make new works raises numerous issues regarding the identity of these organizations, the rights of the artist, and the artist's requisite freedom of creation and the often-conflicting visions of what it is they are doing and why it is they are doing it. Collecting artworks, by comparison, would seem to be a relatively straightforward, or at least highly codified, business. The expectations of the commissioning process and the patriarchal nature of the institution/artist relationship often conflict with the assumption of artistic autonomy that underlies modernist museum practice. In the case of Francis Alÿs's *Modern Procession*, the museum clarified its position by stating that it would not commission works that re-presented or reinterpreted works within its collection but would exhibit such works after their production. For example, a film of *The Modern Procession* could be screened by the museum but the procession itself could not be commissioned. Thus, the Public Art Fund commissioned *The Modern Procession*, and The Museum of Modern Art exhibited (and ultimately acquired) the working drawings and the film of that work.

The inclusion of a living artist had always featured in Alÿs's earliest plans, and he remained ambivalent as to whether to use the term "living icon" or "artist ambassa-

dor" to describe that person. This aspect of the procession conveyed the sense that Alÿs's homage was to modern art itself rather than strictly to this particular collection. His initial instinct, when we discussed it over the phone, was to invite an artist for whom performance had provided a critical aspect of their career: Nam June Paik, Vito Acconci, Bruce Nauman, Robert Rauschenberg. He then expanded his thought to seminal figures of the

New York art world: Louise Bourgeois, Lawrence Weiner, Sol LeWitt, Cindy Sherman, Kiki Smith. Some were clearly too fragile to be carried at shoulder height for two hours. Others were unlikely to agree, for their own perfectly legitimate reasons. Kiki Smith was the outstanding choice. The daughter of the late sculptor Tony Smith, who received a retrospective at the Museum in 1999, and sister of artist Seton Smith, Kiki represented a generational bridge—an artist who had participated in the cultural life of New York's art world from childhood, through the evolution of the East Village scene, as a member of Collaborative Projects, and as a rare individual artist who has chosen her own often-idiosyncratic path without ever denigrating the work of others.

Asociación Tepeyac, the New York–based Mexican cultural center that works with recently arrived immigrants, was engaged to find people who had experience carrying processional palanquins. The issue was a serious one, for the weight of the wooden stretchers that carry church icons demands a coordinated swaying rhythm if the participants are to last the duration of the procession. The music in effect sets the tempo to which the pole bearers march. Diego Medina at Tepeyac suggested St. Brigid Church on the Lower East Side, where a *banda de guerra* played at various community events.

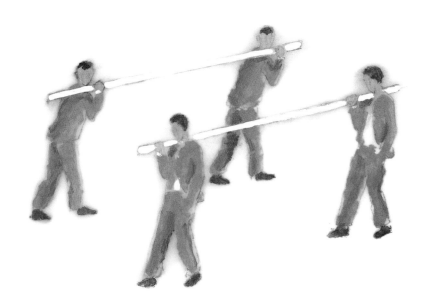

From there, Father Michael gave us the name of Banda de Luis Cuervas in Corona Park, Queens, who agreed to participate. Most other volunteers were invited through word of mouth. And finally, a horse was found in Jamaica Bay Riding Academy, Brooklyn, who could handle the streets of Manhattan but would be transported by trailer over the Queensboro Bridge and met on the other side.

Standing in the middle of MoMA's now-empty lobby in the early morning of June 23 felt like the final days of Hanoi. All that remained were the four stretchers carrying *Les Demoiselles*, the *Standing Woman*, Duchamp's *Bicycle Wheel*, and the empty chair for Kiki Smith. Too large for the front entrance, they would be carried out of the loading dock on 54th Street. In a (subsequently) amusing twist, the keys to the exit could not be found, threatening to delay our departure. Outside, the horse was becoming temperamental. Laurence Kardish came with his two Jack Russell terriers, Fiona and Cyril, and project coordinator Miki García brought Chacho the pug. Kiki Smith looked like a Madonna. The band emerged from the F-train subway as Francis distributed color-coded shirts to the carriers, blue for the Kiki Smith carriers, coffee-colored for the bicycle-wheel group, green for the Giacometti, blue for the Picasso team, and white for everyone else, all embroidered with a red *Modern Procession* stencil across the back. Out of the chaos, the band struck up, providing a regimenting

order, and right on cue the police cars rolled out onto Sixth Avenue. We were off.

Just as Francis had predicted, within a few blocks the procession had achieved its own life and pace. From a somewhat shaky start, the carriers gathered momentum following the laconic strains of the brass band as the morning sun grew tremendously hot. By Park Avenue, the procession had become its own pied piper, drawing in passersby and art-world stragglers. Every few feet, a handful of rose petals was tossed onto the sidewalk. Bill Cunningham, the *New York Times* society watcher, was spotted passing on a bike. Kiki Smith maintained a regal and serene posture atop the crowd. The bicycle wheel gently turned with the rolling movement of the carriers. At the Queensboro Bridge the heat of the day forced a water stop before we circled around onto the pedestrian overpass. The helicopter with the videographer inside arrived right on time and followed our passage over the bridge.

A remarkable aspect of that day was how natural it all seemed, a summer's Sunday-morning walk through New York from midtown into the gritty environs of Long Island City. At 31st Street in Queens the road turns upward as you reach MoMA QNS. At journey's end (after three hours of walking), participants were greeted by a Mexican fiesta, organized by artist Alejandro Diaz and San Antonio restaurateur Dwight Hobart at the parking lot of the local garage, replete with margaritas, *aguas frescas*, *antojitos*, and Diaz's specially designed cookie *AMOR*, made in the form of Robert Indiana's famous "Love" series. Francis sat down, poured us all a glass of tequila, and pulled out his signature slim cigarillos. Just as he had on the night we started working together.

Tom Eccles is director of the Public Art Fund.

PERMISO No. 2 D.F. REG. HDA. No. 2 HECHO EN MÉXICO

PERMISO No. 1 SRIA. DE INDUSTRIA Y COMERCIO

JUAN DIEGO SANTO

MARCAS REGISTRADAS

MOVING

In the year 1531, the Indian Juan Diego was walking on the top of Mount Tepeyac, when he heard harmonious birdsongs right beside him. Juan Diego raised his head, wondering where those gorgeous melodies could be coming from, and soon saw a shining cloud surrounded by a rainbow. In the center of this light appeared a woman.

"Juanito, my son? Where are you going?"

"To Tlatelolco, my lady."

And the beautiful woman identified herself as the Virgin Mary and asked Juan to take a message to the Lord Bishop, requesting that he construct a sacred temple to watch over the Mexican people at that site.

Juan walked to the episcopal palace and, after a long wait, he found himself in the presence of the bishop. Juan relayed the beautiful woman's request, but nobody believed his story. The bishop asked for physical proof of the beautiful woman's divinity, and Juan returned to Mount Tepeyac, disconsolate that they didn't believe his words, drying his tears on the rough fabric of his cape.

"Juan Diego, my son, why are you crying?"

"Because, my lady, the bishop didn't believe me and he wants proof of who you are!"

"Your tears on your cape are the very proof, my son! Now take these beautiful roses to the bishop as the manifestation of the sign he requested."

Juan picked up the roses, wrapping them in his cape, and took off running down the hill to bring them to the Bishop. Once again in front of the high priest, Juan unfolded his cape to show him the flowers that Our Lady had sent as a sign of her divinity. But then, as the roses fell at the Bishop's feet, the image of the Virgin Mary appeared before their dumbfounded eyes, imprinted in miraculous form on the humble piece of cloth. Juan knelt down and cried.

Since then, the portrait of the Sacred Virgin has become the most iconic emblem of the Mexican people's faith, and has been venerated each year by more than 12 million pilgrims who come from all over the country to the Basilica de Guadalupe.

–ANGEL TOXQUI
Mexico City, March 2003

2. Following page: Manuel de Arellano, *Inauguration of the Sanctuary of Guadalupe*, 1709, oil on canvas (detail)

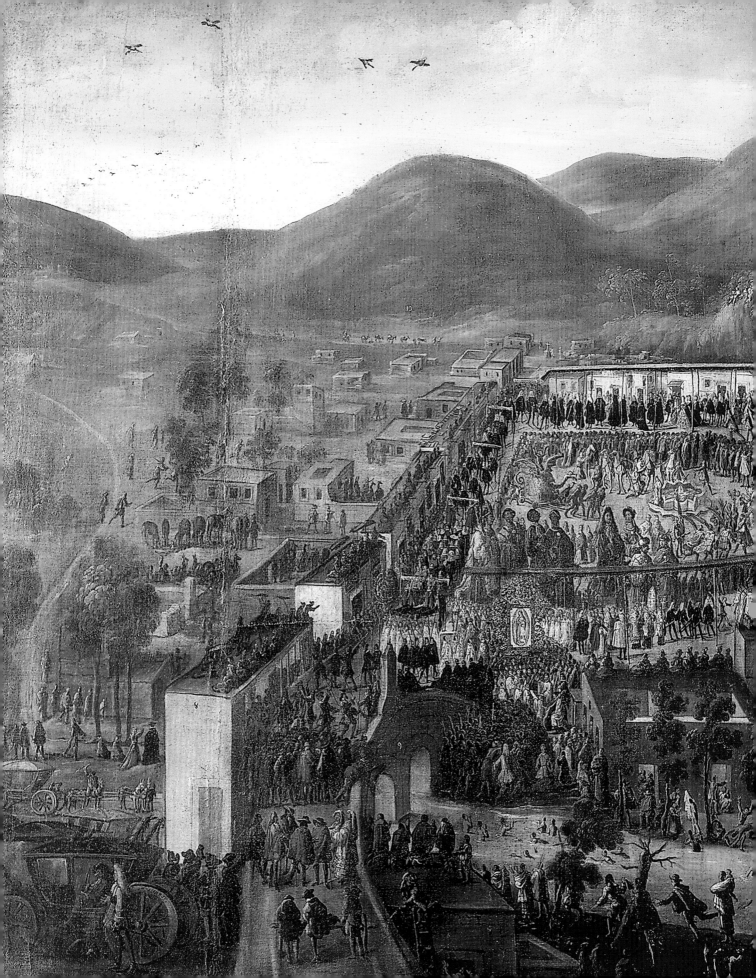

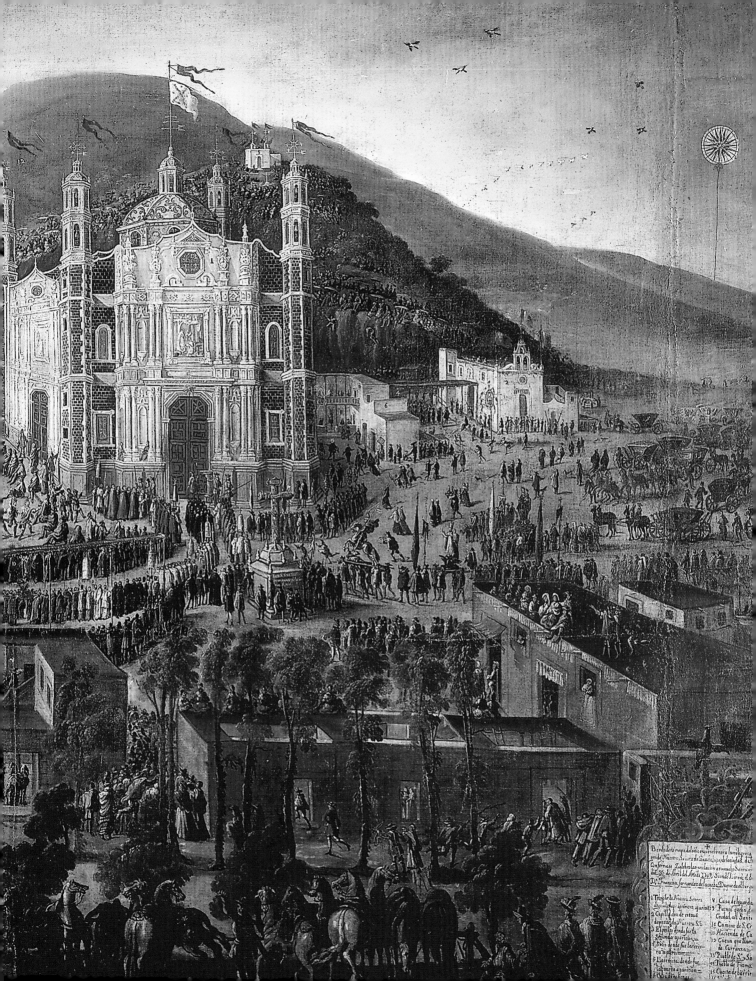

MoMA'S PROGRESS: FRANCIS ALŸS

Francesco Pellizzi

*I envisioned an immobile
procession not unlike the
friezes on Greek temples.*
Morton Feldman,
"The Rothko Chapel," 1976

Francis Alÿs's procession of art was led, to the sound of
a Latin brass band, by a riderless horse which added a
funerary flavor to the event-performance: an unmount-
ed horse often leads burial cortèges in our military tradi-
tion—a remnant, perhaps, of the ancient Eurasian prac-
tice of burying horses with dead warriors. In general,
more often than not, the remains of the dead were and
are removed with some ceremony from their previous
living quarters, to be disposed of at special sites deemed
sacred or at least separate—subject, that is, to rules and
interdictions. Staging the transference of the departed
from one to any other form of dwelling is an action by
which a person, a once-active agent, must be handled, by
necessity, as a *thing*; yet so much affective memory may
be attached to such an object that it is generally quite
difficult to perceive and treat it as inanimate.

Innumerable rites, the world over, deal with this
conundrum: the *death* of the being and his or her lin-
gering *life* (both "here," in memory, and "over there," in
the afterlife). Through often elaborate procedures, a
trans-formation must be effected from visible to invisi-
ble conscience (or from present, visibly active con-
science, to the recollection of it). One of the key acts of
this is the *trans-lation* of the corpse by a procession of
mourners, wherein the participants can become the liv-
ing, visible, experienced sign of both the person's disap-
pearance as physical presence and his or her lingering
as mnemonic image. (In archaic societies, the person
departs as a *relative* and returns as an *ancestor*). It
might be said that our collective consciousness, and

handling, of death and its "object," are at the very root of
processions, and conversely that something of these
funerary beginnings lingers in all processions.

There were other early processional rituals,
those associated with hunting or, later, with the seasonal
rhythms and toils of agriculture. These often inspired
elaborate ceremonies to and from fields or temples, the
latter also frequently linked to the cult of the dead. But
as their more generically "religious" character evolved,
in ever larger, more complex, and eventually urban
communities, a new sort of ambiguity came to be asso-
ciated with them: processions, which had once been
fully and exclusively participatory events, began to take
on the nature of spectacles, becoming more like
parades. At the start of our written civilization—
towards the end of what classical archaeologists refer
to as the "archaic" period—these changes were docu-
mented in the cult of sanctuaries as well as in the
representations "ornamenting" them, from seasonal
devotional pilgrimages to periodic spectacle-*défilés*
staged by special groups of citizens, in which just as
important as the cult was the display of its enactment

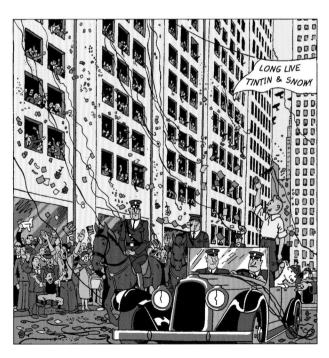

3. *Tintin in America* from the work of Hergé, 1932

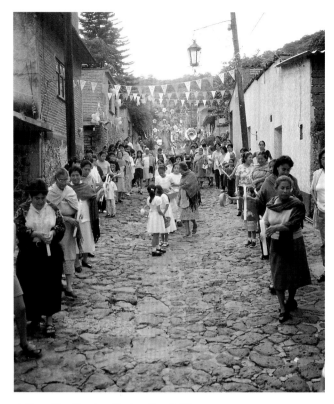

4. Tepoztlán, Morelos, Mexico, May 2000

for all to see. Though modern processions bear different contents from those of their historic antecedents, an uncertainty between pilgrimage and *display* still characterize most of them, be they religious, military and patriotic, ethnic and celebratory, or more like mass masquerades, such as those of Greenwich Village's Halloween, New Orleans's Mardi Gras, and the Carnaval in Rio.

Carrying objects and effigies over a distance, from one sacred site to another, in and out of communities, enclosures, wildernesses, and buildings, is common to processions in many places and times. The image may have replaced the carried body, or reliquary bundle, of the remembered saint-hero, just as shared offerings may stand in for the blood of sacrificial victims, but there is still an *object* involved—an inanimate "thing" that is *animated* by action and movement. Through the emotional investment of those carrying it, the processional image manifests its power, the magic of its nature—which makes of it, in this sense, a "fetish." The

collectivity's *movement* with the object endows it with a life that at the same time expresses and transcends its particular worldly condition, as well as that of the collectivity itself, at any given moment, in any given place. The "dis-placement" of the object may stand, so to speak, for its immateriality. It is a figurative enactment of the mobility, arbitrariness, and even "abstractness" of the social group to which it belongs. But at the same time, it also reaffirms both the "corporality," that is, the *everlasting presence*, of the saint-hero (in Alÿs's processional piece, of the "artist-hero") and the *corporate* nature of the community, its "body," through the pain and effort of carrying and marching. Transporting communal objects focuses on them the affectiveness with which the group might wish to be permeated. There is collective expression and transmission, but also reflexivity, in the procession of objects, a way for a collective body to see itself as both moving and enduring through space and time: such objectified, periodical, and orderly dislocations and relocations reaffirm the group's permanence through the chaotic turmoil of the ages and the uncertainties of belonging—the flow of time and the fixity of space.

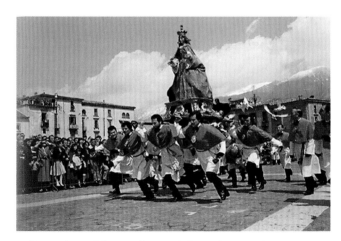

5. Procession in Sulmona, Abruzzo, Italy, no date
6. Facing page: Tepoztlán, Morelos, Mexico, May 2000

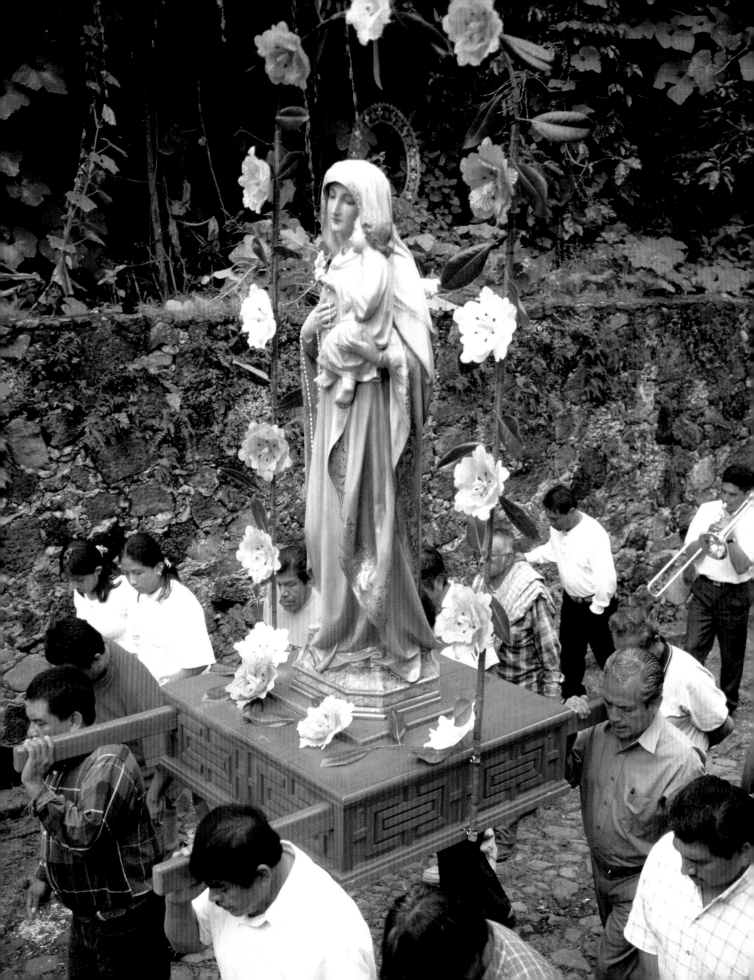

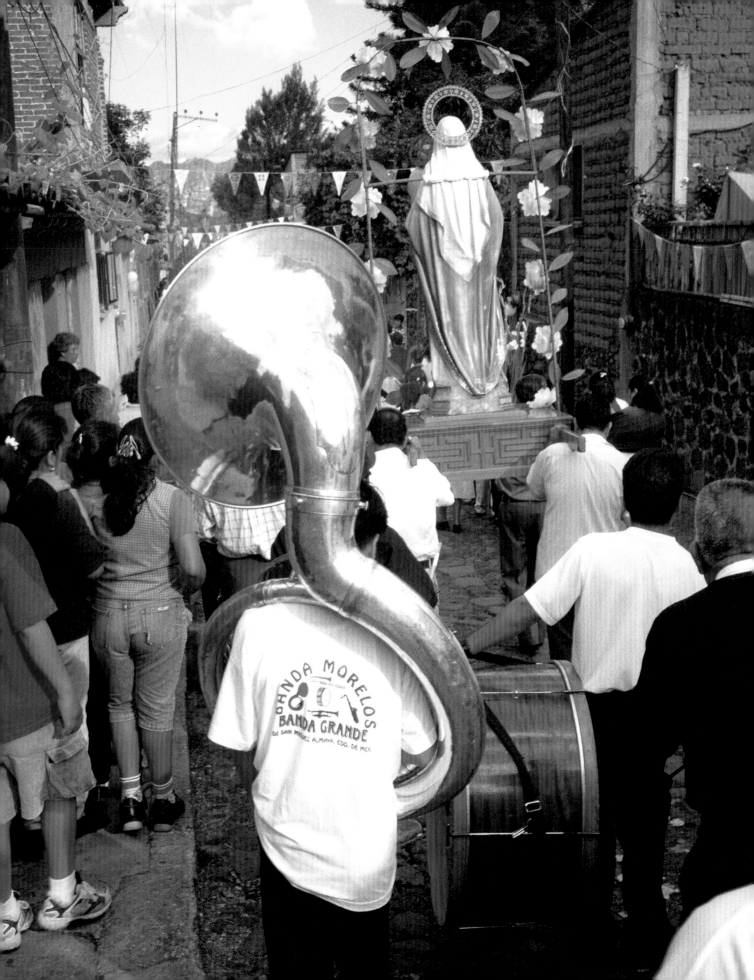

Since time immemorial, objects have moved with people and have made people move. Cult icons as well as works of art have always been strongly associated with their place of origin, and they have been the objects of journeys: we still speak of the *Pietà of Avignon*, though it is at the Louvre. But in our time, we have also come to closely identify certain objects and images with their more recent abodes—often museums: Picasso's *Demoiselles d'Avignon*, at New York City's Museum of Modern Art, has become the object of a modernist cult. Communities have always been connected through moving artifacts. Since well before Napoleon's Italian campaigns, art accompanied the victor home—often in triumphant or covert "processions"—to national treasure houses, while the material success of capitalist democracies converted good old plunder into a feature of the global flow of art and, of course, of its innumerable images and copies. Today, an intricate network of loans and counter-loans regulates the circulation of art objects, "aesthetic things," between public and private institutions throughout the world. But what is it that truly *moves* when cult and art objects travel? And to what extent, if at all, have their visits from and to art institutions (and their state or private supporters) simply replaced those which, for millennia, were made by, and to, icons and their sacred sites? Certainly, our capacity to be *moved* by any movement associated with these *things* appears to be somewhat similar to our capacity to be moved by journeys of sacred objects. Through inner or outer displacement from their original sites, objects become identified with *places*. Yet saints' relics and images as well as artistic "masterpieces" acquire some sort of plus-value every time they are transferred from one place of worship to another and every time somebody *goes* to visit them. It is as if the portent of both sorts of journey nourished and expanded the miracle of their "sanctity," and of their "beauty."

All famous artifacts are "relics" of sorts, material "leftovers" of acts of being and doing that touched many: as such, they tend to be rooted to the places where they first appeared, which often become sites of pilgrimage. Like a religious relic, when a work of art travels, its "resting-place" is shifted, thus establishing a new site for devotional journeys. As eminently *movable* things imbued with aura—quite different in this from still monuments—both relics and reputable works of art come to embody the link between their place of origin and where they dwell, albeit briefly, through the communion of worship. The museum is, in this sense, like a medieval "church," a gathering place—ecclesia—for both images and people, but one where instead of the quintessential "presence" of the saint (as a mummified body or skeletal fragments within a reliquary), we make do with the expression of the artist's doing. While we do not pray to works of art to obtain blessings, both relics and artifacts carry the aura of past states of being and the trace of deeds. It is a power both *in* and *beyond* death. Sainthood, like artistic reputation, is relatively secure only once it is out of the world's reach: it flows from inside the relic through its container, as from the conception of the art object through to its form. There is an invisible attraction that emanates from both cult and art objects, based on the idea of their *authenticity*. Yet, in the way religious relics were broken up and scattered, and in the reproduction of icons of any sort—as in Francis Alÿs's "procession" of MoMA copies—*doubles* can become the "emissaries" of powerful objects. The Colombian philosopher and aphorist Nicolás Gómez Dávila said that "the work of art has no meaning as such

7. Facing page: Tepoztlán, Morelos, Mexico, May 2000

but power. Its presumed meaning is the historical form of its hold on the spectators of a given time."[1]

Processions in which this (devotional) "power of images" is apparent may have begun as staged visitations of a group's forebears through which the recently deceased gradually joined them as full-fledged *ancestors* to the whole community. In this process of depersonalization and substitution, an actual single human being becomes a member of a *category* of beings who are, in some way, *trans-human*—a change often expressed in their "totemic" animal representations. But in some sense all processions, including parades, deal with both an absence and a presence, with the exorcism of a loss and the glorification of continuity and "rebirth": "Remembrance, like Rembrandt, is dark but festive," wrote Vladimir Nabokov in *Ada, or Ardor.*[2] Ambivalence also lingers over our "ethnic" parades in New York City, as they glorify life in the New World while evoking the Old, projecting present paradise into nostalgia for a barely "remembered" lost one. This phenomenon is like an eerie mirror image of Hamlet's "unknown country from which no traveler returns." *Which* land is the truly "unknown" one in the processional image of emigration and collective exile?

Formalized collective pilgrimages and processions have something of the appearance of journeys to the "Other World": the congregation moves across geographical and human territories, as invocations, prayers,

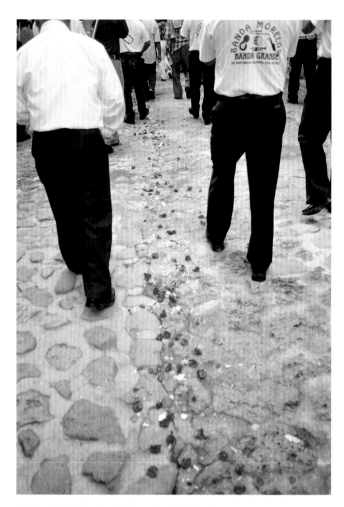

9. Tepoztlán, Morelos, Mexico, May 2000

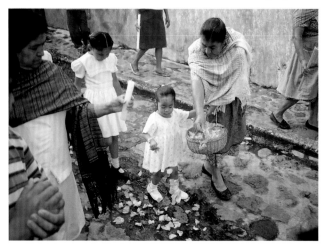

8. Tepoztlán, Morelos, Mexico, May 2000

incense, and fireworks rise up to the heavens. Everyday rootedness is lifted, and frequently the transportation of *objects-endowed-with-power* creates a special order of perception which brings "otherworldliness" into everyday experience. Referring to Swedenborg, Kant said that "when obstacles to spiritual intuition are removed, this is called the other world: which is not another reality but the same reality, only intuited differently."[3] And the philosopher Giorgio Agamben has spoken of "the movement described by Plato as erotic re-cognition (*anamnesis*), which transfers an object not towards another place or thing but towards its own 'taking-place'—towards the Idea."[4] The processional enactment can be the means towards such a transfiguration of the object.

As in the frenzied rituals inspired by the death of Orpheus (and of his bride) or in those that fielded a

"running amok of young wolves" in ancient Rome's *Lupercalia*, there can be something subversive, even "deviant," in processions—a formalized defiance that can go so far as to perform and display bloody self-mortification and ecstatic celebration within the same event. Such transgressions, which are inherent to any collective *movement*, tend to break through both visible and invisible boundaries, established enclosures, and partitions. In medieval Rome, the periodic pilgrimage-processions between churches and sanctuaries, held by religious borough guilds—which often included elaborate picnic-banquets along the way—proceeded across generally accepted and respected boundaries between frequently "hostile" neighborhoods. And funeral and processional revelries can also remind us of wedding feasts, in the course of which separate groups move towards each other, bearing material gifts, across spatial and social distance, to be united in celebration. Thus are exorcized (for a time, at least) the dangers of that "close distance" and "distant closeness" between *aliens* that always threaten to break out into war—as acknowledged in the well-known anthropological dictum "die out or marry out."

A movement of people and objects, connecting communities, may be inherent to the idea and performance of Francis Alÿs's "art-procession" from MoMA-Manhattan to MoMA-Queens. But what can we say of the agents (or "actors") and the objects taking part in public events of this nature? We should note that the first can be "believers" as well as "non-believers": belief does not determine and is not an essential element of processional efficacy. One does not proceed in belief in traditional processions, as one would in ideological manifestations, and one could more aptly speak of "suspension of belief" in relation to them: what the participating group expresses is the significance of its own chorality—something more akin to faith than to belief. In a word, the collectivity performs a rite.

Francis Alÿs's art-procession was meticulously staged as a performance—but not exactly as a "parade," because no preordained or expected "audience" was involved, nor truly as a demonstration or a "show," since no immediate or delayed effect was hoped for. It shared and underlined the arbitrary nature of the "aesthetic object," though reduced to the indexical status of the *copy*, and that of the "artist-creator," as a live figure, or impersonation, of the exalted condition of the "saint." Here, *dis-belief* and disenchantment may be presented as the starting points, the outward condition, but in order to bring into evidence a "faith" that is hidden, and of which we may not be fully aware: our lingering devotion to form, the visible remnant of our metaphysics, which paradoxically extends to our art commodities, and to the figure of the "artist," agent of their making, its all-consuming nihilism. It is as if our faith in "art" matched our quasi-theological discourse on its production in ways that parallel the "processional" mode of production of our industrial goods and the iconology of their promotion. And yet, the act of actually walking along with the art images, and with Kiki Smith—the local artist as icon of herself—all held up on their palanquins, in the company of Alÿs, the Belgian puppeteer himself (and his family), broke for all participants, at least for a time, the mold of everyday mindless acceptance of our devotional "cultural" structures. In fact, it reaffirmed the improbability of any "authentic" experience of art

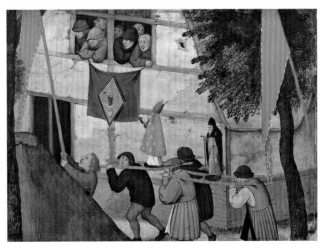

10. Pieter Brueghel the Younger, *Procession*, c.1615, oil on oak

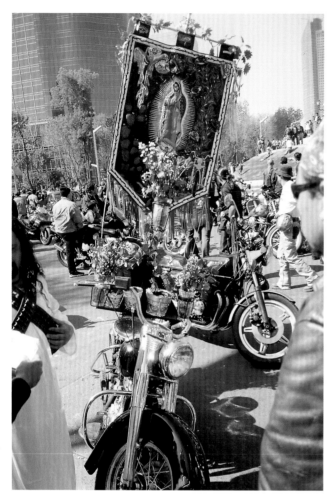

11. Mexico City, December 11, 2000

through its institutions—already announced by
Duchamp's "original-non-original" *Bicycle Wheel*—
but also injected into such an unlikely experience a
semblance of new life through both the feast and hard-
ship of actual participation in its movement.

In our world, sports and the "high" arts are often
viewed as antithetical. But it is not by chance, perhaps,
that the modern explosion of "l'art pour l'art," the mod-
ernist view of art-as-function, and the current view of
art as ("postmodernist") *dis-function* correspond to the
evolution of organized agonism into a mass spectacle.
The resurgence and media globalization of the Olympic
Games was based on the ideological reevaluation of a
culture—that of ancient Greece—which was the first
(perhaps in synchrony with China) to free the represen-
tational object of at least some of its *magical* connota-

tions and powers. As in Herodotus's story of Helen's
sculptural double—significantly revived in the European
Renaissance—mimesis splits the auratic presence by
means of craft. It is a presence of attributes—beauty
more beautiful, desirable, and unperishable than living
beauty, hence endowed with another life, a purely "aes-
thetic" one—which is one *without will*, hence a life as
object. The "fetish," on the other hand, in all its forms—
invariably tinged with monstrosity, even when stunning-
ly compelling—embodies the will that is hidden, rather
than manifested, by its *looks*. The Olympic games were
and are preceded and followed by a procession of ath-
letes and their handlers, to be witnessed and admired as
embodiments of physical prowess and skill, like a display
of moving artworks. Francis Alÿs's procession of doubles
of "masterpieces"—the originals, significantly, could not
be made available—evokes the qualitative dis-harmony
of our world in its global synchronicity. At the time of
Alÿs's art-pageant, images of team processions at the
World Cup soccer tournament in Korea, attended by
multitudes—again, not unlike those which, in the
pompa circensis of the ancient *ludi romani*, went from
the Roman Capitol to the Circus—coexisted in the
media with those of equally well-attended Mexican pil-
grimages to the Virgin of Guadalupe, just as historic
documentary footage of track-and-field award cere-
monies at Mexico City's Olympic Games in 1968
(complete with "black power" gestures), was juxtaposed
with images of costumed Korean she-shamans dancing
on swords.

This hybridity of forms now makes up the image
texture of the whole world, even in areas quite remote
from the centers of power. Among the Highland Maya of
Chiapas and Guatemala, still today, "circular" shamanic
processions—in which departure and arrival coincide,
though an experience of the limit, an initiation rite, has
changed some of the participants in between—redefine
communal territories, connecting *stations* at which
intensified communication with the above and below
takes place, complete with the sacrificial offerings
necessary to facilitate this transcendental economy.

These ritual journeys coexist with "linear" processions in which minor copies or versions of certain saints from certain sanctuaries *visit*—with great pomp and fanfare—other saints in other, often distant, sanctuaries, then return home. Networks of such visitations exist in many traditional regions the world over: the "saints"— their images—are somehow energized by these contacts, by the confrontation of their relative powers and those of the devotional practices associated with each one of them. In the flow of our modern-art exhibitions and ecumenical art collecting, works also visit each other, in multiple peregrinations involving their caretakers: Francis Alÿs's art-procession from Manhattan to Queens was also a sort of concentrated "traveling exhibition" which through its pseudo-traditional participatory enactment, on a unique occasion (*una tantum*), and at a single moment in time, celebrated and questioned the circulation and status of public aesthetic icons today. Participants were made not only conceptually but *physically* aware (this body-presence is a common trait throughout Alÿs's work, but also one it shares with traditional forms of religious "performance") of the communally attractive power of these objects. They were made aware also of the mystique attached to the names of their makers by a dialectical (that is, problematic) "staging" of the works' *historicity*. They are both of the past and of the present, unique and "multiple," *things* and *images*: in their handling, presentation, reproduction, and "cult," they are at once stereotypical and moving, ritualistic and spontaneous, avant-gardish and traditional (or old hat), formulaic and poetic. In Alÿs's persistent cultivation of the ephemeral, and in his specific settings—in their permanent impermanence and impermanent permanence—one is tempted to recognize instances of that *methodos*, or way, advocated long ago by Walter Benjamin, by which "the lifework is preserved [...] and at the same time canceled; in the lifework, the era; and in the era, the entire course of history."[5] Which is to say that with its polemical streak Francis Alÿs's procession is both dialectical and symbolic. Dialectical, in the inherent contradictions

12–13. Tlayacapan, Morelos, Mexico, 1999

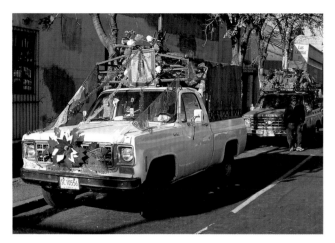

14 – 15. Above and facing page: Mexico City, December 11, 2000

1. Dávila, Nicolás Gómez, *Escolios a un Texto Implícito* (Bogotá: Procultura, 2001), p. 67. See also David Freedberg, *The Power of Images* (Chicago: University of Chicago Press, 1989).

2. Nabokov, Vladimir, *Ada, or Ardor: A Family Chronicle* (New York: McGraw-Hill, 1969), p. 103.

3. Kant, Immanuel, *Lectures on Metaphysics* (Cambridge: Cambridge University Press, 2001).

4. Agamben, Giorgio, *La Comunità che Viene* (Turin: Giulio Einaudi, 1990), p.4.

5. Benjamin, Walter, "Theses on the Philosophy of History," in *Illuminations: Essays and Reflections*, ed. Hannah Arendt, trans. Harry Zohn (New York: Schocken Books, 1969), p. 263.

of its construction (art duplicates versus real-life artist, live band versus secular images, "going" but no "return," etc.); symbolic, as is the case for every true work of art, in the nonreductive upholding of these very contradictions, giving epochal significance to the uniqueness of an event: this is one "procession" which will *never* happen again.

Francesco Pellizzi is a New York–based anthropologist and chief editor of *RES: Anthropology and Aesthetics*. Over the past thirty years, he has conducted extensive research in Mexico on various aspects of religion, shamanism, ethnic identity, and politics, principally among the Mayan people of the highlands of Chiapas.

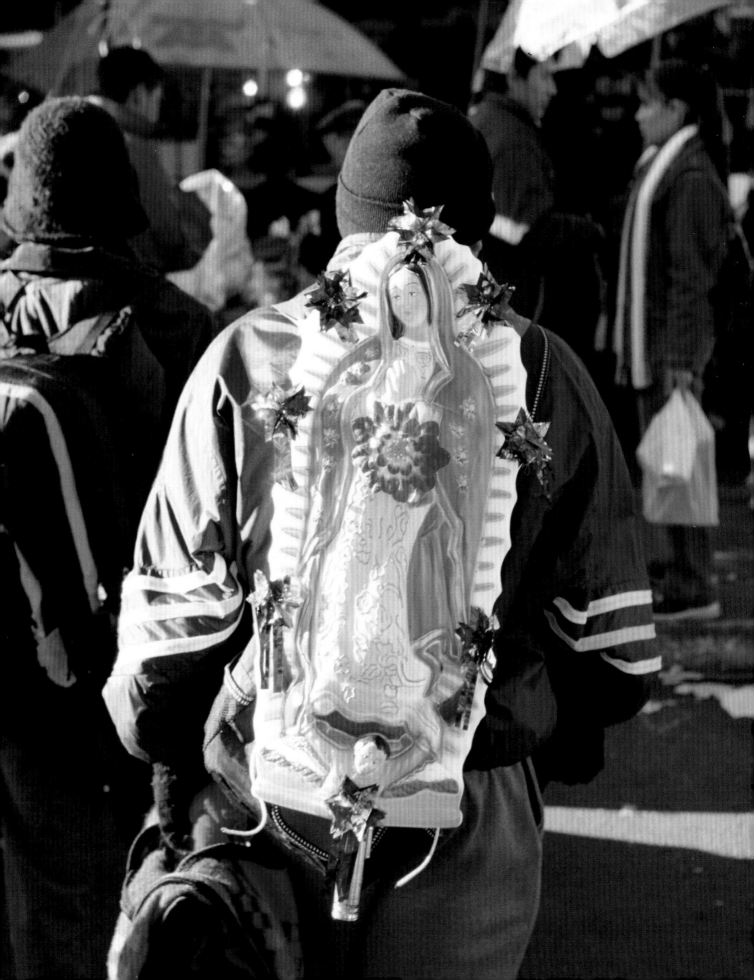

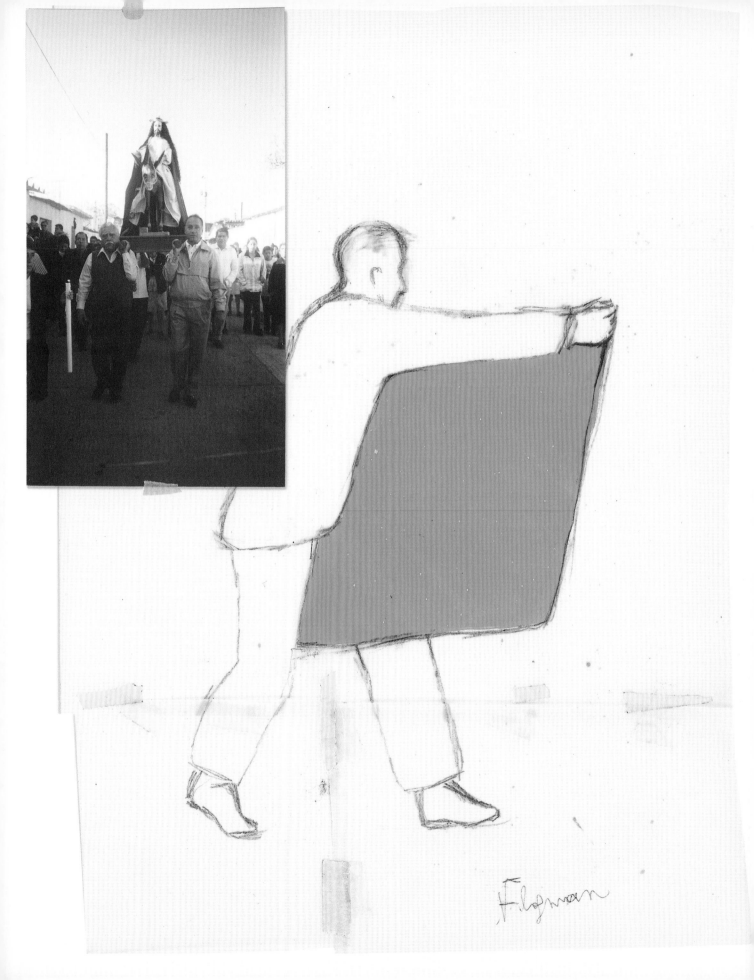

Michelangelo's David, *carved from a marble block originally intended to decorate the Florence cathedral, was soon redefined as a symbol of just leadership for the Republican governing body which had replaced the ruling Medici family. A council of citizens, including many artists, decided that it should be placed in front of the civic Palazzo della Signoria. It took four days to transport the* David *from the cathedral, a difficult process which Giorgio Vasari described in his* Life of Michelangelo *as a reflection of its high quality:"This statue, when finished, was of such a kind that many disputes took place as to how to transport it to the Palazzo della Signoria. Whereupon Giuliano da San Gallo and his brother Antonio made a very strong framework of wood and suspended the figure from it with ropes, to the end that it might not hit against the wood and break it to pieces..." Having been hidden from the public in a masonry box during its carving, the* David *was revealed on the evening of May 14, 1504, apparently not without controversy, as Luca Landucci indicates in his contemporary Florentine Diary:"During the night stones were thrown at the giant to injure it, therefore it was necessary to keep watch over it." Medici supporters may have perpetrated the attack.*

<div align="right">

–ANDREA BEGEL

New York City, January 2004

</div>

WALKING ICONS

Dario Gamboni

The Modern Procession has no direct antecedents but, like Francis Alÿs's earlier magnetic dog and shoes, it is able to attract partial ones and visualize its past trajectory. This brief essay will mention some of these historical and anthropological echoes and suggest an interpretation of their configuration.

In its form and its title, *The Modern Procession* refers to the long tradition of image processions. Sacred images have often been linked to specific places and contributed to a sacred geography or "hierotopy."[1] In many legends of the foundation of religious institutions, it is an image that chooses the location where a church must be built to house it—like the statue of the Virgen del Transito in Argentina, which manifested its will to be worshiped in Luján by refusing to be transported further, and which is now the patron of truck and bus drivers. Cult images are closely related to relics and to burial sites. They also come to be seen as persons, capable of being visited and of paying visits.[2] Miraculous images were and still are the goal of pilgrimages, attracting crowds and sending forth innumerable emissaries in the form of prints, badges, and other reproductions or derivations.[3] They are displayed out of doors in processions (fig. 17), structuring space as well as time, through the succession of stations and the cycle of feasts and seasons. Processions demonstrate faith and require the unanimous participation of the community. In 1766, in a case made famous by Voltaire's protest, the French chevalier de La Barre was executed for having failed to remove his hat before a procession.

Important images thus had a destination, which means that they were made for a place and a purpose, mostly religious. It is against this background that artistic activity and aesthetic values became increasingly autonomous in the West in the late Middle Ages and the Renaissance. Giorgio Vasari wrote in his *Lives of the Artists* that the *Rucellai Madonna*, painted by Cimabue in the 13th century, in which he saw a move from the "Greek" (Byzantine) manner to the "modern" one, had filled the painter's contemporaries with such admiration that it was carried from his studio to the church of Santa Maria Novella in Florence "with much celebration and trumpets and in the most solemn procession."[4] This first "modern procession" was chosen as a subject in 1853 by painter Lord Frederick Leighton for his debut at the Royal Academy (fig. 16), where the picture obtained

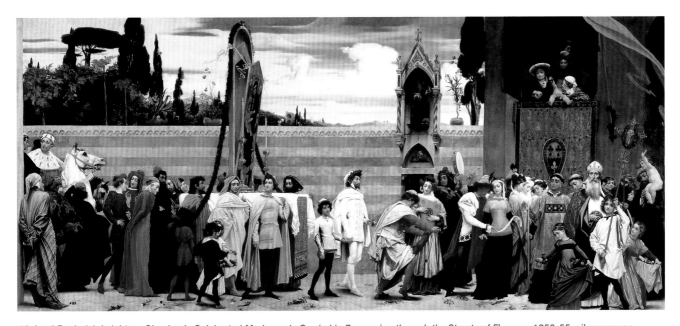

16. Lord Frederick Leighton, *Cimabue's Celebrated Madonna is Carried in Procession through the Streets of Florence*, 1853-55, oil on canvas

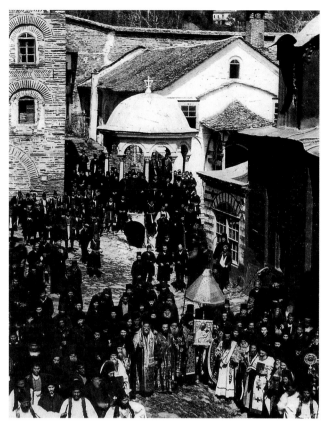

17. Icon procession on Mount Athos, around 1900

18. Anonymous, *The Return to Cologne of Peter Paul Rubens's* The Martyrdom of Saint Peter *(detail)*, 1837, lithography

a huge success and was bought on opening day by Queen Victoria. In this doubly teleological fiction, art has purely and simply taken the place of religion while retaining its rituals. Many more stages and combinations were actually needed for such a replacement to occur. A transition took place, for instance, in Paris in a literally liminal space, the parvis of the Cathedral of Notre-Dame. In the 17th and 18th centuries, the altar paintings offered yearly by the guild of goldsmiths to the Virgin were first exhibited there to be admired by the public before being hung in the chapels for which they were destined.[5]

The emancipation of aesthetic values went hand in hand with the rise of movable objects devoid of pre-determined or definitive destination. This tendency was augmented in the 18th century by the massive "disloca-tions" of artifacts caused by the rise of archaeology, the growth of princely collections and their opening to the public, the French Revolution and its ambitious museum

program, and Napoleon's conquests. On their arrival in France, the artworks looted by the French troops were sometimes shown in procession before reaching their new location, the most spectacular case being that of the third convoy from Italy which ended up on the Champ-de-Mars in Paris on July 27th, 1798.[6] The empha-sis put on the public transportation was indebted to the tradition of religious ceremonies as well as to that of military triumphs including the display of trophies, such as the spoils from the Temple in Jerusalem depicted on the narrative reliefs of the Arch of Titus in Rome (fig. 19). The bronze horses from San Marco, visible in a French drawing from the collection of the Musée Carnavalet in Paris (fig. 20), had already been taken from Constantinople to Venice during the Fourth Crusade in 1204.[7] Such transfers were meant to signal epochal changes in geopolitics, the rise of a new center and the

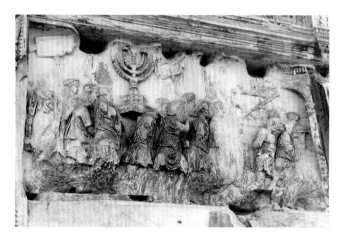

19. The Arch of Titus (detail), Rome, after 81 A.D.

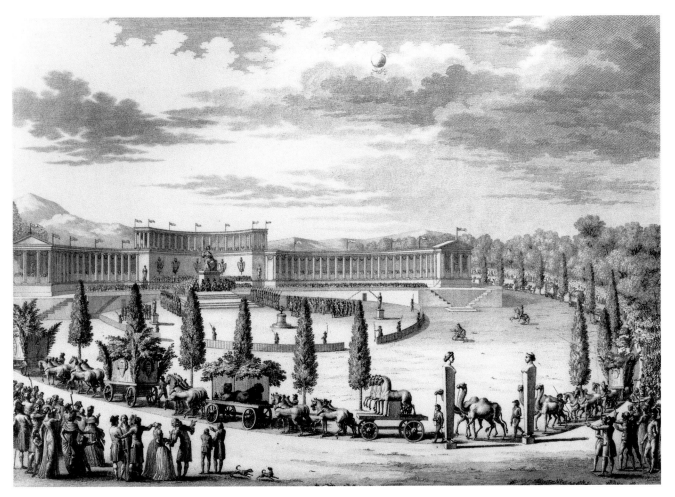

20. Anonymous, *Entrée triomphale des Sciences et des Arts au Champ de Mars*, 1798

demise of an older one, and an exchange of central and peripheral positions.[8]

But the large-scale plunder feeding the Parisian museums also led to protests affirming the existence of an organic link between artwork and context, and the superiority of art made for a "destination" over art made for museums.[9] Quatremère de Quincy, the most vocal defender of this position, was instrumental in organizing the return of many looted objects after Napoleon's defeat. These were greeted with pomp, and a vignette shows us, for instance, Rubens's *The Martyrdom of St. Peter* preceded by a standard-bearer on horseback and followed by a long line of citizens winding through the streets upon its return to Cologne, with other spectators at their windows[10] (fig. 18). The resemblance to religious-image processions is striking, but despite the

subject matter of Rubens's painting, one may surmise that it was primarily as a work of art and a piece of cultural heritage, an "icon" of local identity, that the painting was paraded in the city. Despite political restorations, the processes of secularization, museumization, and nationalism launched or supported by the Napoleonic wars proved irreversible and many returned objects landed in museums rather than in their previous locations. In the 19th century, this process was extended worldwide by Western imperialism and colonialism, resulting in an extraordinary concentration of artifacts in European and North American collections. It was emulated in the 20th century in their "peripheries," where material culture was also put at the service of the construction of national identity and the promotion of new centers. In the early 1960s, excavations were

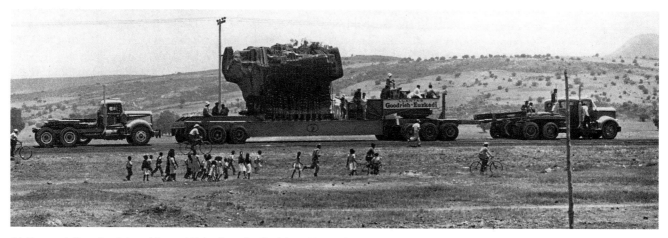

21. Transportation of a statue of the god Tlaloc from Coatlinchán to Mexico City, April 16, 1964

conducted throughout Mexico to complement the collections to be displayed in the brand-new National Museum of Anthropology, which opened in 1964 in the capital. A statue of the pre-Columbian rain god Tlaloc was unearthed in the village of Coatlinchán and, after the resistance of the local inhabitants had been appeased by the (later fulfilled) promise of a road, a school, a medical center, and electricity, it was transported to Mexico City (fig. 21), where it was greeted on the zócalo by twenty thousand people and a heavy storm.[11]

The aesthetic values and instruments of bourgeois culture came under fire from different quarters in the early 20th century. The Western avant-garde rejected the burden of tradition and the separation of art and life. With the readymade, Duchamp went so far as to abolish the manual dimension of artistic activity and the uniqueness of the work of art. The Russian revolutionaries, on the other hand, proclaimed the primacy of social needs and "utilitarian purposes." Constructivists and productivists participated in the design of mass propaganda, staging, for example, a mass theatrical action and parading Vladimir Tatlin's model for a Monument to the Third International (i.e., the Third International Communist Congress) through the streets of Petrograd (St. Petersburg) in November 1920[12] (fig. 25). But the authoritarian and totalitarian regimes that followed implemented a more thorough re-functionalization of art. The Nazis used mass rituals to the greatest effect, occupying public space and seducing or terrorizing

attendants into participation. On the "Day of German Art" in 1933, a giant model of the *Haus der deutschen Kunst* was paraded, together with reproductions of "highlights of German culture," in Munich (fig. 22). Four years later, this "House of German Art" itself presented the show of official art opposed to the defaming exhibition of modern "degenerate art."[13] Supported by a sociocultural elite and deemed adverse to the "healthy sensations of the people," modern art was derided, banished, and destroyed for political as much as aesthetic reasons.

After the Second World War, modernism was not only rehabilitated but also fully institutionalized, and an iconic status was paradoxically granted to the anti-art manifestations of the "historical avant-gardes" themselves. The "religion of art" displayed many features of traditional religion and fulfilled some of its functions in a secular context. It was also combined with cultural tourism and the leisure industry, with masterpieces and temporary exhibitions becoming the destinations of ever larger pilgrimages supported by the spread of ever more numerous reproductions and derivations. New York claimed to have inherited from Europe the role of artistic center of the world, with The Museum of Modern Art (created in 1929) as its leading institution. In 1953, its building on 53rd Street received the open-air addition of the Abby Aldrich Rockefeller Sculpture Garden designed by Philip Johnson, who applied in it his "processional theory" emphasizing the primacy of "space perceived in movement."[14] The Garden was used

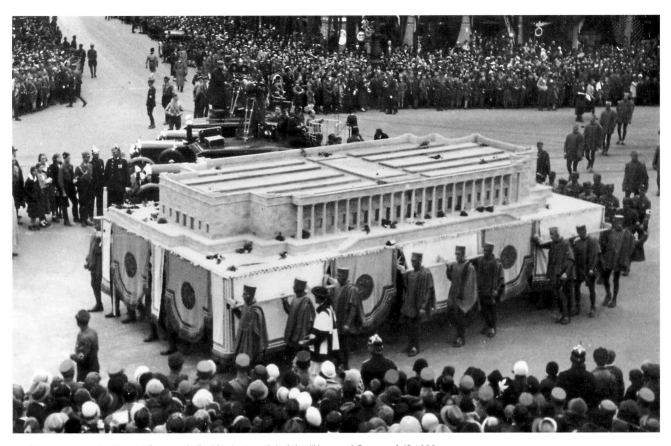

22. Procession on the "Day of German Art" with giant model of the "House of German Art," 1933

as a geographically, socially, and psychologically liminal space by John Cassavetes in his first movie *Shadows* (1958 - 59), where three young misfits, wandering through the city, limit an attempted visit to the Museum to an improvised stroll among the statues. The (half-) black member of the group, a jazz musician played by Ben Carruthers, experiences an illumination in front of a primitivist work entitled *Revelation* by the Greek-born Polygnotos Vagis[15] (fig. 23). In 1960, the garden was the site of an epochal "happening," the self-destroying *Homage to New York* staged by Jean Tinguely with Marcel Duchamp's benediction. Nevertheless, the two following decades would see the Museum come repeatedly under attack, like the whole cultural establishment. Individuals and movements calling for a renewed conjunction of political and artistic radicalism rejected the modernist notion of aesthetic autonomy while condemning as idolatrous the popular cult of masterpieces. In 1974, the Iranian-born Tony Shafrazi—

later to become a Manhattan art dealer—thus performed a "Guernica action" by spraying the words "Kill lies all" on the painting commissioned by the Spanish Republic from Picasso in 1937, in order (as he explained in 1980)

23. Film still from *Shadows* directed by John Cassavetes, 1958-59

"to strip it of the veneer of art-historical acceptance which so distorts its meaning, and make it stand in the present time"[16] (fig. 24).

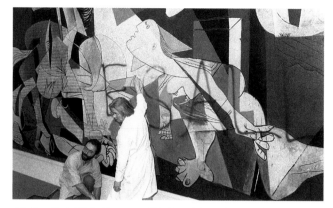

24. New York City's Museum of Modern Art employees clean paint off of Pablo Picasso's mural *Guernica*, Thursday, February 28, 1974

The end of the 20th century has seen a crisis in the definition of museums of modern art, which have had to bid farewell to the unilinear narrative, the hegemonic geography, and the universalist values of modernism. They have been forced to choose or distinguish, more or less clearly and reluctantly, between the "modern" and the "contemporary," between history and the present, between a descriptive or contemplative, and a prescriptive or active, role for themselves. While the centers of consecration, distribution, and definition of criteria have remained firmly in the West, the production of "contemporary art" has spread worldwide. In a time of globalization and (temporary) economic boom, collections have also been decentralized and new museums, such as Frank Gehry's Guggenheim Museum in Bilbao (1991-97), have been used to requalify peripheries.

Against this background, Francis Alÿs's *The Modern Procession* of June 23, 2002, appears at the meeting point of an individual strategy with institutional and urban transformations.[17] Based in Mexico City, Alÿs has been using movement and flaneurship, in relation to physical objects, as an artistic means for a decade. In his *paseos*, or walks through cities, an object can grow (like the magnet attracting urban refuse in *The Collector*) or

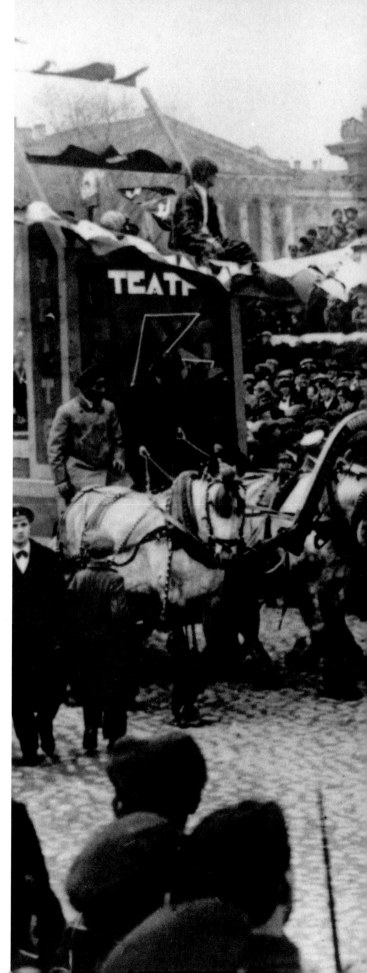

25. Vladimir Tatlin's model for a Monument to the Third International shown in the street at the same time as the mass theatrical action "The Storming of the Winter Palace," St. Petersburg, November 1920

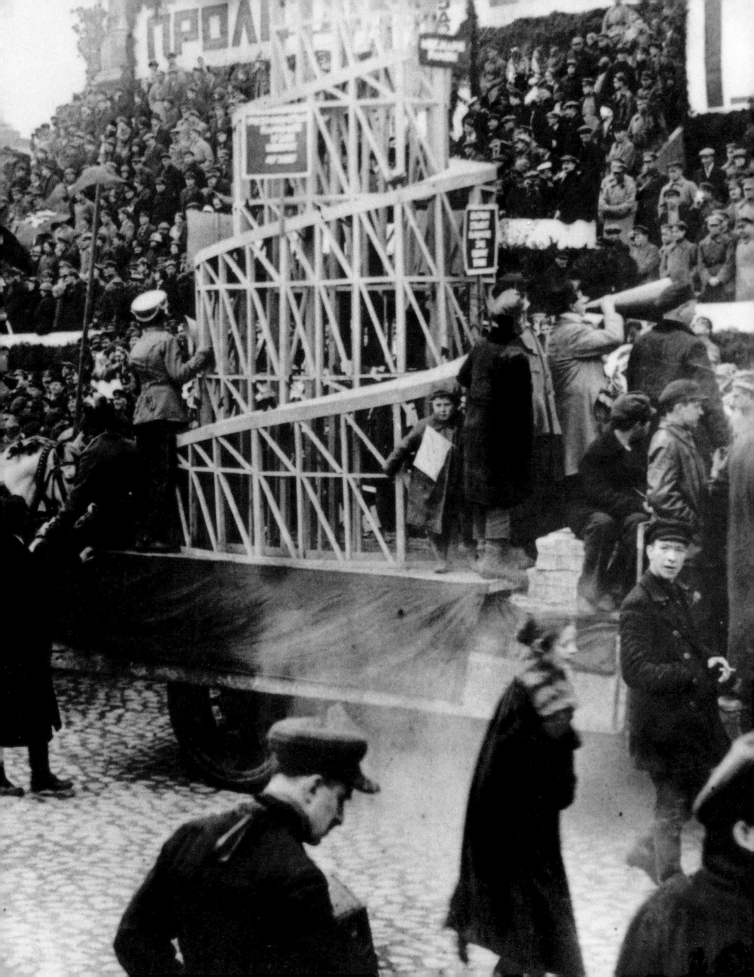

disappear (like the parallelepiped of ice in *Paradox of Praxis*).[18] In *Walking a Painting* (fig. 51), a carrier takes a painting daily off the wall of a gallery when it opens, walks it through the city and brings it back for closing time, covering it with a veil "for the painting to sleep."[19] One person does not make a procession, but in *Cuando la fé mueve montañas* (*When Faith Moves Mountains*) (figs. 47-48), 2002, 500 volunteers equipped with shovels were asked by Alÿs to "form a single line in order to displace by 10 centimeters a 500-meter-long sand dune from its original position."[20]

Works of art housed in museums only seem unmovable, while their actual mobility has been consistently increasing in the last decades (at least until September 11, 2001).[21] These movements, however, are mostly pragmatic and performed as discreetly as possible. *The Modern Procession* doubled such a move, from 53rd Street in Manhattan over the Queensboro Bridge to 33rd Street in Queens, with a ritual or mock-ritual celebration. In a brochure published by the museum about the performance, Alÿs writes that it was meant "to welcome MoMA's most sacred icons to the Periphery...for they bring us pleasure, peace, and sometimes redemption..." The moving of the collection to a peripheral location is meant to be temporary and last only while the central premises of MoMA are being renovated and expanded. But it does coincide with the move that I have mentioned, from the "contemporary" to the "historical." *The Modern Procession* displayed some of the most popular works from MoMA's collection, carried in the streets on palanquins like images of the Virgin of Guadalupe, to the sound of Peruvian procession music. One of the works was Picasso's *Demoiselles d'Avignon*, showing prostitutes and African masks in lieu of the Virgin and angels. The terms in which Alÿs phrased this celebration and the means he employed for it introduce therefore the periphery (from greater New York, from the Americas, and from the world at large) into the heart of the center and question their dialectical relationships.

Another "icon" was a reproduction—since Alÿs was not allowed to transport the works themselves—of Duchamp's *Bicycle Wheel* of 1913, that is, of the replica made by the author of his lost "original."[22] Duchamp was a Voltairean skeptic who professed to lack all "faith in art" yet was deeply involved in the building of collections and museums. His first readymade, which made use of real movement to open "avenues onto other things than material life of everyday," was turned into an idol commanding the legs of human carriers. One of Alÿs's preparatory drawings shows that he had also considered including in the procession a small three-dimensional image of the Golden Calf, perched on top of a multi-layered palanquin (see page 62). Equating the homage (material or psychological) paid to images with the worship of the Golden Calf has been a feature of iconoclastic discourses and actions from antiquity to the present,[23] and this reference points to a critical dimension of Alÿs's project. In another drawing (see page 56), a large group of carriers seems almost crushed by the weight of an empty container in the middle of which looms the auratic presence of *Les Demoiselles d'Avignon*. Alÿs's quotation already mentioned speaks of "MoMA's most sacred icons," but his Golden Calf drawing goes a step further by commenting: "from Icon to Idol."

The Modern Procession therefore possesses an element of parody, of carnival in the subversive sense explored by Mikhail Bakhtin. It reflects on a situation and a history, to which this essay has also turned, and aims at promoting a greater awareness of the phenomena at stake. It had to go into the streets as the museum's "Projects 76," because there is no department for ephemeral art within the structure of MoMA. Yet Alÿs does not attempt to "save" art from the museum, as Shafrazi claimed to do with his "Guernica action," and his critique resorts to irony and metaphor, not to physical assault. In addition, the final absence of the Golden Calf and the presence of a living artist among the "icons" opened the procession to more varied and even contradictory interpretations. The participants were required to avoid hats and sunglasses, but the public was not asked to take off its hat (or to throw tomatoes); instead, it was left free to "revere" or reflect, and even to do both.

Dario Gamboni is professor of art history at the University of Amsterdam, where he has taught since 2001. He is the author of several books, mainly on 19th- and 20th-century art, including *The Destruction of Art: Iconoclasm and Vandalism since the French Revolution* (1997) and *Potential Images: Ambiguity and Indeterminacy in Modern Art* (2002).

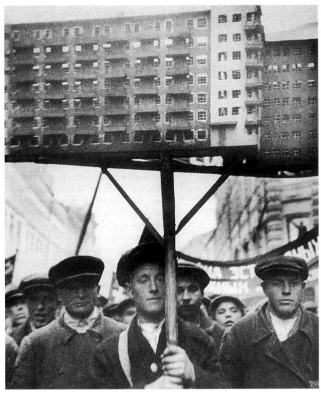

26. Soviet workers carrying a model for planned housing, c. 1930

1. Alexei Lidov, "Hierotopy as a New Vision. The Miraculous Image in the Making of Sacred Space," unpublished paper presented in 2002 at the Center for Art and Media in Karlsruhe.

2. See Hans Belting, *Bild und Kult. Eine Geschichte des Bildes vor dem Zeitalter der Kunst* (Munich: C.H. Beck, 1990), notably pp. 61, 208.

3. See David Freedberg, *The Power of Images* (Chicago: University of Chicago, 1989), pp. 99-135.

4. Giorgio Vasari, *Le vite de' più eccellenti pittori scultori ed architettori* (Florence, 1878), I, pp. 254-55 ("che da casa di Cimabue fu con molta festa e con le trombe alla chiesa portata con solennissima processione"). Another major case is the procession accompanying Duccio's Maestà altarpiece to the cathedral of Siena in 1311, of which contemporary chroniclers emphasize the solemnity and the "great devotion" (see Elizabeth Gilmore Holt, *A Documentary History of Art*, vol. I (New York: Doubleday 1957), pp. 134-136.

5. See Olivier Christin, "Die Maibildstiftung der Pariser Goldschmiede. Ein Beitrag zur Entstehungsgeschichte des ästhetischen Gefühls," in O. Christin and D. Gamboni, *Crises de l'image religieuse—Krisen religiöser Kunst* (Paris: Editions de la Maison des sciences de l'homme, 1999), pp. 157-90.

6. See Philippe Bordes and Régis Michel, eds., *Aux armes et aux arts! Les arts de la Révolution 1789-1799* (Paris: Adam Biro, 1989), pp. 219-20.

7. See André Corboz, "Walks around the Horses," *Oppositions*, 25 (Fall 1982), pp. 85-101.

8. For a dynamic understanding of the relationship between center and periphery in the geography of art, see Enrico Castelnuovo and Carlo Ginzburg, "Centro e periferia," in *Storia dell'arte italiana, I: Questioni e metodi* (Torino: Einaudi, 1979), pp. 285-352.

9. See D. Gamboni, "'Independent of Time and Place': On the Rise and Decline of a Modernist Ideal," in Thomas DaCosta Kaufmann, ed., *Time and Space: The Geohistory of Art* (Burlington, VT: Ashgate), forthcoming.

10. See Marie-Anne Dupuy, ed., *Dominique-Vivant Denon: l'oeil de Napoléon*, exhibition catalogue (Paris, Musée du Louvre), 1999, fig. 75.

11. Pedro Ramírez Vázquez, *The National Museum of Anthropology Mexico: Art—Architecture—Archaeology—Anthropology* (Mexico: Panorama, 1968), pp. 36-37.

12. See Jürgen Harten, ed., *Vladimir Tatlin: Leben, Werk, Wirkung* (Cologne: DuMont, 1993).

13. See Peter-Klaus Schuster, *Die "Kunststadt" München 1937. Nationalsozialismus und "Entartete Kunst"* (Munich: Prestel, 1987).

14. Philip Johnson, "The Seven Crutches of Modern Architecture," *Perspecta*, III (1955), and "Whence and Whither: The Processional Element in Architecture," *Perspecta*, IX-X (1965), quoted in Emmanuel Herbulot, "Le manifeste esthétique in situ de John Cassavetes. La séquence du jardin des sculptures dans *Shadows*," *Cahiers du Musée national d'art moderne*, 52 (Summer 1995), pp. 52-99.

15. Ibid, pp. 82-90; this sculpture seems to have been installed in the garden for the purpose and it is worth noting that Cassavetes was himself the son of Greek immigrants.

16. "Tony Shafrazi—Interviewed by Ted Mooney," *Art in America*, December 1980; see Peter Moritz Pickshaus, *Kunstzerstörer. Fallstudien: Tatmotive und Psychogramme* (Reinbek bei Hamburg: Rowohlt, 1988), pp. 41-64.

17. I thank Francis Alÿs for documentation and our discussions about his work, especially *The Modern Procession*.

18. *The Collector*, Mexico City, 1991; *Paradox of Praxis*, Mexico City, 1997; see Francis Alÿs, *Walks/Paseos* (Guadalajara, 1997).

19. F. Alÿs, postcard, *Walking a Painting*.

20. F. Alÿs, postcard, *Cuando la fé mueve montañas (When Faith Moves Mountains)*.

21. See Walter Grasskamp, *Die unbewältigte Moderne. Kunst und Öffentlichkeit* (Munich: Beck, 1989), pp. 27-44.

22. See Arturo Schwarz, *The Complete Works of Marcel Duchamp* (New York: Delano Greenidge Editions, 2001), pp. 588-89. MoMA's *Bicycle Wheel* happens to have been stolen near the main entrance and returned to the sculpture garden in August 1995 (Carol Vogel, "Inside Art," *The New York Times*, September 15, 1995).

23. See David Freedberg, *The Power of Images, op. cit.* (as in note 3), pp. 378-428, and D. Gamboni, *The Destruction of Art: Iconoclasm and Vandalism since the French Revolution* (London: Reaktion Books, 1997), p. 210.

la traversée de Paris

Detailed preparations for The Modern Procession *had begun months earlier, but the night before it took place I—along with the rest of the Public Art Fund staff—busily worked at pulling thousands of rose petals off their stems to be strewn along the streets the following morning. With red-stained fingers, I arrived the next day to a gathering mass of people waiting for their positions, uniforms, and instructions. There was the band to account for, the horse to arrive, and the artist to be seated, along with so many other things to arrange. But once the procession started to move and the band began to play, my worries faded so I could enjoy this extraordinary event which led us all through the streets of midtown Manhattan into the sunlit borough of Queens.*

—MIKI GARCÍA
New York City, October 2003

27. Following page: Pieter Bruegel, *The Tower of Babel*, 1563, oil on wood, and postcards of New York City

— la petite Procession

CHRONOLOGY OF THE MODERN PROCESSION

- JUNE 1999 : MoMA invites Francis Alys to propose a work for its
 Projects series. (Project 76)

- SEPT 1999 : F.A. proposes a rumor-based project.

- JAN 2000 : MoMA officialy announces its temporary move to Queens,
 scheduled for 2002.

- MAY 2000 : F.A. witnesses the Procession of Sta Cruz in Morelos,Mex.

- JUNE 2000 : F.A. proposes The Modern Procession for Project 76.

- JULY to : F.A. negociates with MoMA to include original master-
 DEC 2000 pieces from the collection in the procession.

- DEC 2000 : F.A. has discussion with anthropologist Francesco Pellizzi
 about the way that substitutes are commonly used as stand-
 ins for original icons in traditional processions.

- DEC 2000 : MoMA and F.A. agree to do the procession using "represen-
 tations" of MoMA's permanent collection masterpieces.

- FEB 2001 : MoMA reconsiders the matter and decides not to allow the
 use of representations of its masterpieces in the procession.

- MARCH 2001: F.A. proposes "Alternative Procession I : the container
 truck."

- MAY 2001 : Dead end; F.A. proposes "The Procession without icons."

- JUNE 2001 : F.A. cancels The Modern Procession.

- SEPT II, 2001.

- OCT 2001 : The Return of The Modern Procession.
 F.A. reinstates the project and proposes "Alternative Pro-
 cession II: "The golden calf."

- DEC 2001 : F.A. proposes "Alternative Procession III: The guerilla
 version."

- DEC 2001 : Meeting with Tom Eccles and agreement that Public
 Art Fund will organize with Francis the production
 of the event "The Modern Procession".

- MARCH 2002: I. Contract is made between F.A. and MoMA for a movie titled
 The Modern Procession about MoMA's move to Queens.
 II.Contract is made between F.A. and the Public Art Fund
 for a public event titled The Modern Procession.

- APRIL 2002: Kiki Smith accepts the role of "the living icon".

- MAY 2002: New York City Police Department grants permit for The
 Modern Procession.

- JUNE 23rd,
 2002 : The Modern Procession.

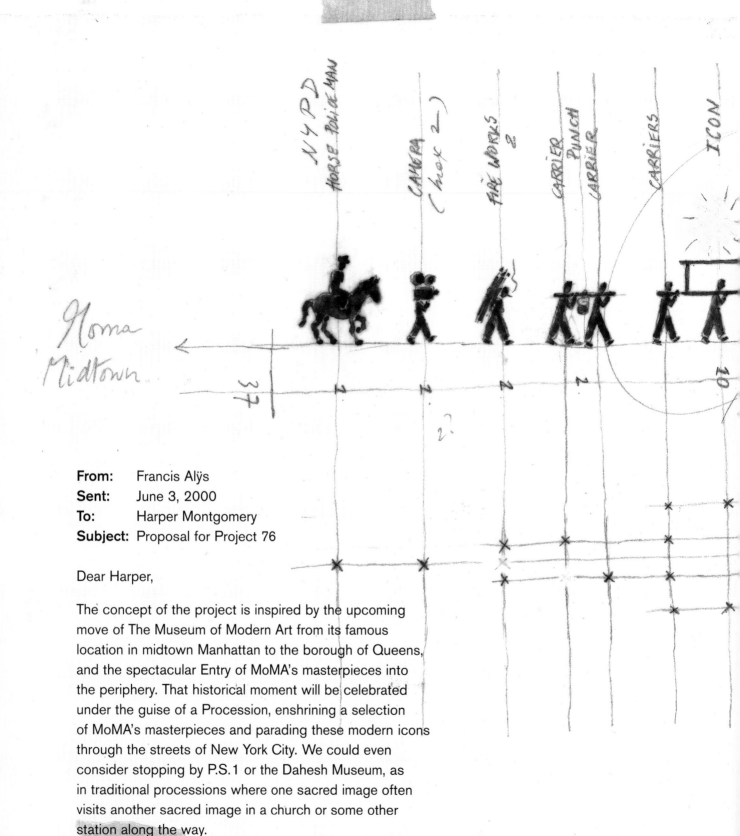

From: Francis Alÿs
Sent: June 3, 2000
To: Harper Montgomery
Subject: Proposal for Project 76

Dear Harper,

The concept of the project is inspired by the upcoming move of The Museum of Modern Art from its famous location in midtown Manhattan to the borough of Queens, and the spectacular Entry of MoMA's masterpieces into the periphery. That historical moment will be celebrated under the guise of a Procession, enshrining a selection of MoMA's masterpieces and parading these modern icons through the streets of New York City. We could even consider stopping by P.S.1 or the Dahesh Museum, as in traditional processions where one sacred image often visits another sacred image in a church or some other station along the way.

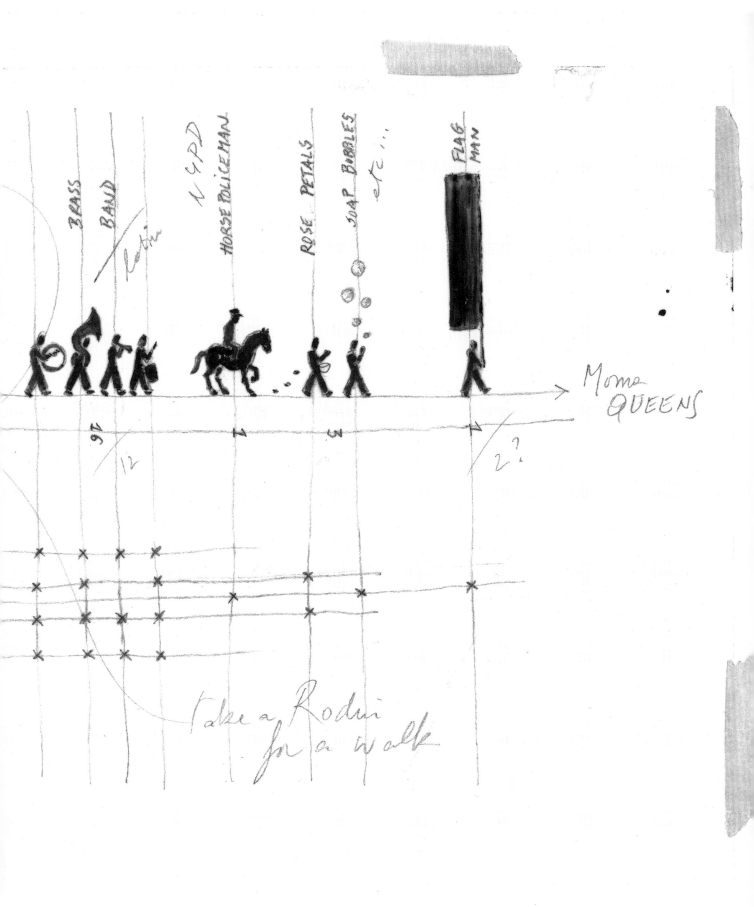

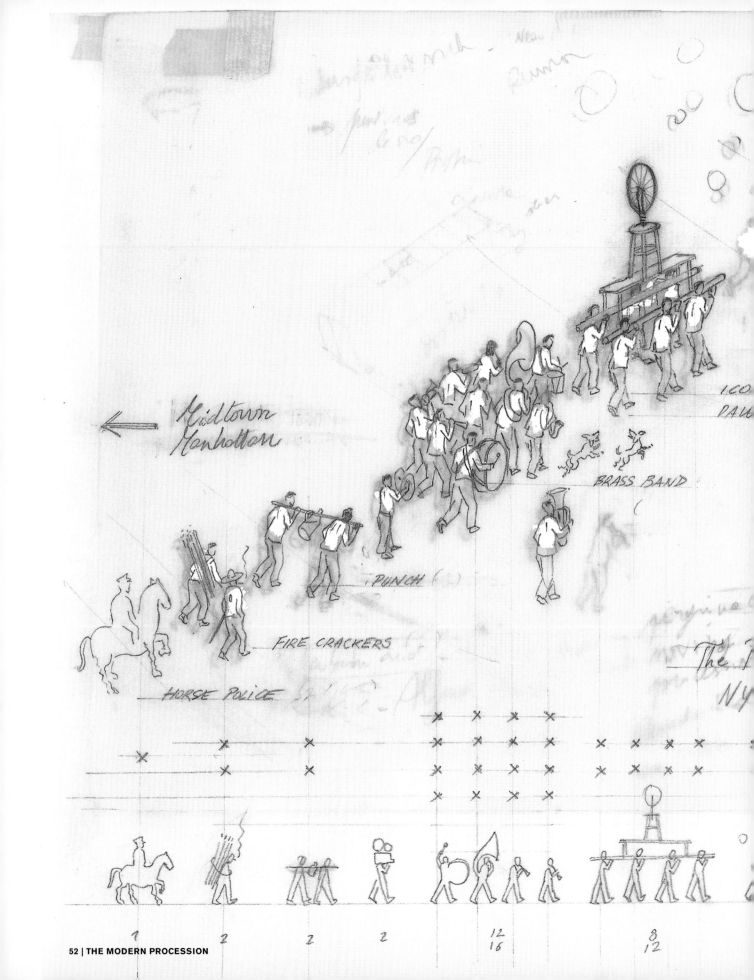

← Midtown
Manhattan

BRASS BAND

PUNCH ()

FIRE CRACKERS

HORSE POLICE

1 2 2 2 12 8
 16 12

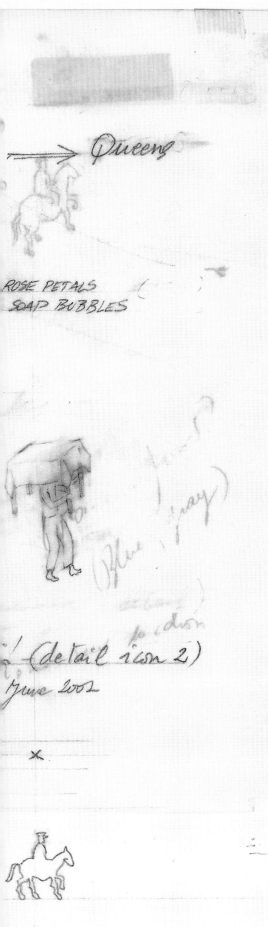

ROSE PETALS
SOAP BUBBLES

(detail icon 2)

June 2002

From: Francis Alÿs
Sent: June 15, 2000
To: Harper Montgomery
Subject: The Modern Procession

A Grand Modern Procession, A Parade of Masterpieces

The Modern Procession will announce the temporary move of The Museum of Modern Art from Manhattan to Queens, and will celebrate the entry of its permanent collection into the periphery. The pilgrimage will take the guise of a traditional ritual procession: a selection of MoMA's masterpieces will be carried on palanquins, a Peruvian brass band will set the pace of the journey, and rose petals will be strewn in its path while fireworks will rise up at street corners. The procession will depart from MoMA's famous home on 53rd street, and the congregation will march through midtown. It will cross the Queensboro Bridge and enter Queens along Queens Boulevard, and will finally deliver the artworks to MoMA QNS on 33rd Street. By enshrining modern art icons as if they were religious idols, and by parading them with due ceremony along the streets of New York, The Modern Procession teases and questions the status of the consecrated art object in our 21st-century society. It also surreptitiously inserts a grand-scale performance into the opening of MoMA QNS, a discipline strangely absent from MoMA's six departments of the arts.

2

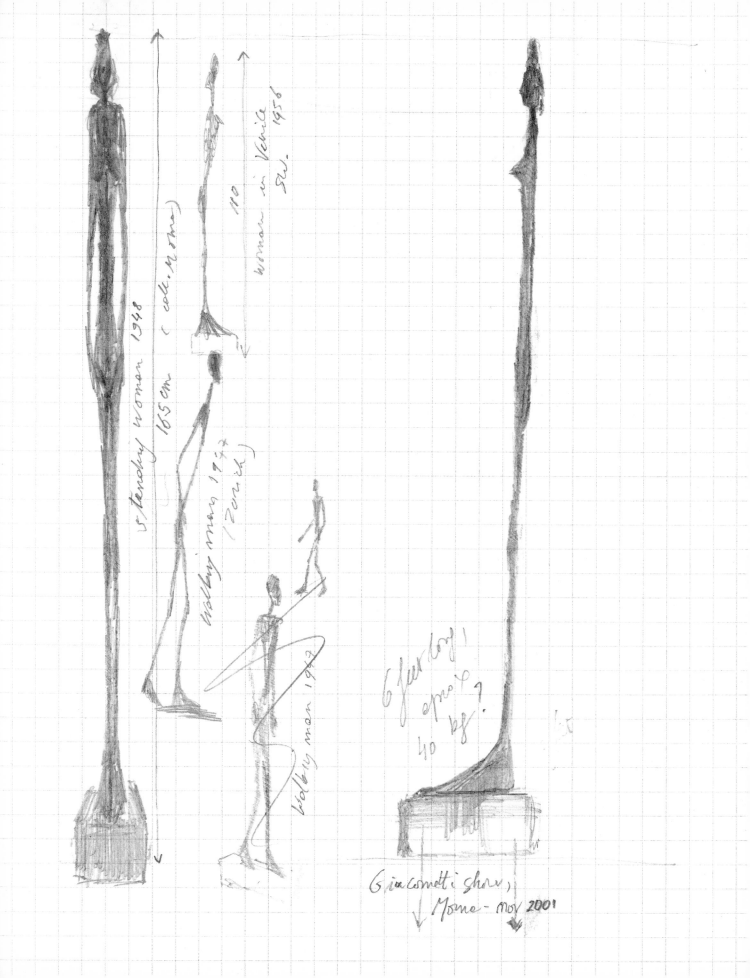

standing woman 1948

165 cm (coll. MoMA)

Walking man 1947 (Zürich)

Walking man 1947

woman in Venice IV, 1956

110

6 feet long!
single ?
40 kg

Giacometti show,
MoMa - Nov 2001

THE CANDIDATES - ICONS

- Demoiselles d'Avignon P.
- Stary Night Van Gogh
- Anna's world A. Wyeth
- La danse Matisse
- Gypsy Night Rousseau
- Standing woman #2 Giacometti
- Spoon woman
- Unique forms of continuity in space too heavy Boccioni
- Study for naked Balzac too heavy Rodin
- Endless column balance !
- Bird in space Brancusi
- African-American flag David Hammons
- Little girl Louise
- Broadway Boogie Woogie Piet
- Bycicle wheel Marcel
- Boy leading a horse (demoiselles)
- House by the railroad Hopper
- Echo Newman
- Flag J Johns
- Gold Marilyn Monroe Warhol
- Abstraction blue G O'Keeffe
- Self-portrait with cropped hair Frida Too small
- Intolerance Griffith

-

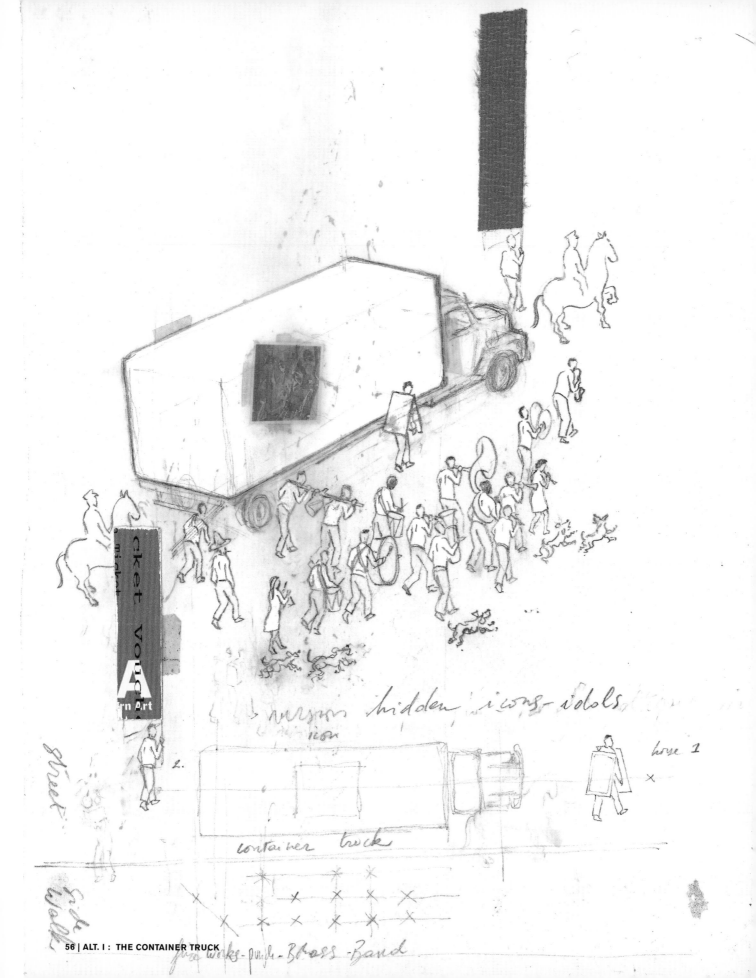

hidden icons-idols

container truck

hose 1

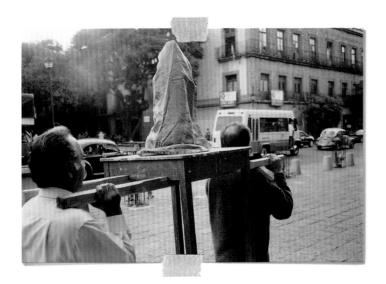

From: Francis Alÿs
Sent: March 24, 2001
To: Harper Montgomery, Laurence Kardish
Subject: The Procession in progress

Dear Harper, Dear Larry,

The spark for this project is the physical moving of MoMA from midtown Manhattan to Queens, the spectacular entry of MoMA's collection in the suburbs.

MoMA's insurance policies imply certain measures that have to be integrated in the reality of the Move. If the selected Masterpieces require maximum protection—transportation in an unidentified container truck—then why not integrate into our caravan this carrier, whose perfect looks mock Carl Andre's or Donald Judd's minimalist sculpture, and whose proportions could recall the mathematical beauty of a Greek temple? Our horse-guards will escort this hermetic vehicle until its arrival at MoMA QNS. I would leave the responsibility (and the honor) of the selection of the carried icons to the concerned authorities of MoMA, and I will not ask to be informed of their identities.

Very best,
Francis

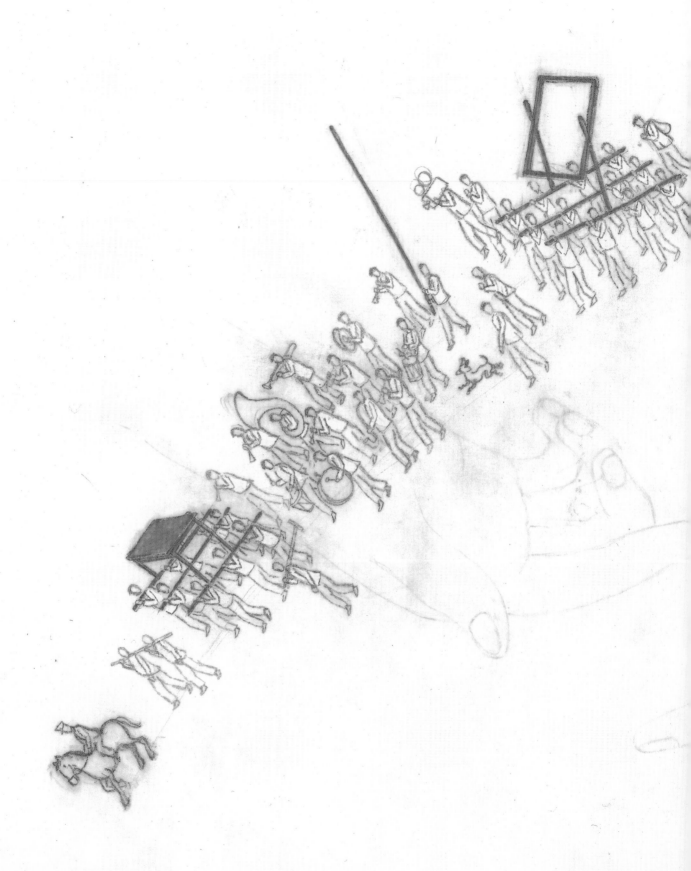

From: Harper Montgomery
Sent: May 2, 2001
To: Francis Alÿs
Subject: Original works

Dear Francis,

I'm afraid we encounter familiar problems with the original works you proposed in your drawing. We would not be able to borrow a Giacometti walking man, and would run into the same problems with a Warhol print or a drawing (as much as I hate to write you this!). I'm afraid that the answer that I received from the very top on this subject (including works of art from the collection or borrowed by the Museum) is a resounding and unbendable "no."

Best wishes,
Harper

From: Francis Alÿs
Sent: June 15, 2001
To: Harper Montgomery
Subject: None

Dear Harper,

In light of the last unbendable "no" from MoMA, I am afraid the integrity of the original proposal is becoming too much at risk. For the sake of the art and all the good reasons that made us enter this project together, I have decided to cancel The Modern Procession.

I hope that you understand my situation.

Very best,
Francis

From: Francis Alÿs
Sent: September 29, 2001
To: Harper Montgomery
Subject: The Return of The Modern Procession

Dear Harper,

How are you? As you know, I will be staying with E. and P. in Rhinebeck, New York, for the rest of the month while waiting for the National Guard to clear out from downtown and the surrounding area of the apartment on the Lower East Side. Somehow, in this period of reflection and mourning, I feel more than ever that the procession, for its reverent nature and collective power, could be a most relevant vehicle for a public event in the streets of New York City. Shall we re-open the project?

Very best,
Francis

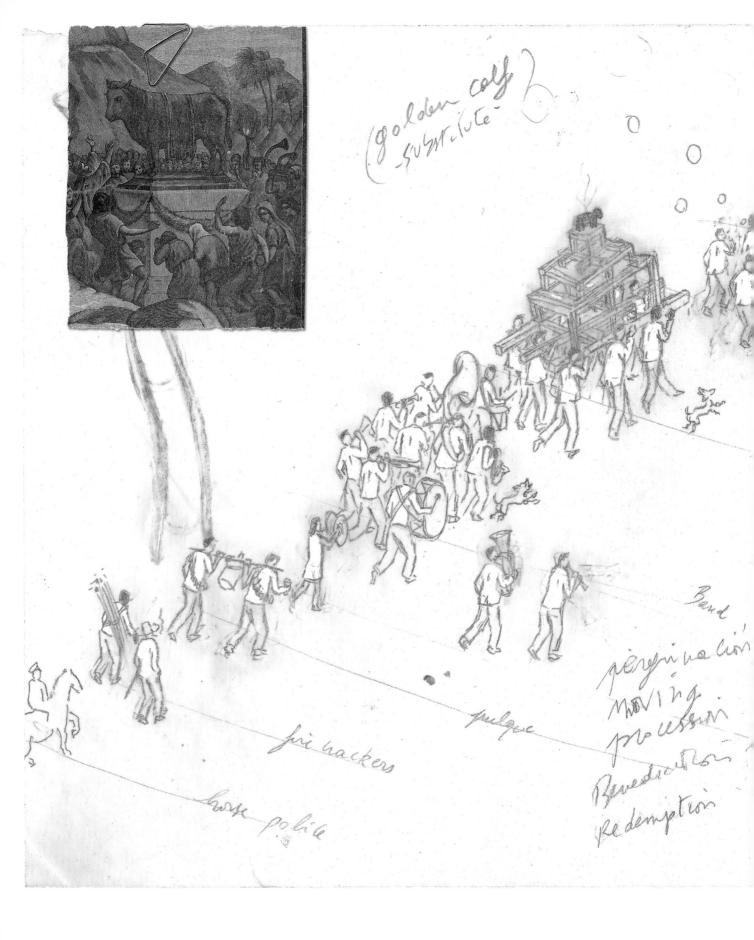

(golden calf?)
substitute

Band

peregrination
moving
procession
Benediction
Redemption

firecrackers

pulque

horse police

From: Francis Alÿs
Sent: October 10, 2001
To: Harper Montgomery
Subject: The Entry of the Golden Calf

Dear Harper,

In order to avoid wasting more time negotiating the loan of (or representation of) MoMA's masterpieces, I suggest we introduce as the main icon of the procession a sculpture of a golden calf, made in solid gold, as a perfect substitute for the present occasion. This will allow us to progress without delay in the logistics of the project.

Very best,
Francis

"They put their faith in a thing shaped like a pumpkin."
Hans Staden, "The True History and Description of a Country of Savages" (1557)

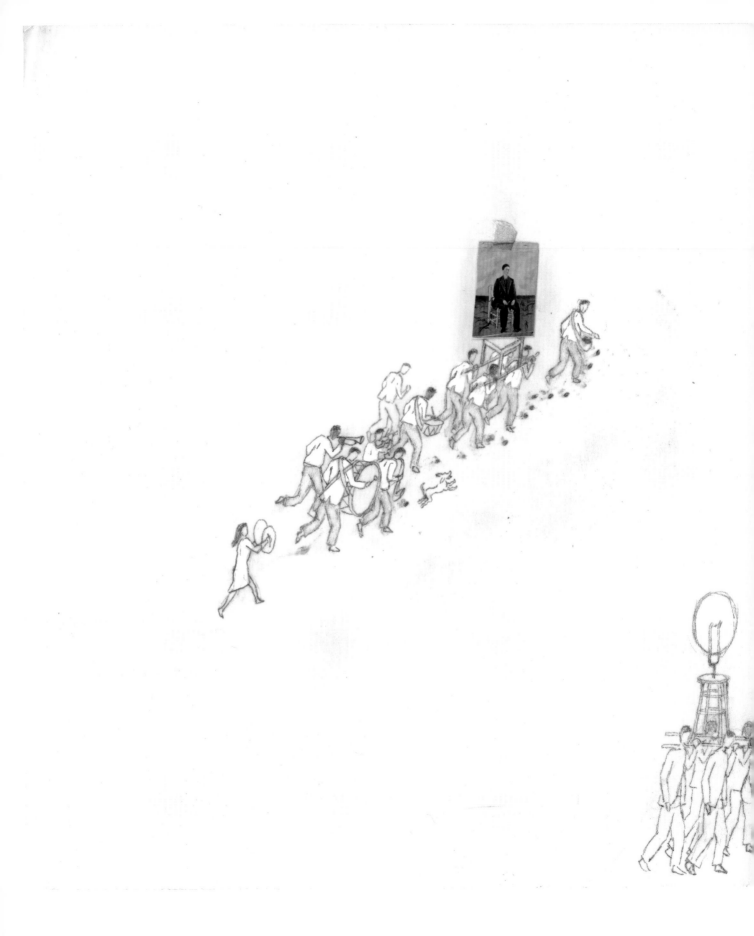

illa Scenario)

From: Francis Alÿs
Sent: December 12, 2001
To: Harper Montgomery
Subject: Guerilla Procession

Dear Harper,

The main questions left are now related to the nature of the icons and the scale of the procession itself. I am thinking more now of a "guerilla" intervention: A much reduced version of the original procession. No permits, a few musicians, and just one symbolic icon. We take off and see how far we get...

Very best,
Francis

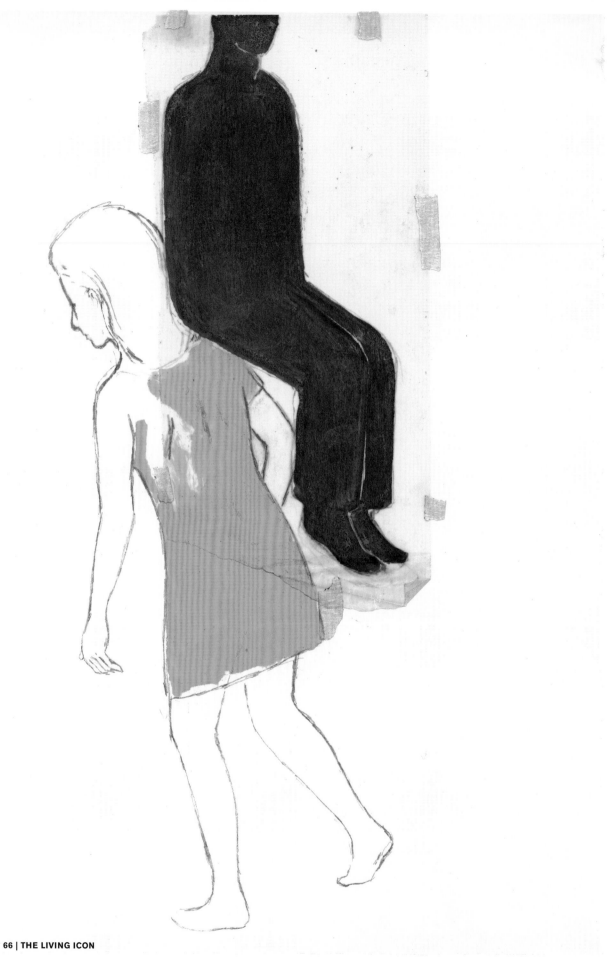

From: Francis Alÿs
Sent: March 3, 2002
To: Tom Eccles, Harper Montgomery
Subject: Living Icon

Dear Tom, Dear Harper,

Remember I once mentioned that the missing icon (after the classic painting and sculpture icons) would be a guest star as part of the procession, a living icon, an ambassador of our 20th-century art history? Can you help me think of any artist of that stature who would agree to participate? See my list below.

Very best,
Francis

Short List / Living Icons. Louise Bourgeois
Merce Cunningham
Richard Serra
Vito Acconci
Kiki Smith
Yoko Ono
Robert Rauschenberg
John Baldessari
David Hammons
Cindy Sherman
Lawrence Weiner

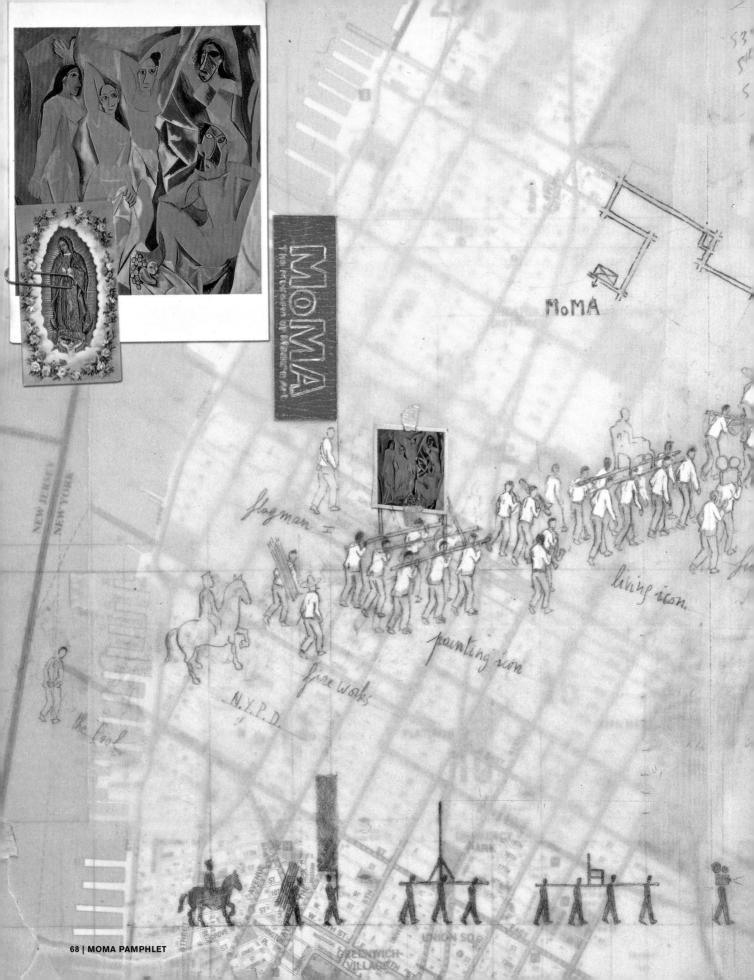

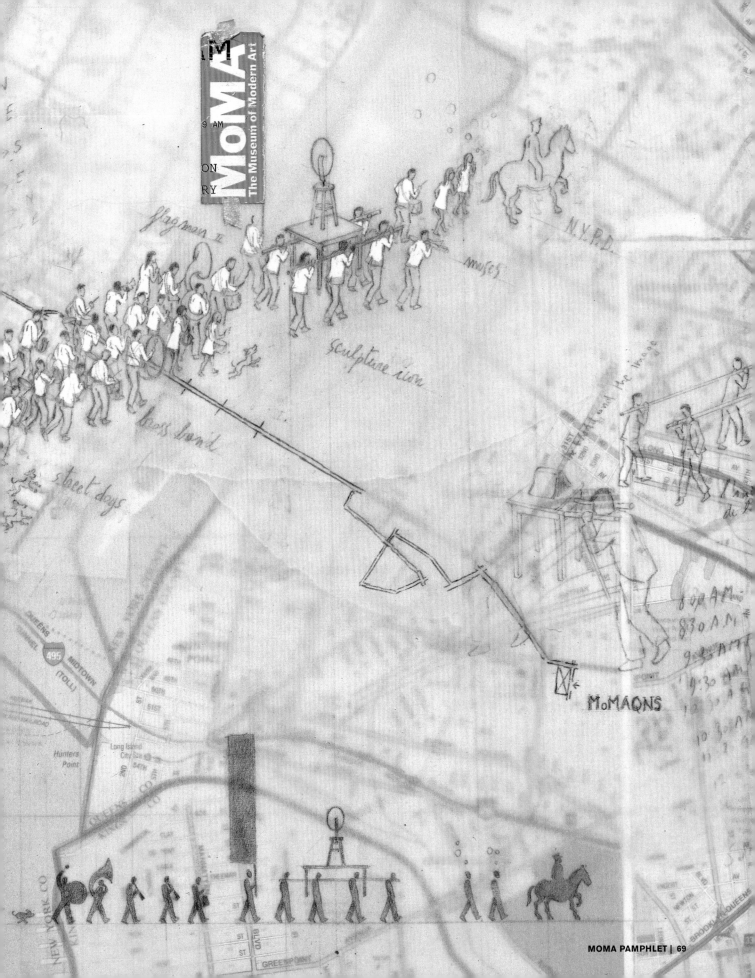

Giacometti

Verde x
Dup.

+20

16 + ·19 4/reserve

20
Verde afara

8

Duchamp
Dcil.

Blue

6 + 2
reserve

· 8 reserve

white

Demoiselles

8

Pi.

+ 8

Gummy 16

· 16 reserve

6 '2 white

KiKoi

5 + 2 < F
M.
+ Diego
+

Blue
1

bueto

green

2

14
white

Dolly's

· 14 reserve

14 carriers

THE MODERN PROCESSION - N.Y.C. June 23rd 2002

43

- Tepeyac

- Palanquin-Demoiselles d'Avignon5 left ⟩ 12 \18
 + 4 columns3 right
 ·8
- Palanquin- Bycicle Wheel.................3 left ⟩ 6 ~ ②
 3 right
(- Palanquin - Standing Woman#2...............7 left ⟩ 14 ~
 7 right
- Palanquin - Living icon4 right
 4 left 2 ⟩ 10
 + 2 stools2 right
 2 left 2 Dolly
 +2 replacement
- Banners2 ⟨ Red Blue
- Punch3 c/HORSE
- Fireworks2-
- Petals, soap bubbles4
- Camera crew-battle field3 ⟨ R F + Front end :Procession
- Dog walkers2— LARRY
- precursorsI V ⟩
 I H
- T.B.D.2
- Peruvian FanfareI tambor
 I bombo
 2 x 8 large I platillos
 1 x 8 x large I saxo tenor ⟩ 12
 3 x 40 3 mediums 2 saxo alto
 3 trumpetás
 2 trombones
 I tuba
 ─────
 76

- N.Y.P.D. / horsemen I up front
 I end

160
180 30

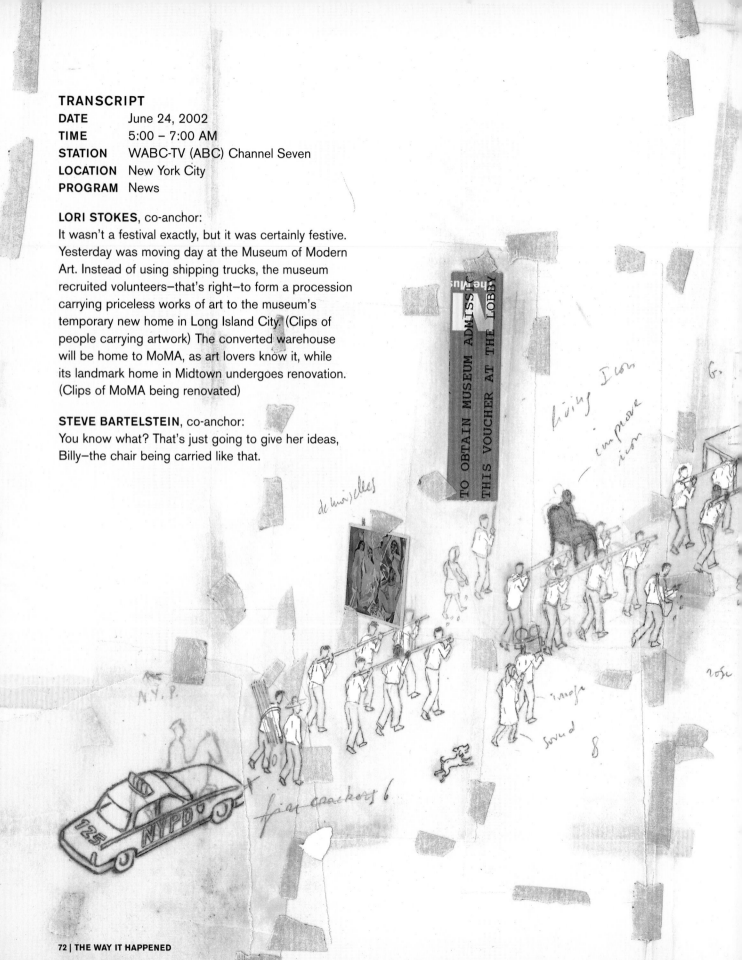

TRANSCRIPT

DATE June 24, 2002
TIME 5:00 – 7:00 AM
STATION WABC-TV (ABC) Channel Seven
LOCATION New York City
PROGRAM News

LORI STOKES, co-anchor:
It wasn't a festival exactly, but it was certainly festive.
Yesterday was moving day at the Museum of Modern
Art. Instead of using shipping trucks, the museum
recruited volunteers—that's right—to form a procession
carrying priceless works of art to the museum's
temporary new home in Long Island City. (Clips of
people carrying artwork) The converted warehouse
will be home to MoMA, as art lovers know it, while
its landmark home in Midtown undergoes renovation.
(Clips of MoMA being renovated)

STEVE BARTELSTEIN, co-anchor:
You know what? That's just going to give her ideas,
Billy—the chair being carried like that.

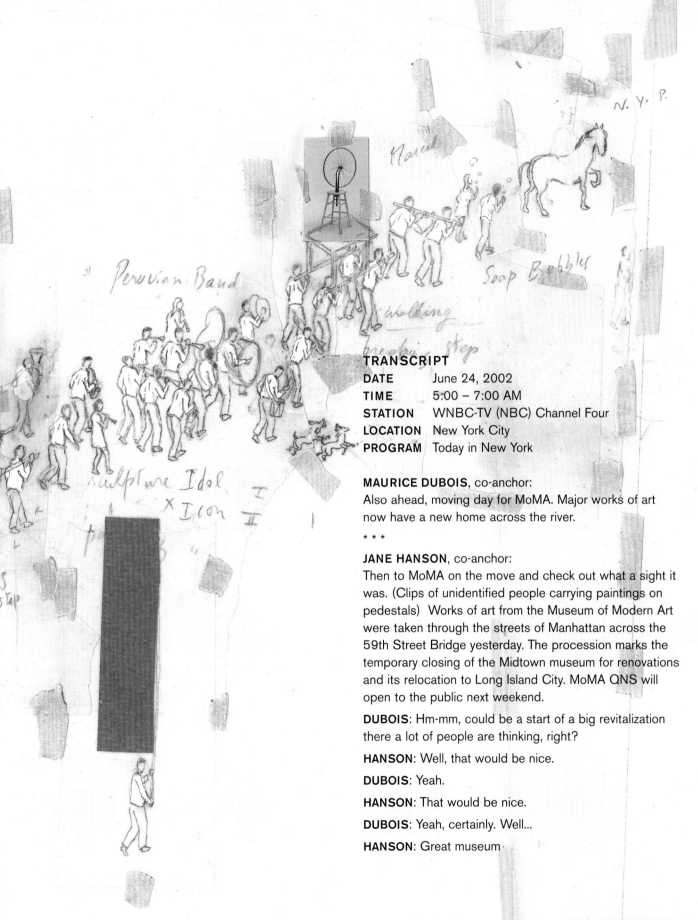

TRANSCRIPT
DATE June 24, 2002
TIME 5:00 – 7:00 AM
STATION WNBC-TV (NBC) Channel Four
LOCATION New York City
PROGRAM Today in New York

MAURICE DUBOIS, co-anchor:
Also ahead, moving day for MoMA. Major works of art now have a new home across the river.

* * *

JANE HANSON, co-anchor:
Then to MoMA on the move and check out what a sight it was. (Clips of unidentified people carrying paintings on pedestals) Works of art from the Museum of Modern Art were taken through the streets of Manhattan across the 59th Street Bridge yesterday. The procession marks the temporary closing of the Midtown museum for renovations and its relocation to Long Island City. MoMA QNS will open to the public next weekend.

DUBOIS: Hm-mm, could be a start of a big revitalization there a lot of people are thinking, right?

HANSON: Well, that would be nice.

DUBOIS: Yeah.

HANSON: That would be nice.

DUBOIS: Yeah, certainly. Well...

HANSON: Great museum

McWennebe

In Europe, museums often sit next to cathedrals, and people choose one, the other, or both for their devotional excursions: seeking their subjective individuality either in the experience of aesthetic judgment or in the common identity of the congregation—Protestant or Catholic—under the auratic gaze of the minister or the cathedral window, or even in the formal and spiritual complements of these, traditional or modern art.

In proceeding across the Queensboro Bridge with the relics of modernity, Francis Alÿs returned these things to the place where they belong, the street—for a moment. In the street, however, you also find their modern-day analogues, which are, as Baudelaire well knew, the expensive consumer fashion items proceeding down the cosmopolitan avenue adorning their owners with the aura of the moment.

The moment is merely the aura of the moment. What does this mean? It means, first of all, that the modern has to be repeated once more, and then once more after that. Secondly, it means that proceeding can only return modernity to its having been, and therefore, Alÿs's procession is the only true modern form of The Museum of Modern Art.

–SAUL ANTON
New York City, January 2003

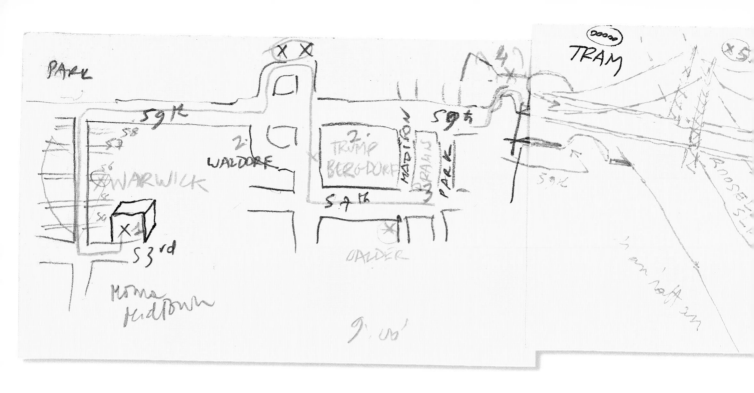

to get from MoMA to McMAGNS,

walk west on 53rd St,

turn right and walk up Six th Avenue,

turn right again onto 57th Street,

Walk along 57th until you get to Park Avenue,

Turn left on Park,

and then right on 59th Street,

Continue on 59th past Bloomingdoles until

you get to Second Avenue,

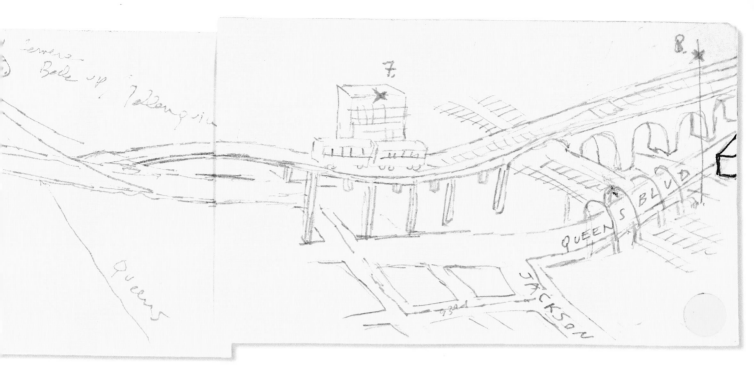

enter the pedestrian walk to cross the bridge,
continue along Queens plaza under the elevated
Tracks,
go over a small bridge,
turn left onto Queens boulevard,
then right onto 33rd street,
MoMA QNS is the blue building on
your right .

A CONVERSATION AMONG FRANCIS ALŸS, ROBERT STORR, AND TOM ECCLES

Robert Storr: Several years ago when Harper Montgomery first approached me and the Projects committee about doing something, the idea put forward as the strongest possibility was to do some kind of a storefront project in the Bronx or at least outside of Manhattan. I wonder if you could talk a little bit about where your thinking began and how this other idea of a procession began to take hold.

Francis Alÿs: When I learned about MoMA's upcoming move to Queens, I thought there was a historical coinci-dence to take advantage of, that it was a key moment in MoMA's history, and I started focusing on that transition. And the most obvious manifestation of MoMA's moving was the physical displacement of the work. I am always interested in art in motion. Also, although I know that, technically, Queens is one of the five boroughs of New York, just as Manhattan is, it is commonly perceived as belonging to the periphery of Manhattan. I considered the entry into the periphery of these masterpieces, which have become trademarks of our culture, to be a small revolution; I saw that passage to be something to celebrate. I myself belong to the so-called periphery, and I believe in the distance it allows me. And the freedom. When Harper Montgomery mentioned the transition, two images came right away to my mind: James Ensor's

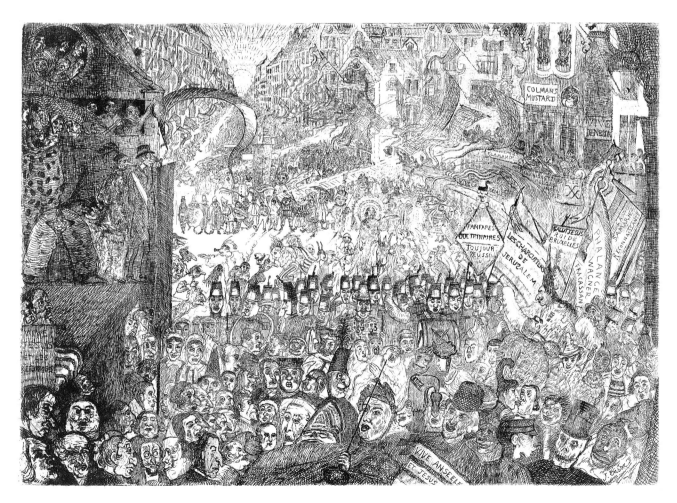

28. James Ensor, *The Entrance of Christ into Brussels*, 1898, etching and drypoint

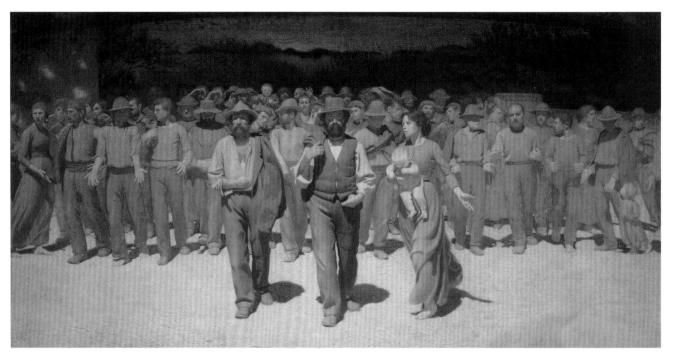

29. Giuseppe Pellizza da Volpedo, *Il Quarto Stato*, 1901, oil on canvas

The Entrance of Christ into Brussels (1898, fig. 28) and a study by Giuseppe Pellizza da Volpedo for his large canvas *Il Quarto Stato* (1901, fig. 29). But what really triggered the project was when I witnessed a traditional religious procession in Morelos at about the same time.

30. Announcement for Sidney Janis Gallery, New York, photo by Duane Michals © DUANE MICHALS

RS: In the marketing of museums and the business of tourism, they talk a lot about destination, that's where people head to when they come to a city. It's almost as if what you've done is to take that idea of tourist destination and turn it around and make it the point of departure. MoMA on 53rd Street isn't the place to go to, it's the place you leave from. Which nicely scrambles up the language, though in another way your procession cuts a path to MoMA QNS. Have you done projects before with institutions that are seemingly this monolithic or have this particular aura about them—both as a cultural entity and as a building? I mean, MoMA is a big item!

FA: Although I had worked with major institutions before, I think in the past I've tried to insert my practice more discreetly, to fit in the little cracks of these temples, addressing their heaviness nearly by eluding it, by dismissing it. Like freeing a mouse at the opening event of the largest art foundation of Mexico. Or walking out of the Reina Sofía with a leaking can of paint. But, although in the case of MoMA there was a shift of scale

in the production, the basic mechanics and strategies of intervention remained similar. First, the principal medium, the material from which the art is extracted, is generated by the act of walking. And the storyboard, although logistically more ambitious, was at the same time quite simple. As in past projects, I tried to maintain a very schematic structure so that the project can travel as a rumor or a story, even while the event or performance is happening. In other words, the plot has to be simple enough so that people can imagine it without having to witness it "live," or have access to visual documentation of the event. If you are told that there has been "a procession with some masterpieces from the collection of MoMA, leaving from 53rd Street to arrive in Queens via the Queensboro Bridge," you can pretty much (re)build a mental image of the scene. You could repeat the anecdote to someone else, who will imagine something different. But if the story is good enough, and pertinent in the air of the moment, the essence of the scenario will survive that process of oral transmission.

Tom Eccles: What I think was interesting was that the procession had a kind of religious overtone, an explicitly religious overtone. And we were dealing with, essentially, a structure not dissimilar from the Catholic Church, with the cardinals, bishops, down to the village priests. And every church has its Martin Luthers! Early on we talked about how we might possibly get the original works, and I remember slightly teasing one of the MoMA people, saying why don't we put *Les Demoiselles d'Avignon* in the back of a taxi cab and take it over the bridge that way? We'd have armed police, so it would probably be the safest mode of transportation you could get in terms of moving artwork.

RS: It's not the first time prostitutes have traveled in taxicabs in New York.

TE: Of course the painting would never fit in the back of a cab in the first place. What was really interesting, in

MOMA, 53RD STREET, MANHATTAN JUNE 22, 2002

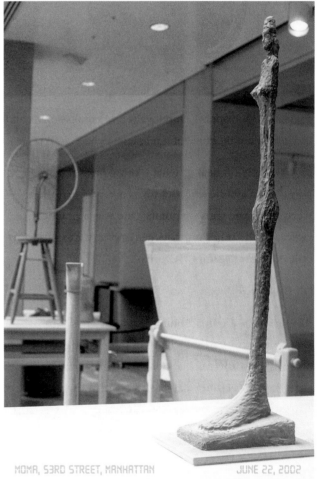

MOMA, 53RD STREET, MANHATTAN JUNE 22, 2002

a way, was how the procession hit a kind of doctrinal nerve that needed to be discussed. You have an insight into those discussions, whereas we were often second-guessing. There was quite a lot of kind of cloak-and-

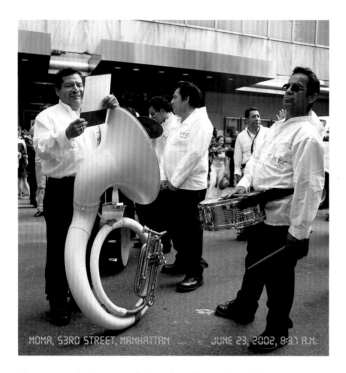

MOMA, S3RD STREET, MANHATTAN JUNE 23, 2002, 8:31 A.M.

dagger and whispers-behind-walls and confessionals and the whole architecture of a religious debate.

RS: Well, a good deal of what I know must remain in-house and can't be said. But my sense was that there were two basic sticking points. One was a practical issue, and the other one touches on the status of the art object. One was simply security.

FA: Insurance policies, mostly.

RS: But it's not only insurance policies. These are unique works of art which are in the custody of the museum, and any damage done to them would be a catastrophe. Consider that at this stage of the game a painting like *Les Demoiselles d'Avignon* barely moves from room to room because it's so fragile, and it's absolutely irreplaceable. So I think there's a very strong conservation argument on that side. And even if you're dealing with bronze sculptures in some cases, you're dealing with unique or relatively rare casts, or casts with irreproducible patinas. Unfortunately, it almost comes down to a medical question: What is the status of the patient? But I think the other issue that arose in

discussions about using original works from the collection was the question of appropriating one artist's work to make another artist's work. What role did the museum have in that; whether they had responsibilities to, in effect, act as a protective force on behalf of the original work, or whether they were, as an institution, involved in the collaborative creation of art by forming an alliance with an artist who would appropriate something in our charge.

TE: You, in a sense, started this debate with "Dislocations," no?

RS: Yes, and so far as I know Sophie Calle's *Ghosts* piece, from that exhibition, is the first thing of its kind to have happened at MoMA. I don't know if you know the work, but she replaced works in the collection that had been temporarily taken off view with surrogates which represented the memory of what those works looked like and what they were about culled from members of the staff in a wide variety of positions. This was done in the permanant collection, and in terms of artistic interventions in the institution, there has really been nothing like it before or since. Kirk Varnedoe, who was the head of the department at that time, was willing to take the chance on behalf of a contemporary project which was in no way disrespectful of the classic works

MOMA, S3RD STREET, MANHATTAN 8:39 A.M.

for which Sophie substituted her "copies," and it's very much to Kirk's credit that I was allowed to go ahead.

FA: I think that originally there was a misinterpretation of my intention. I wasn't interested in appropriating works in the collection—I only wanted to re-present them. It had more to do with an act of veneration. An homage to the status that these works had acquired in a "modern" or "postmodern" society. Sometimes the nuance between icon and idol can become very thin, especially at a moment where, in my opinion, the very

society I was addressing was developing an increasingly ambiguous relationship with the concept of "religion," and was simultaneously finding itself confronted with a new volume of free time—a space for "leisure" that would naturally lead to a demand for new entertainment. And all this at a time of exceptional wealth for that society, even if the latter is very unevenly distributed. The golden calf is always around the corner. I felt this whole situation was a worthy basis for a "mise-en-scène," that these changes had to be translated in a sort of play. I wanted to focus on that subtle shift of role of

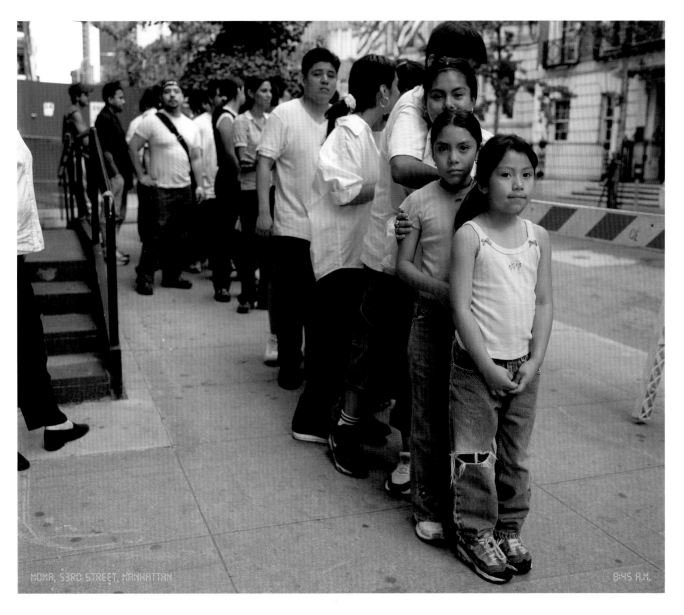

MOMA, 53RD STREET, MANHATTAN 8:45 A.M.

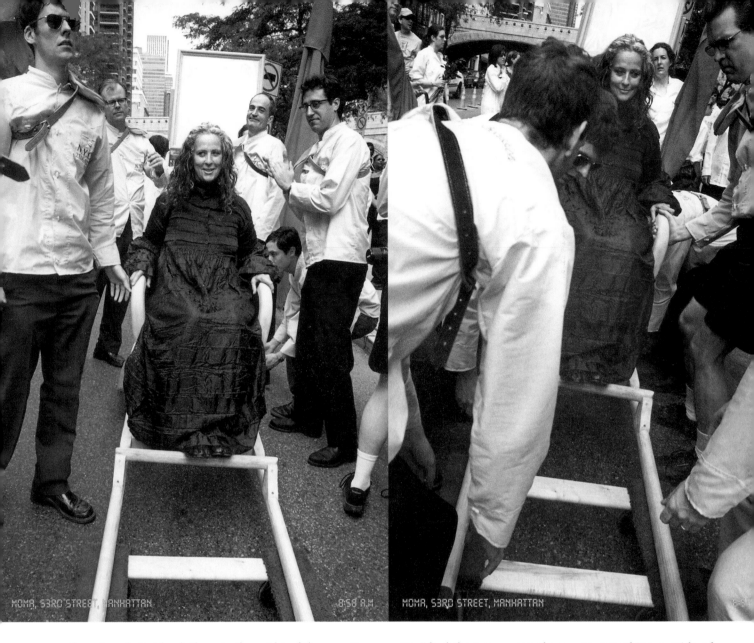

MOMA, 53RD STREET, MANHATTAN 8:58 A.M. MOMA, 53RD STREET, MANHATTAN

the artwork. But back then, in the midst of the negotiations, I felt there was also fear or reluctance to engage in any kind of physical, direct contact with the collection. Or appropriation, or re-presentation, if you want to call it that.

RS: The question of the museum's or any art institution's role as the midwife to the creation of a work goes to the heart of many different debates nowadays, debates about what an art project is in a museum context. Did you have any sense of if or where those questions came up?

FA: I had the impression there was something outside of any rational, logistical, or security-related explanation I was given, that I was hitting a nerve. There was at once an extreme respect for images but also a lack of trust in the ability of the images to withstand manipulation or re-presentation.

RS: That they were sacrosanct?

FA: Sacrosanct is the very word. In a way, I was trying to enhance, to quote that precise aspect. But at once, it was that sacrosanct status of the works that was holding up the whole process.

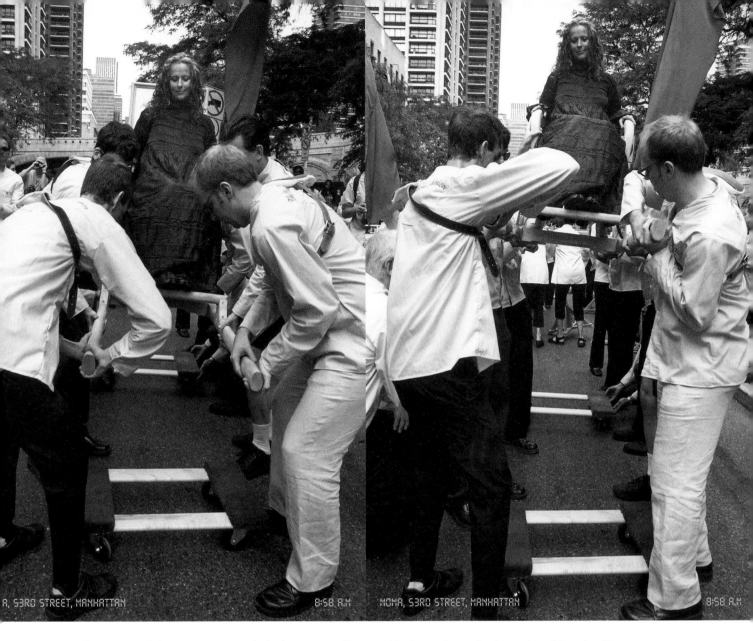

A, 53RD STREET, MANHATTAN 8:58 A.M MoMA, 53RD STREET, MANHATTAN 8:58 A.M

RS: So the statue of the saint is not only holy unto itself but it's holy only within its niche?

TE: But also, you went from using the original works to making *Les Demoiselles d'Avignon* in seeds, and van Gogh's *Starry Night* in feathers. The maquette for *Les Demoiselles* in seeds was almost too good. And that might have been why it was ultimately rejected. Then it was proposed that we use a poster. But only an official MoMA poster.

FA: To continue the story chronologically, what happened in the meantime was that I started consulting with the anthropologist and art historian Francesco Pellizzi about the meanings of these rituals, the mechanics and codes of a traditional procession. And somewhere within our conversations, he said, don't lose too much time fighting for getting the originals; many processions are actually done with replicas. They are not technically replicas but what you call "little brothers" or "ambassadors" of the original icons. So I started considering the option of translating these masterpieces, respecting their uniqueness and re-vitalizing their aura. With due respect, I tested the possibility of re-presenting *Les Demoiselles d'Avignon* in seeds, a ritual practice

31. Burning the Giacometti replica in Mexico City, October 2002

from Mexico that matched the palette of colors of the painting (fig. 32). Also, I was in contact with some masters of feather art in Mexico. Using hundreds of small feathers they (re)produced a minuscule detail of *Starry Night*. The correspondence was astonishing, the brushstrokes became alive, and the light! And if you're going to promenade such an image on the street, it has to have an aura and uniqueness of its own.

RS: Applying traditional techniques to the originals also gives them a fresh or unexpected aesthetic intensity so that you're not dealing with the diminished version of the real thing but a full-blown alternative to it.

FA: In the end, the only one that really managed to

maintain its primary essence was the palanquin with Duchamp's *Bicycle Wheel*. Because it's readymade. And, by definition, you can re-do a readymade. They belong to everybody.

RS: (laughing) You'd think so!

FA: Plus, the history of the *Bicycle Wheel* itself: the one in the collection is already a replica made by Duchamp himself after the destruction of the original, and you could extend the generations. There was an antecedent. It was mounted on a palanquin in the shape of a dining-room table. Once in motion, going against the stasis of the chair, with the wind turning the wheel, and it oscillating along at the pace of the carriers, the whole thing acquired a beauty and identity of its own. As an object, it was the most performative one of the procession. The election of Duchamp had also to do with his direct involvement in the building of the collection. For *Les Demoiselles d'Avignon*, it was more the result of some kind of statistical survey, since it is the "most wanted" painting for the public, together with *Starry Night*. And *Les Demoiselles* introduces an ironic female presence, since a lot of religious icons are mother figures, Virgin, etcetera.

RS: So the Demoiselles are Mary Magdalenes?

32. Seed drawing of detail of Picasso's *Les Demoiselles d' Avignon*, 2001

FA: They are indeed. There were two reasons for the choice of Giacometti. The practical one was that I had contacted the Giacometti Foundation in Zurich directly to get permission to incorporate a homemade replica of *Standing Woman (Femme debout)* (1948) because I couldn't wait any longer for MoMA to make up its mind. And the foundation didn't give a formal approval but said that they would tolerate it. They said officially you cannot do it, but it's ok, the foundation would not undertake any action against it as long as the replica was destroyed right after the event (fig. 31). But, also, they mentioned that Giacometti would probably have approved because he had been very much inspired by Egyptian procession figures (fig. 33). So the choice of the Giacometti made sense. And it is the most iconic, almost fetishlike figure one could imagine standing on a palanquin. Also, there was the circumstance that the Giacometti retrospective was up right after September 11th. A lot of people, I think, went to see the show as they would have gone to church. The atmosphere was very serene, it was as if there was something consoling.

RS: As far as that specific Giacometti is concerned, it struck me that choosing a static figure was surprising in context, since walking is so much an issue in your work as a whole.

FA: I looked into the *Walking Man*, but I think it is actually the verticality, the perfectly erect posture of the woman, in contrast with the motion of the procession, which attracted me. The *Walking Man* would have been a little redundant.

RS: I agree.

FA: And the fourth icon, the living icon, was an homage to performance art, a nonexistent department in MoMA —and an homage to living artists. Like in Europe we have the *Monument au Soldat Inconnu* (Monument of the Unknown Soldier).

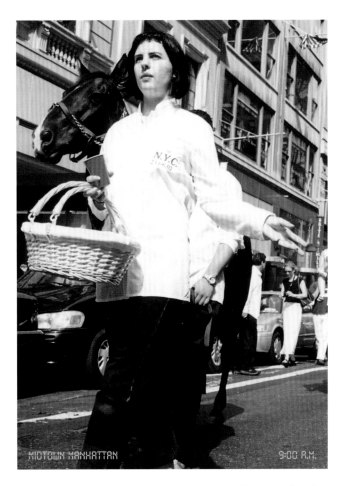

TE: But I know that when we started to discuss who the artist might be, and I was sent out to feel people out on the idea, some artists were very uncomfortable with the notion of "living icon." It's a status that's designated to you, rather than something you assume yourself, even though it's pretty clear who the real icons are. We spent

33. *The Pylon of Karnak Temple with the Bark of the King Being Carried from Karnak Temple to the Nile*, line drawing of wall relief in Temple of Karnak, Luxor, Egypt

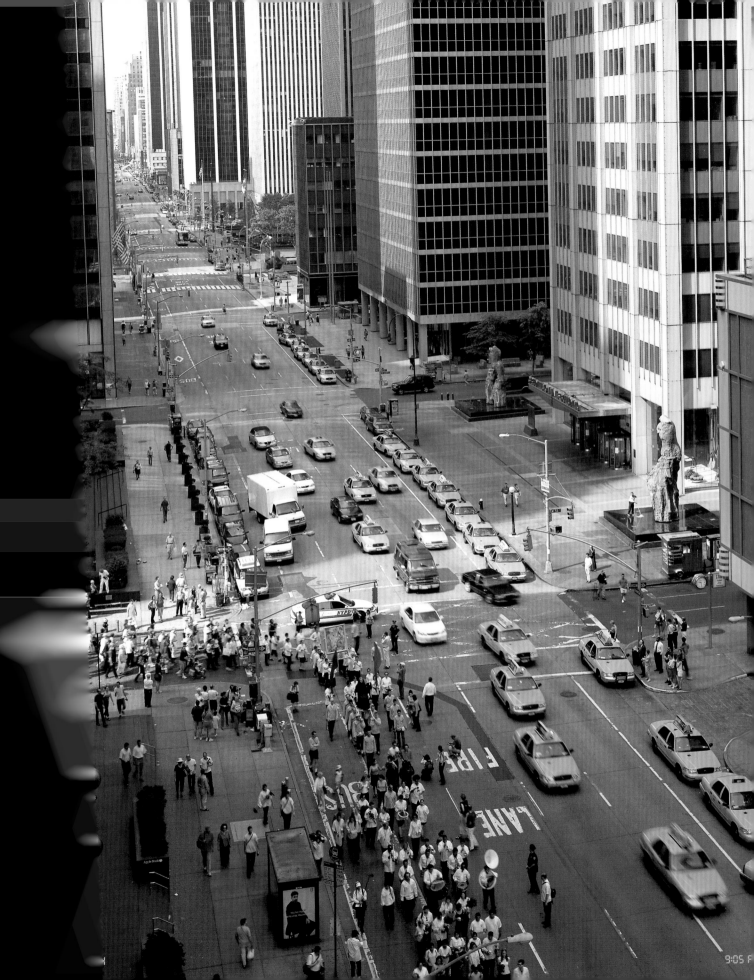

a lot of time discussing who that would be and that was probably the hardest choice you had to make.

FA: People were afraid of representing MoMA as an entity. As Rob said, it's such a heavily connotative institution.

TE: The people we talked about included Louise Bourgeois, Bruce Nauman, Nam June Paik, Lawrence Weiner, and Vito Acconci, among others, and we came to rest upon Kiki Smith. I think Vito called it "jokey." But the reason we thought about Vito was that so much of his work had been about the museum as an institution built around the fragility of art, and how you could break that down. For example, why do museums not have windows? And so, his earliest projects questioned the object status of art, and I think his work fit very well with the nature of the procession itself.

FA: And his logistical use of both MoMA and New York.

RS: His own work in the streets, yes.

TE: I think we were also kind of interested in the nature of an artist who makes art but whose work is also performative.

FA: There was one important factor in asking Kiki, which is that the female presence in the collection is very low. (In fact, about as low as the percentage of the female staff of the museum is high.)

TE: Also Kiki is part of a dynasty. In an earlier drawing you had shown a girl carrying Tony Smith's *Free Ride* (1962) that at the time was in the sculpture garden.

FA: Yes, Kiki was probably the one who represented, in an a-temporal way, the New York artist. She's beyond fashion. People instinctively associate her with the New York art scene. And she has a wonderful charisma.

TE: In terms of sounding the artists out, I think that there was a certain fear that by being lifted on that pedestal, you would also metaphorically fall off it somehow, and Kiki, in a way, is confident enough about her place in the world that she doesn't worry too much in terms of legacy. She immediately grasped the gesture and the spirit of the procession as a whole.

RS: Also that Kiki is in the middle of her career, and she has as many ties to younger generations as she has to older generations. That has a big advantage. It's not the apotheosis of aging genius or something like that.

FA: Why do you think this project raised such a debate within MoMA?

RS: I think that this particular project came at exactly the moment when MoMA was asking itself a lot of questions about what its involvement with contemporary art

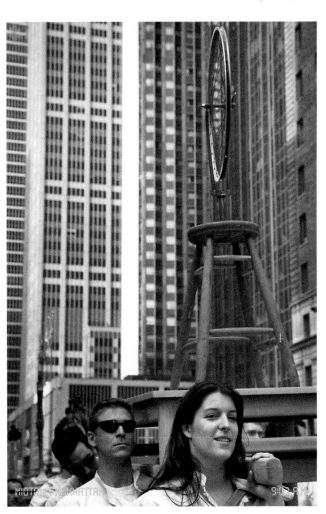

was and should be, what its relationship to radical traditions of modernism really is, what the difference is between documenting a history and actually participating as an institution in that history. All that was coming to a head. Which made what you did especially timely and apropos. That said, I don't think that curators should see themselves as artists or museums should see themselves as "creative" institutions or aesthetic collectives. But that doesn't mean they're not involved in that process. The challenge of such a project is to really engage an artist as he's working and to understand that the museum is a material, it is not only a warehouse.

The very debates that took place inside the institution are, it seems to me, part of the work. Whether you intended it to be like that or not, I think it happened that way. The positive side of it is that a great deal of work that is called "institutional critique" is essentially a kind of protest or statement made from outside the museum about the problems inside the museum.

This was critique, if you want to call it that, or an engagement, or an intervention, that actually stirred the institution from the inside, in the same way, for example, that Felix Gonzalez-Torres's pieces did. In fact both you and he have made works that are in their separate ways things that not only can be touched but that are also sacraments. That really hit a nerve. That it was so difficult to do is an indication of how fundamental the issues that it raised are. They're not just superficial ones. A sort of traditional avant-garde defiance of museum conservatism would have been fine, but it would also have been a set-piece battle. In this case, though, the difficulty of arriving at the decision, the fact that finally the knot was cut, and it did happen, was a sign that there was much more at stake than gestures of defiance.

TE: Exactly. Technically, a very artificial set of barriers were set up. In the end, the Public Art Fund commissioned and organized the procession, while MoMA commissioned and exhibited the film.

FA: But it was a legal trick to let the process continue. Retrospectively, I think it was kind of a smart move for everybody who wanted to see the project happen. Some kind of gentlemen's agreement. And it also allowed Public Art Fund to move in and actually make it happen.

RS: It's almost like the parliamentary model. If you have just two parties, you get deadlocks all the time. But if there's a third party—and I like the example of the Public Art Fund as "the Greens" in this affair—and you want authority to move, you have to make an alliance with a third party, and that gets everybody out of predicaments that they would otherwise stay locked in. So the existing ties between the Modern and the Public Art Fund became a way of finessing things, and working on this reinforced those ties. And in general it's a good thing that art institutions in New York operate in this manner. And if in this particular case the knot wasn't cut clean, at least the alliance of institutions helped to loosen it.

FA: What surprises me retrospectively is that, at the end of the day, my project was extremely traditional, maybe even conservative in a way. In inspiration and manifestation, I was literally quoting a structure that had existed for centuries before me. So I was a little surprised by the resistance it encountered. But this said, I agree with your comment that the project coincided with a moment where MoMA, as many museums, is having difficulty situating itself in between a participatory role and its function as a kind of storage, an archive of collective memory.

RS: And that way what a project does, by a series of decision-making steps, is become a performance piece that articulates those choices and resistance to them. They're already there, but they're repressed or they're

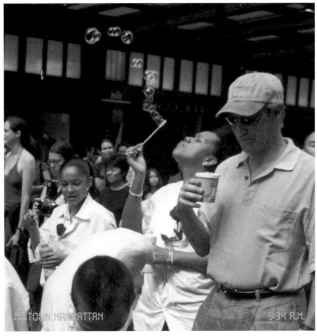

only semi-articulated in the patterns that are those of standard operating procedure. But when something like this, which has many dimensions, comes along, and response is necessary to all those many dimensions, the possible opportunities for change become obvious and imaginable in ways they would never have been otherwise. So what you did was a kind of activist art, if you will, but of a very gentle nature. And I think from MoMA's point of view, it's all to the good that it happened because now it becomes a point of reference for conversations on other issues, not necessarily directly related to this work. In that respect it was wonderful that Duchamp was in this lineup, since Duchamp is the source for so many ways of questioning the status of what a unique object is, what is original, what is not, and so forth. His *Bicycle Wheel*, more than *Les Demoiselles d'Avignon*, belonged in the procession, since one of the tasks of museums nowadays is to think in Duchampian terms, not simply to worship Duchamp as a dead forefather. I think it was precisely by choosing classic modernism—Giacometti and Duchamp—that you created the conceptual lightning rods that were needed to deal

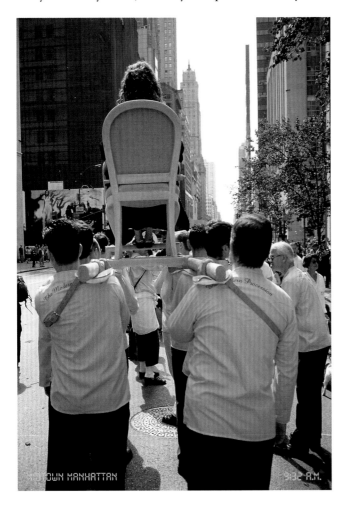

with the issues of aesthetic integrity or sacredness. Once upon a time Duchamp was a very radical figure, but now less so. In fact he's traditional. And there's a wonderful de Kooning story in this regard: when de Kooning was asked about his position vis-à-vis avant-garde art—and he was asked by people who assumed that he represented a good-old-modernist painting position—he said, "We're all on the same train. Duchamp is on that train and I'm on that train." He was right, though many forget that. And you made a train.

TE: There was one crucial moment when we looked at everyone who had volunteered from the museum and it was 95 percent white women. That wasn't to be sexist or racist, but this just didn't represent the city in any form.

FA: There were two levels of representation, an iconic illustration of the museum's collection and an embodiment of the diverse population of New York City. The procession was also a pilgrimage. And in that sense, it was essential to have all the different communities involved.

RS: It began with 100 people and then the crowd grew to 200.

FA: I wanted to maintain its small scale because I feared it would lose its ceremonial aspect if it grew too big. It would become a parade. The constitution of the carriers and followers was important in order to balance off all the different communities.

RS: How actively were you involved in actually setting the tone for how the procession proceeded? Did you marshal it, or talk to people?

FA: Really, when it comes to the reality of the battlefield, my longtime friend and collaborator Rafael Ortega takes over. He has the charisma to move the mountain, and he is the eye and the voice to people. I withdraw, I follow the "cortège" and watch. There were also two groups

that had some experience with processions, the Asociación Tepeyac group, based on 14th Street, and the Peruvian band from Queens. The Mexicans knew the rhythm and how to oscillate an icon like a pendulum. But what really set the pace were the musical themes played by the Peruvian brass band, which had an enormous role in the emotional buildup of the whole event. Once the music started the rest just kind of fell into place, or rather, into motion. I think it took a while for the participants to lose a little bit of their self-consciousness and to become just another part of this marching body. To become complicit. Eventually that happened when the procession crossed the bridge. The path became narrower, people got closer, touching shoulders, it got windy, you nearly felt vertigo, and there was the forever-now tragic beauty of the New York skyline. Then, maybe, that little magic touch happened, the one you can't plan...

RS: There was a sort of exultation.

FA: Yes. By then, there is nothing I could do. The procession had taken its own course and life, and I became just another participant. And that is when I started looking at it. And enjoying it.

TE: You once said that the point at which the procession will have succeeded is the moment when people are actually under some physical duress. You know, the procession was split between people who were carrying the palanquins, which were heavy things that demanded a great deal of concentration, and those who were merely walking. The intensity of the heat at the end of June made the activity of the procession really one of endurance. The whole journey took approximately three hours before reaching MoMA QNS.

FA: In turn, for most of the participants, the carriers, there was a considerable endurance factor involved that certainly contributed to building up this emotional ten-

sion. In Lima, for *When Faith Moves Mountains* (figs. 47-48), that element was very powerful and by the time the line of people reached the summit, the strain and exertion produced a kind of massive phenomenon of collective hallucination. A combination of effort, time, heat, and sweat made people transcend to a different level. Some kind of social sublime. I like to think that something close to that happened on the bridge, something heroic, out of time, out of control.

RS: That is the nature of ritual. All kinds of rituals involve long meditations, singing, chanting. All of those things actually do physically alter the way your mind operates and your body rhythms work, and so on. And it allows access to states of consciousness that you can-

not have under normal circumstances, particularly in New York.

TE: I also think the fact that it was Sunday morning was actually kind of symbolic. It gave it a tone and a character and a connection to ritualistic activities, religious activities. That was kind of understated but was definitely present. We didn't do it on a Thursday afternoon. It was timed specifically not to be when art-world events happen.

RS: Was anybody uncomfortable with the religious connotations or religious framework?

FA: No, I think the reverential nature of the event was always obvious. And the beauty of the palanquins somehow protected that dimension.

TE: I think it's also important that we didn't make a spectacle out of this. I mean, it had spectacular possibilities, but it was never going to be this enormous public event with a corporate sponsor.

FA: At one stage I considered doing a "guerilla action" procession. No permits, no publicity, just six musicians, four people carrying an icon on a table, a couple of dogs going from MoMA to MoMA QNS on the sidewalks. And it would have been equally valid.

TE: But the piece would have had an absolutely different meaning. What was so significant about this version was that it was attached, heart and center, to an institution.

FA: True. We needed MoMA's credit and benediction. In a way, it wouldn't have made any sense without MoMA's involvement. It would have lost all its credibility and reason to be. Because while we were negotiating with the institution, works of art were discreetly going from one place to another, in these huge, unlabeled container trucks. That's what attracted me: to make direct use of that preexisting movement, like a natural migration. Just

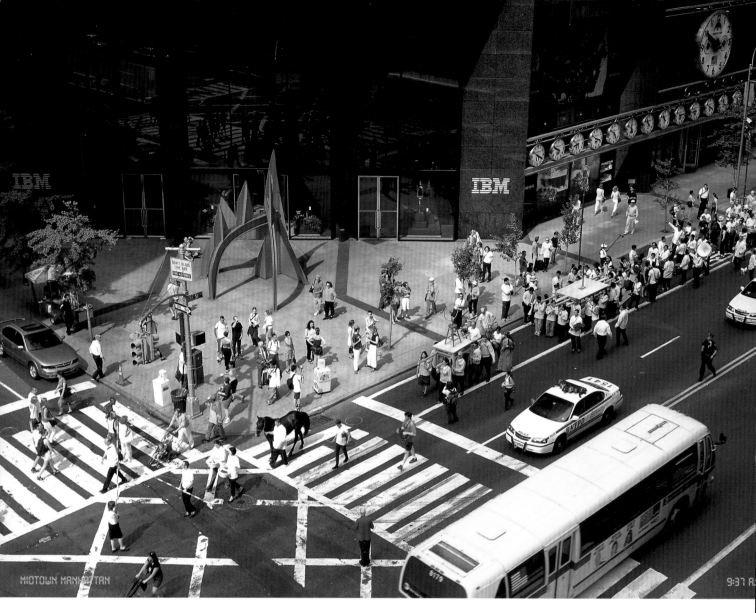

enshrining it. There was also something interesting about the secret form of that displacement, considering many traditional processions deal with hidden, veiled icons.

RS: Is Guy Debord somebody important for you in setting the tone? There is his idea of the city as something that gets rediscovered and remapped constantly when people move through it in different ways, and also his idea about creating situations, and of using spectacular opportunities against spectacle, so that the work doesn't overwhelm the viewer but instead draws the viewer in and makes them alert, active. Does any of this figure into the background of what you did?

TE: In a way, the procession was a kind of Situationist act.

FA: The situations were there, before us. I think we made something out of something else, we transformed or crystallized an energy that was already in place. Do you think the move of MoMA is somehow symptomatic of a larger crisis of identity of MoMA?

RS: Well, as I said before, I think this project brings some of the issues to light. I mean, MoMA has been in crisis for the whole time I was working there—even before. It's an institution which was and in many ways still is the model of what a modern museum should be.

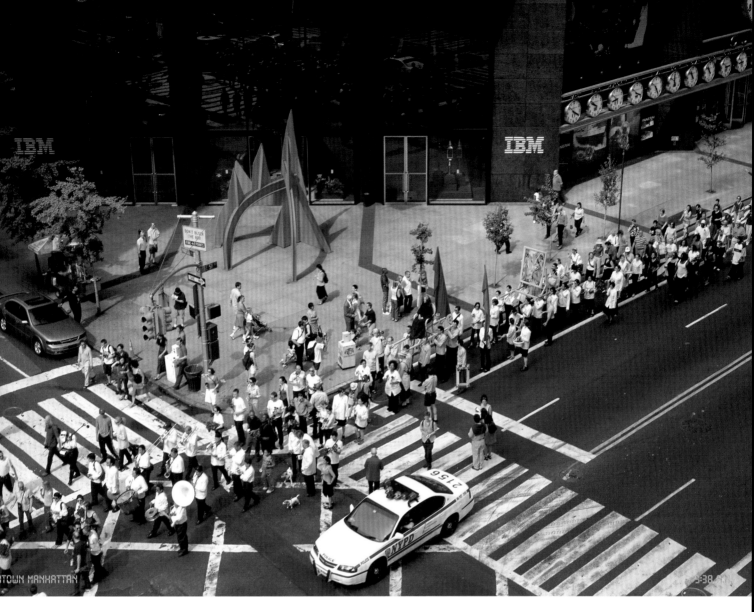

When it was created by Alfred Barr it was one of the first, if not the first, multidisciplinary, international museums of new art anywhere. By the 1960s and 1970s, however, MoMA had become increasingly narrow in its focus. That was the period when the so-called "mainstream" dominated, and the institution became preoccupied by the idea that it was responsible for some kind of fixed canon of great modern art. In terms of exhibitions and collection display, good things to the right and to the left of that mainstream were treated as incidental and often ignored altogether, even though the historical collections held huge reserves of just that kind of work.

In the last decade and a half or more, that approach has been gradually reexamined, and an awareness of the wealth of material that is already in the museum and that could be shown but rarely is has also grown. And all these realizations argue for a much broader definition of what contemporary work should be collected and exhibited. The series of exhibitions that were done around the year 2000 were a trial run in this process. Some were successful, some less so, but the aggregate of them got the museum thinking about a much more diverse field of possibilities, both in collection installation and in exhibition. It has taken a lot to get there. At

the first acquisitions-committee meetings I went to, there were people who I quite like and respect who argued forcefully for the notion that with the advent of postmodernism MoMA had arrived at the end of its epoch and should round out its collection of classic modern art and, in effect, become a museum of half of the 19th and most of the 20th centuries. This was definitely the view of some leading people. But there are shifting generations of curators. As they rose in the museum structure, the generation that came of age in the flux of the '60s increasingly had a voice that began to say, "Let's not stop. Let's really look at what we have as well as what's going on around us and figure out a way to carry on with Barr's museum in the present tense." And that tendency has essentially prevailed. Actually doing that, of course, remains very complicated.

TE: Where do you see the parameters for working with younger artists through the Projects series now?

RS: Well, the Projects series has been very lively and interesting all along, but there were times when it was practically the only sign of life in dealing with contemporary art. And as a result it was often reviewed rather severely, more so than it deserved, because it was seen as a stopgap or a token rather than a full-fledged effort in the right direction. I think that attitude will change and has changed already. But frankly, there has to be much more attention paid to breaking events than there

is now, or can be immediately foreseen, and more attention to the recent art that has not yet been elevated to the status of the newly constructed canons of the last 20 years—art from outside the postmodern mainstream that is being taught in art schools and universities. In the mid-1990s, I did a small show called "Mapping," and Lynn Zelevansky did another called "Sense and Sensibility," and inside the museum I argued very strongly to have similarly scaled exhibitions that allowed curators and the institution to move fast, that weren't horrendously expensive, so that the museum could be more responsive. In other words, something bigger than a project show but smaller than the every-four-or-five-year big-themed show or big retrospective. But one of the things that we ran into was the press saying, "Here they go again at MoMA, another half-hearted effort to deal with contemporary art." Rather than understanding that what we were trying to do was set up a range of exhibition formats, so that you'd have the big ones, the medium-sized ones, and the little ones, but all of them together would give a much broader representation of a wider variety of contemporary work. I hope that in the future they will again pick up the idea of building shows of various sizes — 4,000, 5,000, 7,000, 8,000 square feet — and shows with contrasting curatorial strategies to make the point that there is no one right way to present art. The sequencing of these different exhibitions must be regular like clockwork to underscore that diversity of approaches and contents comes from developments in art that are occurring in real time, not in historical time lapse. Exhibitions of this kind would help break down the expectation that what you see at MoMA is definitive or pretends to be definitive, and reclaim the participation of the audience on the grounds that they and the curator are engaged in an immediate response to something that is happening right in front of everybody, for which different angles of interpretation and types of presentation will and should follow. If MoMA can accomplish that—make things happen in the museum

galleries as they happen in the culture and in art rather than with big delays and rather than being viewed from an Olympian height—then we're back in business. Rona Roob, who was formerly the museum's archivist, and Barr's last assistant, said that he told her once that a curator at The Museum of Modern Art ought to be like the editor of a big-city newspaper. There ought to be stories moving across his desk all the time, being processed and decided on as events take place and at the pace they take place. I think that's a terrific model. In a sense, we are publishing the news of modern and contemporary art. We edit it carefully and then we put it out there. And I think as long as we are publishing it as news rather than as if it was already art history then we're better off.

FA: I think the present debate gravitates around where to situate this thin border between the "almost news" and the "not-yet history"?

RS: And it's a matter of style, too. You have to wear the institution lightly even though you know the institution is heavy.

— NEW YORK CITY, OCTOBER 17, 2002

Robert Storr is the Rosalie Solow Professor of Modern Art at the Institute of Fine Arts, New York University. He was the senior curator in the Department of Painting and Sculpture at The Museum of Modern Art from 1990 to 2002.

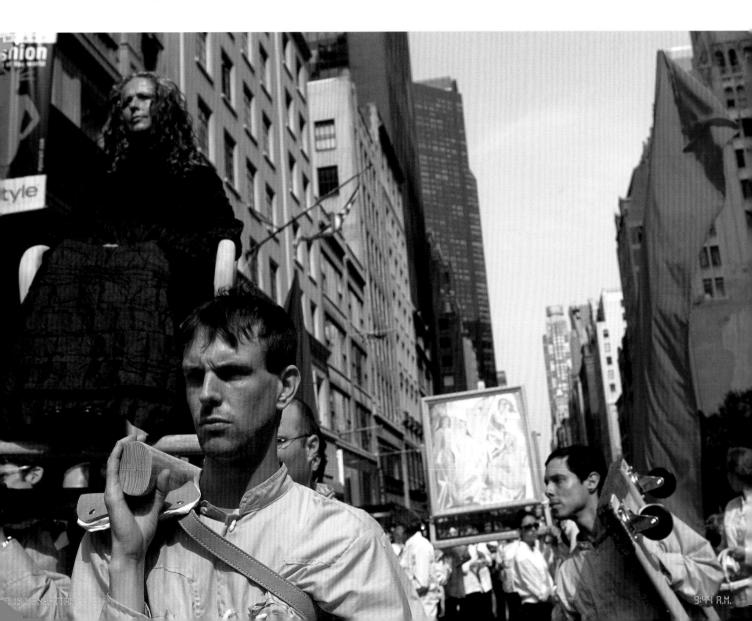

*While I was in Paris last week I came across the following
story which I tell you, for what it is worth. All the museums
along the river Seine have now started packing up all the art
stored in their basement facilities and, as I am writing you,
centuries-worth of masterpieces are being evacuated from
Paris to undisclosed destinations outside the city. There is
indeed a rumor that in the coming decade the Seine might
experience an overflow (in French,* crue) *such that the entire
basin of Paris might be flooded, just as it happened in the
very same place one hundred years ago. And, of course, as
you can imagine, the most affected areas would be the ones
directly adjacent to the river, the ones along the promenade
that Louis XVI laced with some of Paris's most prestigious art
institutions: the Grand Louvre, the Galerie nationale du Jeu
de Paume, later followed by the Petit et Grand Palais, up to
the present Musée d'Art Moderne and the Musée d'Orsay. This
massive exodus will occur with due respect under the guise of
large, unlabeled container trucks. The exact length of the exile
is unknown. One could even wonder if the art will ever
return to its former home at all. As the insurance policies'
requirements for storing artworks belonging to the National
Patrimony are becoming more demanding every year, it is
highly possible that, by the date of their return, the conditions
of storage offered by the artworks' former residencies will be
declared totally obsolete and quite inadequate under the rule
of the now-updated policies, and that what started as a tem-
porary exile might well turn into a permanent new home.*

–FRANCIS ALŸS
Mexico City, February 2003

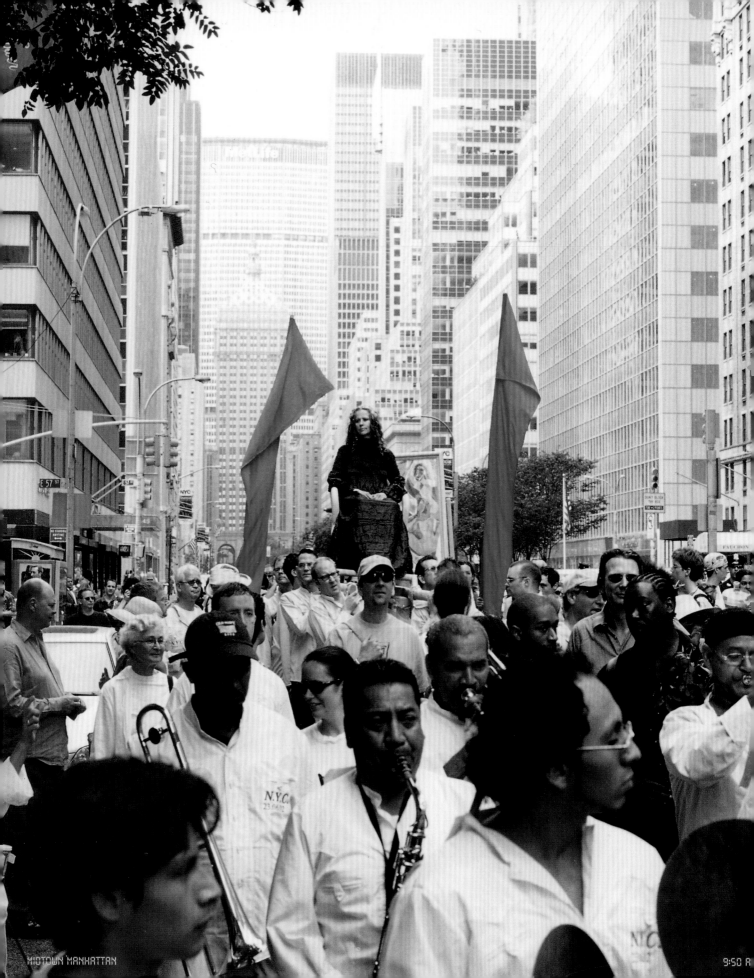

MIDTOWN MANHATTAN

9:50 A

FRANCIS ALŸS: MARKING TIME

RoseLee Goldberg

It should come as no surprise that Francis Alÿs spends hours and hours strolling the streets of cities big and small, as he has done in Venice or Brussels or Panama City, given the fact that he is a former architect and urban planner. In that capacity he worked for two years in a town in northern France as part of a planning team responsible for "growing the city." His job was to configure new neighborhoods and render diagrams and charts indicating the density and distribution of social housing, while others determined the routes of the wind and the rain that might stream through them or the location of parks to be planted so new generations might play. As did many a young, highly trained, and utopian European urbanist, he envisioned a city foot-print that would shape the tempo of daily life into new and exciting architecturally determined rhythms. Whether studying the tilt of buildings and their lop-sided shadows, following slow-moving pedestrians or fast-moving cars across squares and through archways, or tracking a dog on the run, the acute watchfulness of the city planner remains the modus operandi of the artist. For it is the live organism of the city, with its moment-by-moment shifting theater—of the absurd and of the poignant—that Alÿs is alive to in his draw-ings, his paintings, his solitary street performances, and his large-scale public productions such as *The Modern Procession*.

"In a way, I've maintained the methods of my architecture days," says Alÿs, whose gradual transition into the art world was triggered initially by an urban-planning exercise: taking photographs of street installa-tions and urban squats while still working as an archi-tect in Mexico City. He presented these in a friend's apartment, then in restaurants, and one occasion led to another and another.

"I'd never lived in a major city [he grew up in the countryside] and the clash of my body with such a mega-lopolis called for a constant, immediate reaction, interac-tion, with the urban entity," Alÿs says. "Photographing Mexico City was somewhat of a therapy. Intervening in its streets became a way to survive the city's chaos, its at once disarming and fascinating reality." It was also a way of coming to terms with the ideological and politi-cal dimensions of design. "It's one thing to do an ephemeral act on the street that leaves an urban myth behind. It's another to affect thousands of people's lives because you've changed a city's configuration," he said. Stepping into the art world shifted both the scale of his operation and his sense of mastery over it. "The freedom in the art field is enormous. You can act quickly, which is impossible in the heavy architecture-machine, and even less so in the bureaucratic urbanist system. You can improvise on the spot and invent guer-rilla tactics as you go and still maintain relative control of the process, or at least a certain integrity with the original intention."

Letting go of control, in the sense of working along-side skilled technicians, is an essential aspect of the disci-pline and process of architecture. "I always look for a col-laboration with others," Alÿs points out. "Often, I am just the coordinator, the producer of a project which others will realize, hopefully appropriately, whether it's paint-ings, animation, video, or live events." Not being trained in any single visual-art practice allows Alÿs to conceive of a project first, then decide on the medium and the appropriate collaborators later. Projects develop in

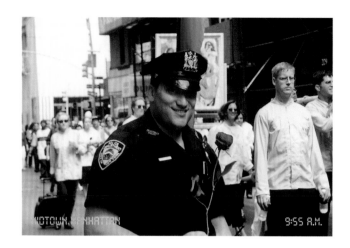

stages; he spends considerable time simply absorbing the feel of a new venue; researching its history, its archeology; considering the pull and push of politics and class that classify districts as distinctly as any street signs. Storyboards follow. Plans are executed. At last, an action or an object is produced, but never in isolation. Five or six ongoing projects may be in progress at the same time. In 2002, they ranged among a large project in Lima, Peru, involving a lineup of 500 people armed with shovels and distributed along 500 meters, with the instructions to move a sand dune; a small project in Los Angeles in which Alÿs and volunteers "walked a painting" through the streets of Los Angeles to mark the tenth anniversary of the riots that ripped that city following the Rodney King beatings; and a full-scale procession through the streets of New York, designed to celebrate the transition of The Museum of Modern Art in its move from its choice Manhattan location to a temporary abode in the largely working-class, light-industry section of the borough of Queens, across the East River.

Each project covered "a wandering space" and was rich in art-historical, political, and religious references. *Cuando la fé mueve montañas (When Faith Moves Mountains)* in Lima was "almost Biblical," he said, in its attempt to gather a small community together "to provoke a little miracle," in a country mired in economic and political malaise. "It was an act of faith, a collective hallucination, because the dune moved only cen-

timeters," Alÿs says. Of his painted rendering of a riot scene in Los Angeles, used in his performance called *Walking a Painting,* he comments that it was "a kind of Paolo Uccello painting," referring to the Renaissance artist's well-known depiction of local battle scenes. *The Modern Procession* was a ceremonial vehicle to mark a historic occasion; it also allowed the artist to connect the high-culture framework of MoMA's collection of iconic 20th-century artworks with a populist cavalcade, in the style of devotional saints-day celebrations held in villages from Spain to Mexico to Peru. "I'm trying to illustrate the thin line that exists between an icon and an idol," Alÿs says, "and to show the ways in which modern art has discreetly acquired a quasi-religious status for a faction of society. That was one of the the underlying drives of the procession."

Such thinking began, as usual, with a view of the street, this time from a hotel window in a small town in Mexico. "The initial spark of the project happened as I was watching a procession from my window," he says. "It struck me that I could use this scene in front of me (people carrying religious statues on their shoulders, people walking to the sound of a marching band) to counter the claustrophobic impression that a powerful institution such as MoMA can give. I wanted to put art in motion," Alÿs explains, "to challenge our habitual staged reading of works of art, to get away from the unavoidably hygienic, safe conditioning which the 'white cube' provides." And he wanted to keep it small— 100 to 150 people—"or it would turn into a parade," as in an officially orchestrated national day of remembrance, such as Columbus Day, which would undermine the ritualistic quality of a slow-moving procession. Such distinctions, between a long-standing American tradition and a South American or Latino one, between the "miraculous aura" of an idol, and the precious capital of a "consecrated" art object, were immediately evident to those of us who gathered on 53rd Street on a hot summer Sunday in June to begin the three-and-a-half

mile walk, led by an NYPD officer, a riderless horse with attendant, a Peruvian brass band, and four palanquins topped by artworks—two sculptures and a painting— and a live artist carried by teams of volunteers.

"I fought for a long time to get the original works, but then learnt that, traditionally, religious processions were mostly done with replicas called 'little brothers' or 'ambassadors.' This made it acceptable for me to use copies," Alÿs says of his choice of a reproduction of Picasso's *Demoiselles d'Avignon*, Duchamp's *Bicycle Wheel*, a Giacometti figure, and the artist, Kiki Smith, in a flowing black robe, who sat regally on a throne-shaped chair. "Kiki is a bit of an emblem. She doesn't really belong to one generation or another, yet in a way she represents 'the New York artist,'" Alÿs says. "She has a certain natural majesty in her presence, which inclined me to her in that role." Moreover, a "living icon" was essential to the procession precisely "to underline the astonishing absence of the performance field, a key

practice in the elaboration of contemporary-art discourse, from the six departments (including painting and sculpture, drawings, photography, architecture and design, film and media, and prints and illustrated books) of The Museum of Modern Art."

Constructing such an event seemed to stem from an emotional desire to capture the complexity of two unrelated occurrences—MoMA's unusual move to a temporary home and the aftermath of a terrorist attack on New York City—than from formal considerations arising from an interest in spectacle per se. Indeed, the weight of the artist's sensitivity to the shock suffered by the city a year earlier, evident in the bearing of the respectfully dressed marchers (they wore black pants and blue shirts) and the accoutrements they carried (baskets of stem roses and rose petals), gave new meaning to each changing vista of buildings, bridge, and water as the marchers progressed north and east along Manhattan's thoroughfares. For local participants, being in the streets

FREE FLUX-TOURS

(EXCEPT FOR COST OF TRANSPORTATION & MEALS IF ANY)

May 1: MAYDAY guided by Bob Watts, call 226-3422 for transportation arrangements.
May 3: FRANCO-AMERICAN TOUR, by Alison Knowles & Robert Filliou, 2 pm at 80 Wooster st.
May 4: TOUR FOR FOREIGN VISITORS, arranged by George Brecht, start noon at 80 Wooster st.
May 5: ALLEYS, YARDS & DEAD ENDS, arranged by G. Maciunas, start 3 pm at 80 Wooster st.
May 6: ALEATORIC TOUR, arranged by Jonas Mekas, meet at noon at 80 Wooster st.
May 7: MUSIC TOUR & LECTURE, by Yoshimasa Wada, start at 2 pm at 80 Wooster st.
May 8: GALLERIES, guided by Larry Miller, start at noon at 80 Wooster st.
May 9: SUBTERRANEAN TOUR I, guided by Geoff Hendricks, start at noon at 80 Wooster st.
May 9: SUBTERRANEAN DANGER by Charles Bergengren, start 11 pm at 47 st. & Park av. island.
May 10 & 11: at 6 am go to 17 Mott street and eat Wonton soup (says Nam June Paik).
May 12: SUBTERRANEAN TOUR III, arranged by George Maciunas, start 2 pm at 80 Wooster st.
May 13: SOUVENIR HUNT, meet at noon at 80 Wooster st.
May 14: SOHO CURB SITES, guided by Peter Van Ripper, meet at 3:30 pm at 80 Wooster st.
May 15: EXOTIC SITES, guided by Joan Mathews, meet 3 pm at Oviedo Restaurant, 202 W 14 st.
May 16: ALL THE WAY AROUND & BACK AGAIN, by Peter Frank, meet at noon 80 Wooster

34. George Maciunas, *Free Flux-Tours*, poster, May 1976

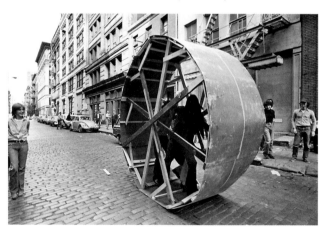

35. George Maciunas and Takako Saito, *Flux Treadmill*,
Flux Game Fest, Wooster Street, New York City, May 19, 1973,
photo by Peter Moore © ESTATE OF PETER MOORE /VAGA, NYC

of New York for a prolonged period of time, while encountering the panorama of a skyline forever changed, had unexpectedly cathartic results. The city seemed less vulnerable and also different: It was as though fresh and more uplifting memories were being laid over recent, painful ones. Such shifts in perceptions and associations with a familiar urban space as those that occurred during the procession itself and which are apparent in its afterlife, an elegantly produced film, have a history all their own.

"In terms of local art history, I certainly had in mind flashes of Fluxus street activities," Alÿs says, referring to photographs from the 1960s and '70s showing streets crowded with artist activists (fig. 35). "Also agit-prop theater," he said of another reference to that period, when costumed performers taunted random audiences with politically oriented and frequently satirical sketches. But Alÿs's procession in 2002 had a far more subtle polemical intent. Although at first it appeared to be more respectful of the institution of The Museum of Modern Art than any number of previous demonstrations outside that same venue—such as a Fluxus protest, for example, of 1963, led by conceptual artist Henry Flynt and filmmaker Jack Smith, protesting "cultural snobbery" with pickets declaring "Demolish Serious Culture! Destroy Art, Demolish Art Museums"—Alÿs's *Modern Procession* was motivated by a critique of the "sanctity" of the edifice of a modern museum. "All my energy went into the space in between the two institutions, the old and the new. I wanted to give those 'frozen' works a chance, for a day, to come to life once more." While the formal choreography of the march seemed less ironic and less playful than previous artist-led street walks—for example, "Free Flux Tours" of the mid-1970s led by Alison Knowles, Bob Watts, and Nam June Paik to a public restroom and a wonton-soup counter in Chinatown (fig. 34)—these events similarly made territorial claims on the city, with the artists marking particular streets as their own, conceptually at least.

Claiming city blocks quite literally, by moving into disused factory buildings and storefronts and transforming them into live-in studios or artist-run galleries, was possibly the most critical element in the evolution of the energetic and enormously varied New York art

The Modern Procession

scene of the 1970s. Cheap rent and vast, 2,000-to-3,000-square-foot spaces, with their wooden floorboards, hardboard partitions, and clip-on lamps with trailing electrical cords, produced a rough-edged, process-oriented aesthetic that matched the raw sensibility of these makeshift environments. They also attracted a unique community of artists from different disciplines, who woke each morning to the rattle of trucks and forklifts on cobbled streets and the shouts of workers on the loading docks of their buildings in the otherwise non-residential neighborhood that was early SoHo. The dimensions of these high-ceilinged lofts, with their banks of large-paned windows, were the same as the galleries that opened in adjacent buildings, and it was the predominance of these features which would radically change the notion of gallery architecture from elegant drawing room to large industrial-looking structure, an architectural preference that would become the style of galleries and museums for decades to come. Moreover, the autonomy of artists in setting their own terms, whether for exhibitions or performances, in alternative spaces or outdoors, was further evidence of a generation's determination to keep its distance from the formal atmosphere of traditional galleries. Street events took place regularly, attended by artists, their friends and passersby: in *Roof Piece* (1973), choreographer Trisha Brown began a sequence of movements on the rooftop of 420 West Broadway, which was then imitated by another performer on a nearby rooftop, and so passed on to another and another, across the rooftops of lower Manhattan. In *Duets on Ice* (1974-75), Laurie Anderson, wearing ice skates embedded in blocks of ice, performed a series of street works in the five boroughs of New York City, accompanying herself on a "self-playing violin" (installed with pre-recorded cassette tapes) and telling stories to those who stopped to listen.

36. *The Freewheelin Bob Dylan*, album cover, 1963

Others organized trips further afield: in *Jones Beach Piece* (1970), on Jones Beach, Long Island, Joan Jonas created a work on the beach between sand dunes and water's edge with eleven performers using mirrors, ladders, and wooden clappers. And some street actions were entirely "invisible": in 1969, Vito Acconci executed *Following Piece* as his contribution to "Street Works IV," a festival organized by the Architectural League of New York (fig. 37). For 23 days Acconci assigned himself the task each day of following a perfect stranger in the streets of New York, from a random starting point until the person left the street and disappeared into a building.

The spontaneity of these presentations and their intriguing experiential results inspired artists to think of the city in new ways—from "found" visual backdrop for individual performance acts to meandering ground plan for choreographic experimentation. A detour to a particular crossroad, undertaken with few expectations, served as a reexamination of a fragment of urban geography, while the trek to and fro exerted its own special bonding effect on anyone adventurous enough to join the expedition. Participation itself was a kind of unwritten

declaration of shared values. In the social history of the community that is the art world, it has always been so. Whether a street action in 1913 in St. Petersburg—in which Russian Futurist poets David Burliuk and Vladimir Mayakovsky, along with their friends, wore colorful costumes and painted their faces to publicize forthcoming poetry readings at the Stray Dog Cafe as well as a "Futurist Tour" to seventeen cities in November of that year—or an excursion organized in April 1921 by Parisian Dadaists including Philippe Soupault, Tristan Tzara, and Paul Éluard, to the deserted church of St. Julien le Pauvre and "other sites that really have no reason for existing," according to posters announcing the event, such outdoor actions have been an expression of intellectual inquiry among artists themselves, examining the edge between the private experience of making art and the public reading of its meaning and relevance outside the academy or museum.

The paradoxical risk in taking art into the public realm is that the desire to connect with the public frequently has the opposite effect of further mystification. But some events were designed to be accessible to large numbers: a reconstruction of "The Storming of the Winter

37. Vito Acconci, *Following Piece*, part of "Street Works IV," Architectural League of New York, October 3-25, 1969

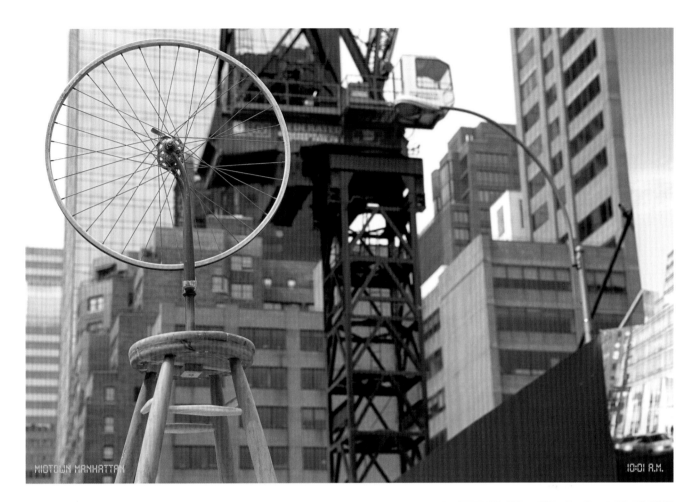

Palace" took place in November 1920 in St. Petersburg
to celebrate the third anniversary of the Russian
Revolution (fig. 25). Under the direction of Nikolai
Evreinov and three additional stage directors—with
sets, banners, and street decoration produced by artists
including Natan Altman and Yuri Annenkov—it involved
more than eight thousand performers, including Russian
Army troops. Less politically ambitious, but meticulously
planned to "displace" art from its expected venues and
to show art "on the move" as a larger urban entity, were
the theme parties at the Bauhaus in Weimar and the
nearby Ilm Chalet, a guest house just a bicycle ride from
the school where the Bauhaus Band had a regular gig.
(fig. 38) Students in Oskar Schlemmer's theater depart-
ment, as well as those in the sculpture, photography, and
cabinet-making workshops, joined forces to create highly
entertaining evenings that put into practice the school's

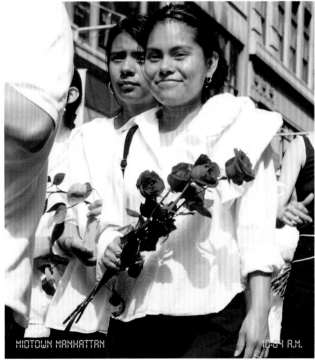

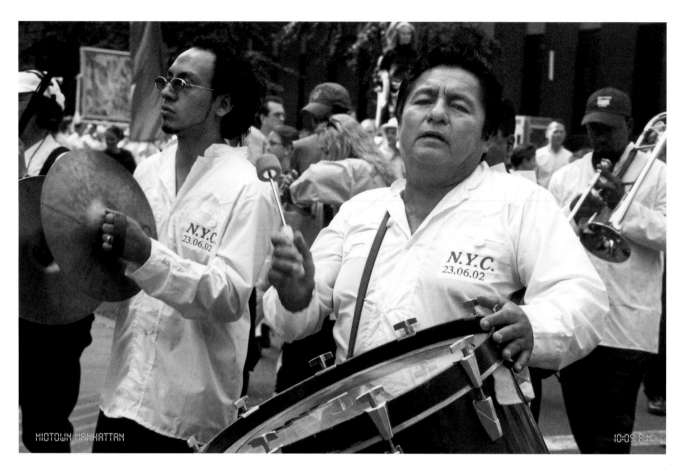

MIDTOWN MANHATTAN 10:09 A.M.

lively theories about the meaning of form, color, craft, and technology, and which dominated classroom and cafeteria discussions at this unique pedagogical institution. Lest one think of these public gatherings led by artists—with their explicit conceptual content and determination to insert art into the public domain—as an especially 20th-century phenomenon, it is important to recall earlier spectacles such as the elaborate mock naval battle designed in 1589 by Polidoro da Caravaggio for the amusement of the Medici family and their friends in the flooded courtyard of the Pitti Palace in Florence. Or a Baroque festival in 1638, "The Inundation of the Tiber," written and directed by Gian Lorenzo Bernini, which involved realistic flooding of a series of connected piazzas in Rome.

Adorning the city in times of prosperity and affirming its political well-being with grand boulevards and monuments designed by town planners and archi-

tects have always been means for extending the glory of the statesman and the state. Less long-lasting are the small acts of protest by artists agitating for a different kind of consciousness of city politics. In the 1980s (and well into the 1990s), New York City was a collage

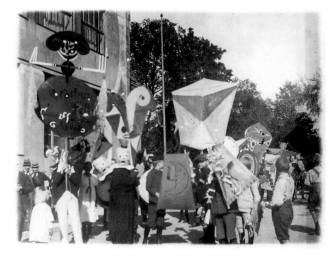

38. Dragon Festival of the Bauhaus, Weimar, 1922, photo by Tut Schlemmer

of bulletin-board announcements that belied the façade of civic celebration. Advertising surfaces—including posters, billboards, and electronic signs that typically addressed the wealth and aspirations of a young, upwardly mobile corporate class—were usurped by arts activists such as Jenny Holzer, Keith Haring, Barbara Kruger, Felix Gonzalez-Torres, David Wojnarowicz, and art collectives such as Act Up, Gran Fury, Visual Aids, and the Guerrilla Girls to make known the appalling conditions of people disabled by AIDS, by homelessness, and by discrepancies in civil rights. More recently, developers have exploited art in public venues to spot-light burgeoning commercial districts, even as the artists themselves point out the underlying contradictions of cleanup operations and gentrification. Tibor Kalman's *Everybody* (1993-94) in Times Square was ingeniously equivocal. The word "Everybody," writ large in black lettering against a bright yellow wall, provided a back-drop for three shoe-shine stands attached to the wall. It was at once a homage to the streetwalkers of 42nd Street and their patrons, who for decades had kept the geographic heart of the city on edge, and, at the same time, an announcement of the mall shoppers who would replace them.

The conditions of a city at any moment in time set the stage for different kinds of street life and art actions; 1970s New York was bankrupt, with a sparsely populated downtown that artists considered their own experimental playing field. Three decades later, post–September 11, streets are uninviting as venues for social gatherings or art events; indeed, they are patrolled to prevent spontaneous actions. Yet these ephemeral, live actions, mostly overlooked by art historians, are significant because they distill a moment in time and seem to give experiential form to the confluence of city politics and culture. Alÿs's *Modern Procession* brought to life current events as well as contemporary polemics about the significance of cultural icons and museums, the class that supports them, and their possible meaning

for those on the outside of the art world looking in. As in festivals of old—18th-century Paris had 32 feast days, without counting the 52 Sundays of the year—a large group of people in marching mode also generated a communal mood that fanned beyond the column of marchers and into the streets. By the time it reached the new MoMA premises in Queens, where a simple meal was laid out on folding tables, its effects had coalesced into an occasion properly observed.

RoseLee Goldberg is a critic, an art historian, and associate adjunct professor of contemporary art at New York University. She is the author of *Performance Art: From Futurism to the Present* (1979), a pioneering study of performance-art history, as well as *Performance: Live Art since 1960* (1998), and *Laurie Anderson* (2000).

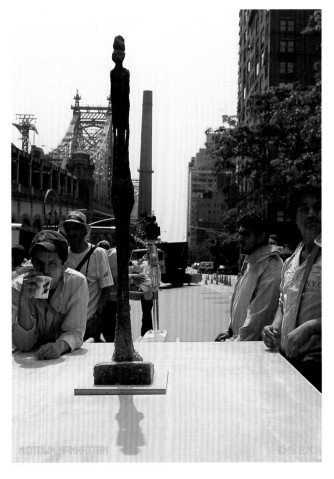

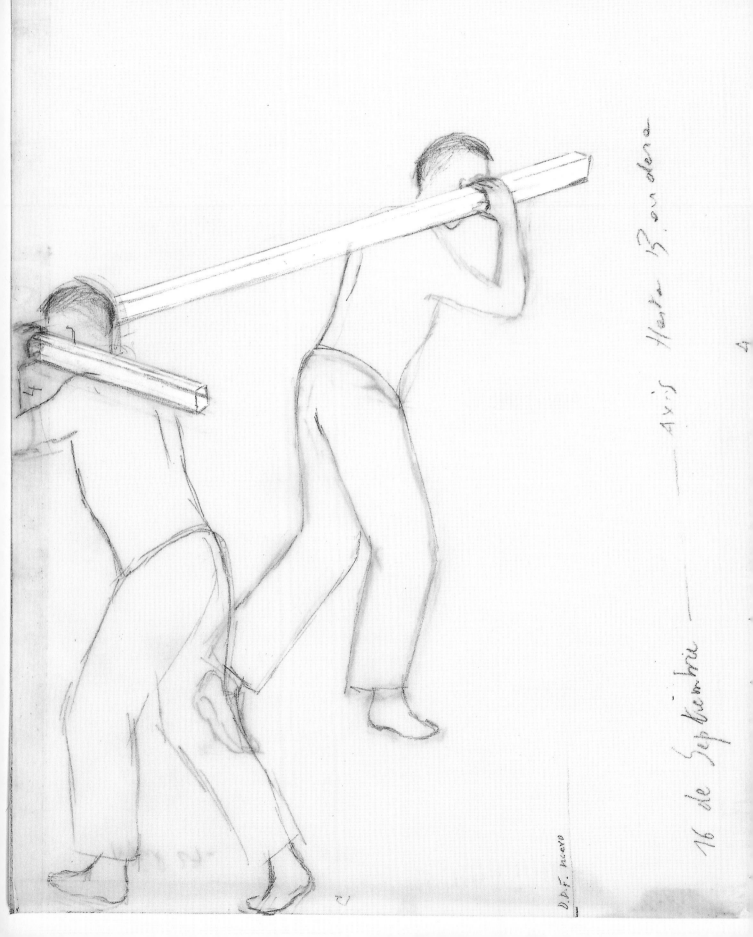

16 de Septiembre —— Avis Haste Bordera

D.D.F. nuevo

There was a moment, somewhere between Manhattan and Queens as the procession made its way across the Queensboro Bridge, that the magic of the event suddenly snapped into focus. It was a combination of the heat of the day, the majesty of the city's skyline, the joyous nature of the procession, and the serenity of Kiki Smith as she was borne on her palanquin, that transformed what could have been a traumatic move from Manhattan to Queens, from our permanent home to a temporary home, from the known to the unknown, into a spectacularly exciting and exuberant occasion—all of this accompanied by the sounds of a Peruvian marching band. What could be better!

— GLENN LOWRY
New York City, March 2003

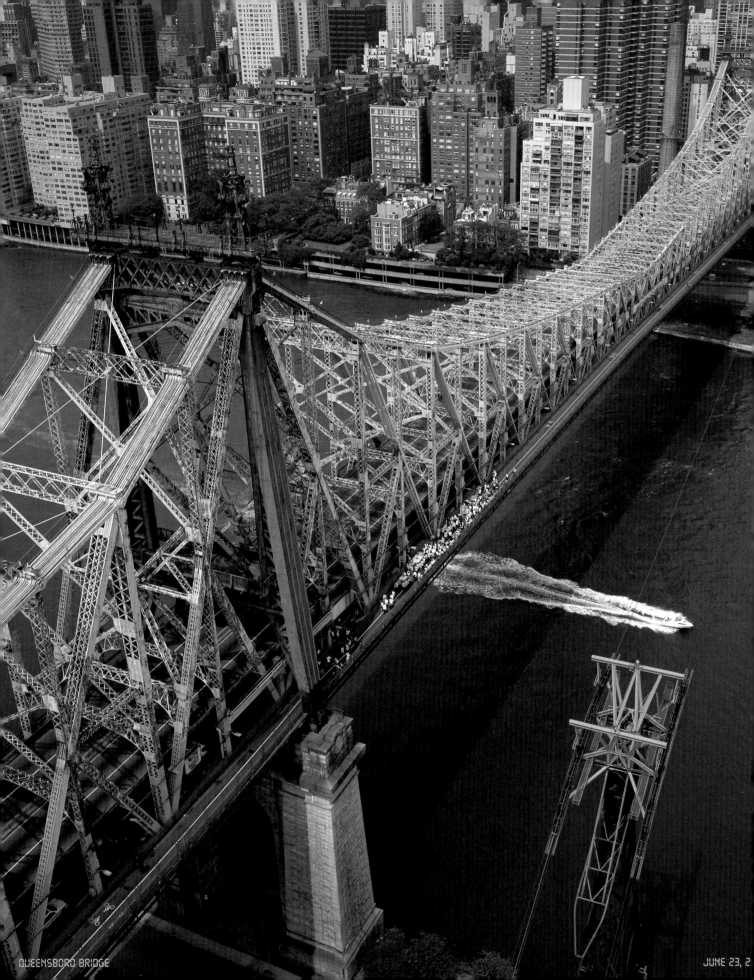

HEARSAY

Lynne Cooke

*"A text is not a line of words
releasing a single 'theological'
meaning (the 'message'of the
Author-God), but a multi
-dimensional space in which a
variety of writings, none of them
original, blend and clash."*

Roland Barthes

Towed by a tug, a barge progresses slowly through the locks that cleave a narrow passage from one ocean to another, its load a monumental pile of sulfur en route from Rosenberg, Texas, where it was mined, to California.

The huge yellow lumps of elemental matter contrast vividly with the precise geometric structures of both the barge and its context—that masterpiece of civil engineering, the Panama Canal. A continuous 40-mile pan of the monumental waterway shot from a small plane high overhead was planned to be intercut with close-ups of the rocky mass filmed from a helicopter probing the minutiae of the situation, buzzing closely around its prey like the mosquitoes endemic to that torrid, malarial region. Echoing the droning insects, the mechanistic sounds of the aircraft would have provided a pulsing, rhythmic audio track, to propel the unfolding visual footage parsed by the overlaid verbal commentary.

Although never realized, Robert Smithson's movie treatment for *Panama Passage* limns a cinematic paean to a "ready-made" earthwork that foreshadows by almost sixty years the artist's own land-art projects of the 1970s. Sketched in an abbreviated storyboard in 1971 (figs. 39,40), Smithson's project generates potent images: it acts as a virtual trailer. Comparison with *Spiral Jetty*, his haunting film made the previous year, reveals, however, the limitations of such speculative imagining. In that film's voice-over, counterpointed by the roar of both the earthmoving equipment and the helicopter from which the completed sculpture was shot,

39. Robert Smithson, *Movie Treatment for Panama Passage*, 1970, pencil and ink ART © ESTATE OF ROBERT SMITHSON/LICENSED BY VAGA, NEW YORK

40. Robert Smithson, *Barge of Sulphur (Panama Canal)*, 1970, pencil

Smithson weaves a highly idiosyncratic, wide-ranging and allusive narrative. There is no record of what its allegorical counterpart in *Panama Passage* might have included, what fantastical links the artist envisioned between the proto-earthwork, the geo-historical context, and the boat he planned to hire with its transport of primordial matter.

Formally, structurally, and thematically inventive, Smithson's written and spoken texts assumed multiple guises. In their dizzying interweaving of visual and verbal languages, as much as in the extraordinary range of voices, genres, and styles he deployed, his groundbreaking forays proved highly influential: among the most seminal are the pioneering magazine article, "A Tour of

the Monuments of Passaic, New Jersey" (1967); the tauto-logical "Conceptual art" drawing *A Heap of Language* (1966); the extemporaneous illustrated lecture "Hotel Palenque," delivered to students in Utah in 1969, which subsequently entered his oeuvre as a work in its own right; and *East Coast, West Coast* (1969), a 20-minute video-interview spoofing current aesthetic parlance. Constructing a hybrid discourse between fact and fiction, documentary and speculation, from such diverse disciplines as geology, paleontology, and dystopian science fiction, Smithson wove dazzling literary texts whose province and locus nonetheless remained firmly within the realm of the visual arts.[1] The verbal commentary in *Spiral Jetty* belongs in this lineage of landmark texts.

Spiral Jetty, the film, is not a documentary designed to explicate the eponymous land artwork located in the Great Salt Lake but an independent companion piece which capitalizes on the ways that textual strategies infiltrated every aspect of Smithson's aesthetic produc-tion: it weaves a miscellany of information based on maps, diagrams, photographs, and related documents into a haunting polysemic discourse.[2] From the concep-tual conjunction of event, site, and geo-historical matrix that formed the raw material of the Panama project Smithson once again devised several interrelated works. Deftly redefining his notion of a non-site, he conceived of the barge with its cargo of raw sulfur as a trans-portable sculpture. A mobile geomorphic artwork, it was one of a number of related proposals he outlined in the early 1970s, none of which was realized before his untimely death in 1973. *Floating Island: To Travel around Manhattan Island* (1970), a related proposal, was aptly described by Robert Hobbs as "a sort of ongo-ing parade, a literal float, tugged around Manhattan."[3] Containing a re-created portion of the ecology of the landmass as it is presumed to have been, it would have offered New Yorkers the chance to see a representative sample of the landscape that once covered their island—not from the water, as tourists conventionally

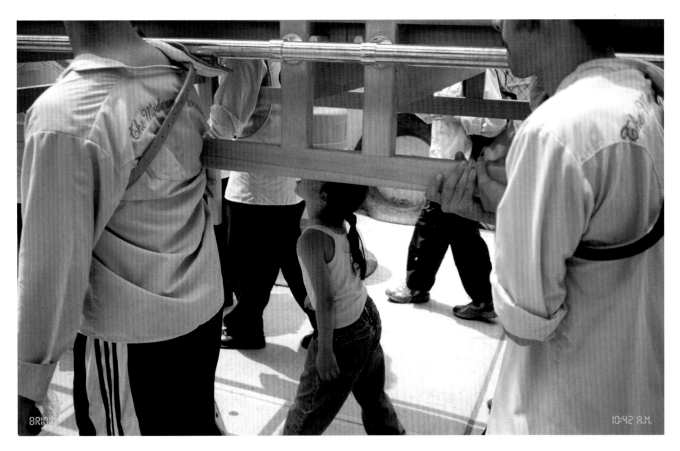

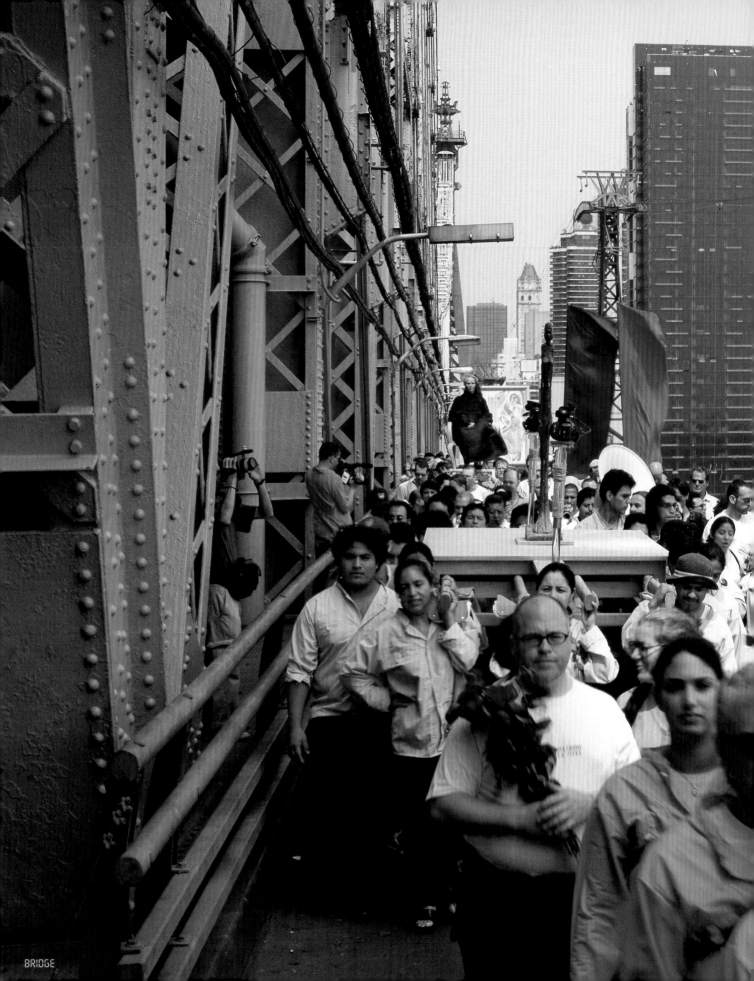

BRIDGE

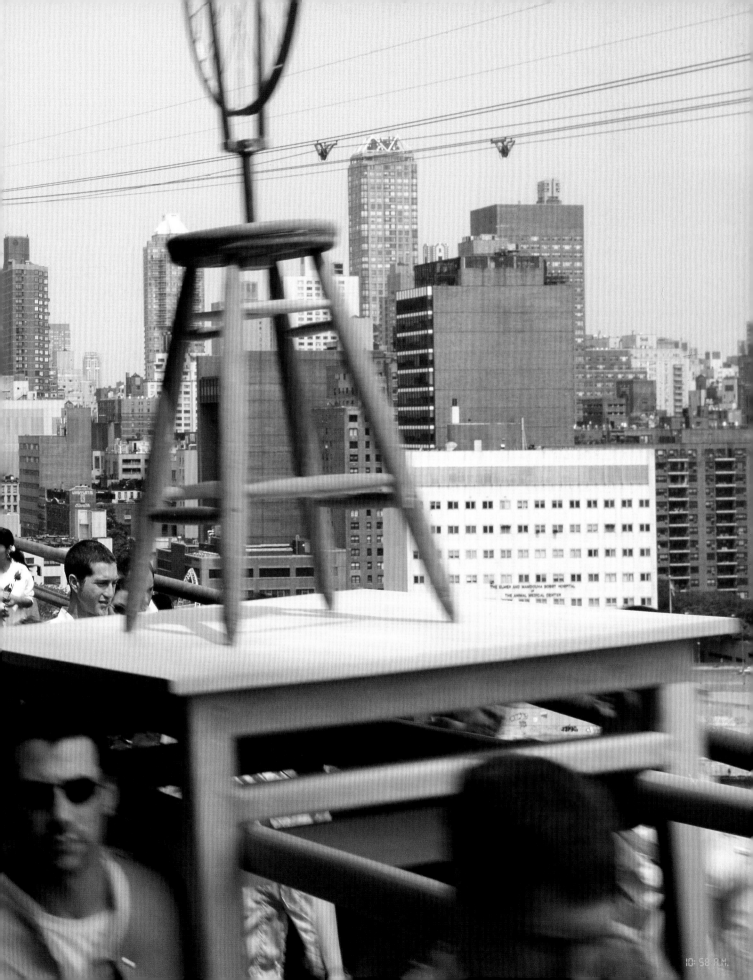

41. Bas Jan Ader, *In Search of the Miraculous*,
exhibition announcement, 1975

42. Bas Jan Ader, *In Search of the Miraculous*,
frontispiece of *Art and Project Bulletin* no. 89, 1975

view it, but from the shores of the modern metropolis.
Boston Project, Juggernaut (1970), another mobile
monument, this time dedicated to entropy, was to have
comprised a flat-back trailer loaded with heavy rocks
and poured concrete. Designed to be pulled around
the city, it could also be parked at different locations.
Among the principal sources for this "cortège honoring
industrial waste and uselessness," Hobbs speculates, are
"the great towering juggernauts that are pulled through
the streets of India during special religious festivals."[4]

II.

Bas Jan Ader planned *In Search of the Miraculous*
(1975) as a three-part work that would culminate in his
exhibition at the Groningen Museum in the fall of 1975.
The first component involved the documentation of a
performance of sea shanties, sung by a small choir
accompanied by a piano, at his solo show at the Claire
Copley Gallery in Los Angeles early in 1975. The second
part was to be completed during his solo voyage across
the Atlantic in the summer. Neither that nor the third
component was, however, realized, for Ader disappeared
at sea, together with his film camera and tape recorder,
some three weeks after his departure on July 9 from
Nova Scotia in a vain attempt to set a new record for
the trans-Atlantic crossing. Even though not in the form
Ader envisioned, this work has posthumously assumed
an identity of its own. Its afterlife owes much to the pre-

liminary material the artist published in advance of both
the voyage and the show that was to mark his triumphal
homecoming. An announcement for the exhibition took
the form of a postcard with a cryptic vintage image of a
boat heaving under a rough swell (fig. 41). With hind-
sight, its caption, "Bas Jan Ader / In Search of the
Miraculous," becomes a poignant, melancholy commem-
oration. In addition, he produced an illustrated bulletin
replete with lyrics from the mournful sea shanties

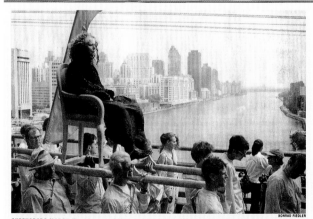

43. *The New York Sun*, front page, June 24, 2002

recorded some months previously.[5] Its frontispiece was an eerily idyllic picture of the artist at the tiller of his tiny twelve-and-a-half-foot-long craft christened *Ocean Wave*, silhouetted against a boundless calm sea (fig. 42). Crucial to the metamorphosis of this ancillary material into the culminating work of his career are the anecdotes and tales that have accumulated around his ill-fated project, stories which include mention of the fact that he chose as his reading material for the voyage a book charting a similarly doomed venture, Donald Crowhurst's delusion-riddled attempt to circumnavigate the globe in 1969.[6] The inclusion of this engrossing biography in Ader's luggage fuels the widely held belief that he, too, seems to have deliberately courted death—or, conversely, that he was guided by (a totally misplaced) faith, a fantasy of a near-impossible salvation.[7] For, by embarking on a perilous voyage without adequate preparation, he implicitly begged fate to determine his future.

The retrospective construction of the content of this work hinges on the central thematic and operative principle of Ader's practice: loss and failure—whether a deliberately willed, tactical failure or an inadvertent loss, his absence serves to withhold meaning and to forestall closure. The preferred vehicles for his modest, compressed, low-budget works were postcards, slides, small black-and-white annotated photo series, and short films—all of which were permeated by a singular tone of wistful or woeful grace. Yet the transmutation of Ader's abortive enterprise into a modern legend depends ultimately as much on oral narrative—based in memory, reminiscence, rumor, hearsay, and anecdote, and filtered through the membrane of critical theory—as it does on the humble ancillary material. Whether foreseen by the artist or not, *In Search of the Miraculous* in this guise proves a strangely fitting finale to an oeuvre grounded in the discursive and catalyzed through recursive material testimony.

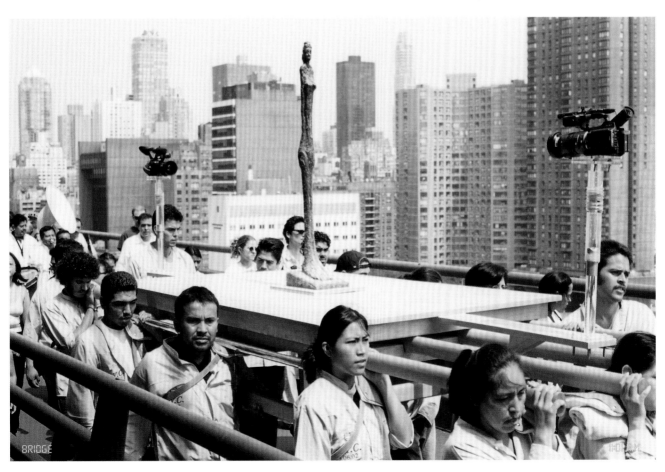

III.

On June 23, 2002, Francis Alÿs realized a long-planned proposal, the staging of a procession in which replicas of seminal artworks—contemporary icons—from the collection of The Museum of Modern Art in New York would be transported to the institution's new, temporary quarters in Queens from its former site in midtown Manhattan. Modeled on a canonical typology—a ceremonial public parading of sacred treasures from one venerated repository to another—this event was realized within the remit of MoMA's Projects series, under the auspices of the Public Art Fund, whose mandate is to commission contemporary artworks for the public arena.

From the work's inception, Alÿs resolved that it should be a procession, not a parade. Participants were solicited from within a limited circle, notably the museum's own staff, which covers numerous fields of expertise and professionalism: from curators to janitors, security corps to librarians and archivists, art handlers to cafeteria management, and so on. Others who participated were affiliates, including employees of the Public Art Fund, or family, friends, and associates of the artist, gallerists, writers and the like. Unified through their collaboration with the artist, this heterogeneous ensemble became a collective whose group identity was temporarily constituted for and by the occasion: they served at once as coproducers, participants, and audience.[8]

Since the event was envisioned as a procession and not a parade, the participants were not on display: they were not part of a spectacle. Some inadvertent bystanders, intrigued by this unannounced event devoid of banners, signage, or placards publicizing its purpose, did pause to watch it file by or even to accompany it for several blocks before resuming their own journeys. (Others, momentarily inconvenienced, sought alternative routes by which they might continue their pursuits, indifferent to its function or purpose.) Guided by the "professionals"—the band, the palanquin bearers, and similar "fixtures" of this typology, notably the riderless horse leading the way and those assigned to distribute flowers and rose petals en route—the volunteers assumed their place in the procession. Like extras on a

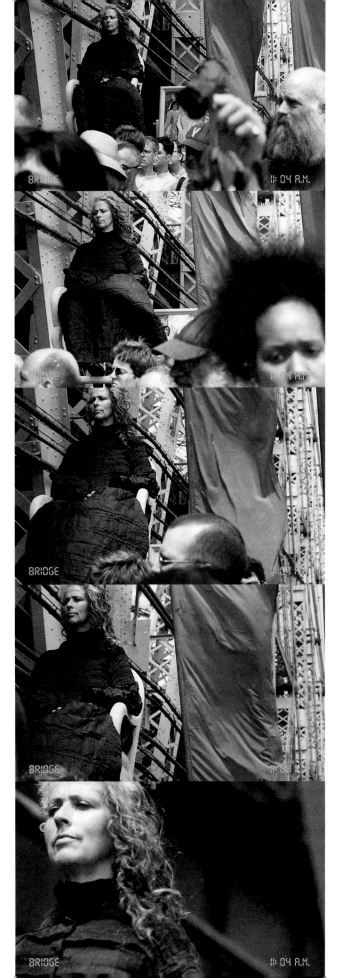

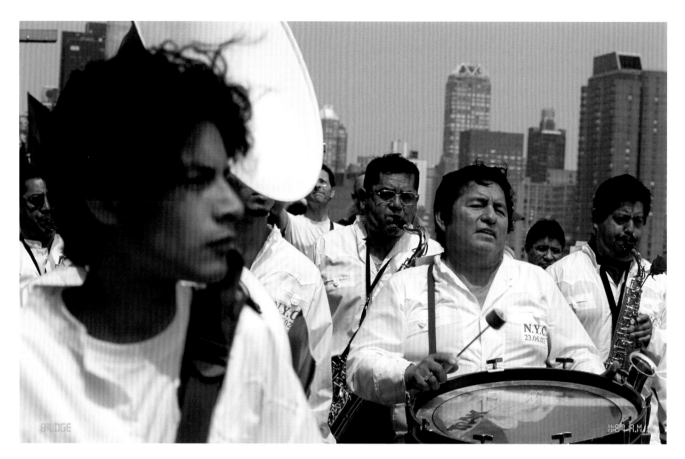

film set, their role was as necessary to the production as those of the more specialized functionaries. Unlike extras, however, they were free to follow or deviate from the loosely choreographed event: they remained subject to their own desires rather than to others' directives.

Signs of officialdom were at a minimum: the organizers were not identifiable either by dress or behavior. Populist and vernacular in spirit, the tone of the event became festive. Yet given its intimate and local scale, the procession was more akin to a neighborhood happening than something addressed to the civic milieu, to the metropolis at large. Eschewing a massive publicity campaign, Alÿs was content with whatever press ensued. Those few journalists who came—news crews and photographers rather than art writers—blended seamlessly with the amateurs casually documenting the episode. Spontaneous, low-key, and improvisatory, self-appointed reporters have today become the familiar accomplices of almost any untoward event that occurs in the public arena.[9]

Shortly after, on June 29, 2002, Alÿs's exhibition in the Projects series, titled "The Modern Procession," opened at MoMA QNS. It adhered to the format or conventions previously devised for this series of modest one-person shows. Visitors to the museum during its four-month run were confronted by an event conjured retrospectively by means of a variety of strategies, from projected video footage of the procession to ancillary data presented in vitrines, including preliminary sketches, plans, notes and permissions, plus photographic documentation of the event itself, and a brochure with interpretative texts.

In August 2003 Alÿs and his film collaborator, Rafael Ortega, completed yet another component in the chain of works generated under the rubric, "The Modern Procession." An eleven-minute video, this work in its definitive form has a very different status, structure, and identity from the loosely edited footage shown the year before in the Projects exhibition. Commissioned under the auspices of The Museum of Modern Art, it was

planned in parallel with the event, which was more properly the province of the Public Art Fund. Exceptional in a practice that normally considers material residues by-products, the requirement to produce a film had impacted, albeit in minor ways, on the actual event.[10] The video opens with shots of the musicians preparing and tuning their instruments. Then it tracks the assembling of the different groupings and their passage through the city streets and across the bridge to their destination in Queens. It ends with brief portraits of some of the participants. Once the band begins to play, the sound track becomes a continuous live recording of one tune, a march. (It was momentarily overlaid at one point with the sound of the helicopter from which the accompanying footage of the procession seen from an aerial vantage was shot.) The visual imagery is edited to this audio track, which unifies, propels, and structures the imagery. Duration is foregrounded by the device of speeding up brief segments, thereby fracturing any residual impression that this is a documentary. Similarly, the use of a split screen permits contrasting viewpoints and divergent perspectives to be juxtaposed, reinforcing the contingency of the point of view, undermining an overarching unified authorial presence. The subjects of this work, the art objects, weave and sway above the marching crowd, which pays little heed to them. When shown at rest, at the beginning and end of the piece, they are in repose on the street beside the palanquins, their vehicles. They are never filmed within the institution, never glimpsed as they were formerly installed in the galleries, nor as they might be housed in their new temporary quarters.[11] Since the narrative is predicated on an empty center, a spectral or phantom venue, the works may be considered doomed to a nomadic existence. Read allegorically, their fate is to be perpetually in transit; their exilic condition not circumstantial but inevitable. In short, this variant of *The Modern Procession* proposes with subtle but subversive wit that works of art that are the property of institutions are, paradoxically, itinerant. Metaphorically, if not literally, homeless, they have become rootless, consigned to a relentless rotation: now on loan, now in storage, now on display....

The Modern Procession is a polysemic composite, constituted of multiple identities, configurations, and incarnations. One of its mutant manifestations, one of "its many lives," to borrow the artist's terminology, is the eleven-minute video projection, among whose key precursors is Smithson's film, *Spiral Jetty*. A second, quite different manifestation is discursively constituted: more immaterial than material in form, it is generated by the congeries of supplementary documentation, recording, evocation, and visual and textual anecdote subtending the historical episode. Testimony to the necessarily porous, polyphonic, unfixed, and even contradictory character of this discursive formation is provided by yet a third of its many incarnations: this book. Alÿs conceived

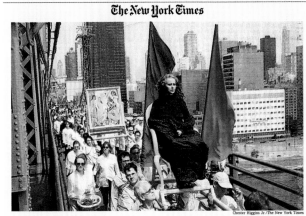

44. *The New York Times*, Metro section, June 24, 2002.

this component of his project as the vehicle which would concretize some of the disjunctive and perhaps irreconcilable analyses triggered to date by the project and stimulate yet more. Ader's *Search for the Miraculous* (1975) is consequently critical to its ancestry.

Several typologically or structurally similar works within Alÿs's corpus confirm the centrality of oral narrative as an abiding trope, a medium, and a vehicle in his practice. For example, in 1997, when he was invited to participate in "inSITE," an exhibition staged jointly in Tijuana and San Diego, he made a work that involved a journey from the city on the southern side of the Mexico-United States border to its northern counterpart without crossing their international boundary: circumnavigating the globe, he avoided the frontier by literally flying around it. An arduous detour of thousands of miles and several weeks, this quixotic gesture by an

artist who, while born in Belgium, has long been resident in Mexico City, may be supposed to be freighted with a certain self-mocking irony. The ease with which he (unlike many of his Mexican neighbors) could presumably have made this short trip across the narrow dividing line was forsaken in favor of the kind of rapid global travel to multiple destinations that epitomizes the lifestyle of the celebrated artist today, and has become the hallmark of a successful career: his apparent gesture of solidarity with his fellow Mexicans, a principled act, was vitiated, ironically, by its resemblance to the paradigmatic behavior of the celebrity artist. As Homi Bhabha argues: "The globe shrinks for those who own it; for the displaced or the dispossessed, the migrant or the refugee, no distance is more awesome than the few feet across borders or frontiers."[12] Alÿs mailed a postcard (fig. 45) to colleagues—curators, critics, collectors, and associates—which contained on one side a map of his itinerary, with the dates of travel, and, on the obverse below a picture of a tranquil, empty ocean, a short message, in the form of a typewritten caption, which stated, in part: "The items generated by the journey will attest to the fulfillment of the task. The project will remain free and clear of all critical implications beyond the physical displacement of the artist." Ostensibly disarming and disingenuous, this provocative contention was designed to incite debate, demurral, rebuttal. For, as the artist admitted, he was "also trying to make a somewhat ironical—[even] a little cynical—critique of the lavish budget some of these projects offer to artists by abusing the offer to the very maximum of its limits: the project was going to spend every single penny of the production budget assigned each artist. [Furthermore, it would involve] doing a kind of mock 'non-site' project for an enterprise called 'InSITE.'".[13] *The Loop*, his contribution to "InSITE," comprised the relics, the evidential material, notably a map of his itinerary, and such related paraphernalia as airline-ticket stubs, copies of visas, tourist snapshots, and the like. Effecting a radical displacement of the locus of the work from the visual to the verbal, from the gallery to a discursive non-site, Alÿs, characteristically, has offered no authorized or official version of

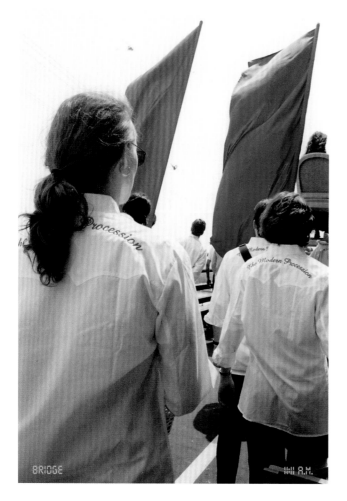

In order to go from Tijuana to San Diego without crossing the Mexico/USA border, I will follow a perpendicular route away from the fence and circumnavigate the globe heading 67° SE, NE, and SE again until meeting my departure point.
The items generated by the journey will attest to the fulfillment of the task. The project will remain free and clear of all critical implications beyond the physical displacement of the artist.

Para viajar de Tijuana a San Diego sin cruzar la frontera entre México y los Estados Unidos, tomaré una ruta perpendicular a la barda divisoria. Desplazándome 67° SE, luego hacia el NE y de nuevo hacia el SE, circunnavegaré la Tierra hasta llegar al punto de partida.
Los objetos generados por el viaje darán fe de la realización del proyecto, mismo que quedará libre de cualquier contenido crítico más allá del desplazamiento físico del artista.

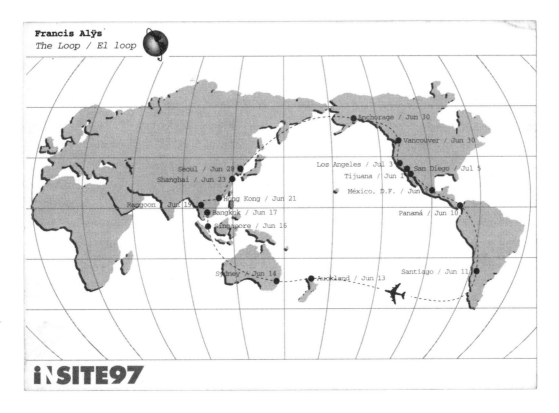

45. Francis Alÿs, *The Loop*, postcard (front and back), 1997

Mr. Peacock will represent Mr. Alÿs at the XLIX *Biennale di Venezia.*

46. Francis Alÿs, *The Ambassador*, postcard, 2001

the narrative and published no written statement.[14] This darkly acerbic work is constructed ontologically by piecing together previously published accounts, perhaps from conversations or interviews with the artist himself, or with the respective curators or the institutional authorities, or by consulting second- and third-hand sources, or via the ancillary documents whose role is, however, ultimately less evidential than textual. In contrast to written tradition, to the logos, oral narrative creates and maintains a form of collective consciousness, transmitted through chains of hearing and repetition. An autopoetic entity, hearsay needs no first draft, no primordial text. Unlike official histories it flourishes facelessly and profits from the absence, the spatial nonpresence, of those who become its subjects. Hearsay, like Chinese whispers, proliferates by mutating; it is volatile, permeable, unbounded.

Another peregrination, devised this time for the Venice Biennale of 2001, involved the introduction of a surrogate. A peacock strolling through the Giardini acted as the ambassador for the artist, who was never himself present over the course of the several days of opening festivities. Notification was provided by an extensive distribution across the city of a postcard which featured a close-up of the wondrous creature with its tail spread (fig. 46).[15] Sightings of the elegant avian flaneur who roamed leisurely through the gardens were frequent. In contrast to the bird's idle encounters, artists engaged in the frenetic meeting and greeting that such occasions demand, and rumor flew through the site. Alÿs's witty lampoon contains a sharper barb, however, in its sly echoes of Aubrey Beardsley and other late-19th-century aesthetes, dandies who not only much prized this exotic animal but cultivated a mode of public posturing as integral to a willfully decadent lifestyle they considered an art form in its own right. It also brings to mind, albeit elliptically, Virgil's famous figuration in the Aeneid, of Fama, or Rumor. Mr. Peacock uncannily evokes the classical poet's eloquent emblem, a swift-footed winged creature, its plumage suffused with sleepless eyes.[16]

Some months before the *The Modern Procession* was staged in New York, on the occasion of the third Bienal Iberoamerica de Lima, Alÿs realized another long-planned idea involving a large troupe of participants. *Cuando la fé mueve montañas* (*When Faith Moves Mountains*) (figs. 47- 48), which took place on April 11, 2002, required some 500 volunteers to shovel sand along the crest of a dune near Ventanilla, a neighborhood of shanty towns just outside the Peruvian capital. Their instructions were to shift the dune a distance of four inches. But, given that sand dunes move of their own accord and that the displacement of any particular dune within a field is virtually impossible to measure or even to register due to the lack of firm coordinates and definable boundaries, this was an inherently absurd task. Offered no monetary or material remuneration, the participants were likely to have been motivated less by rational goals than by belief, by a collective aspiration, or by an idealistic spirit of camaraderie. For his own part, Alÿs hoped to provoke "a little miracle," by means of "a collective hallucination," a rare collaborative action in a society beset with economic, social, and political disputes.[17] Several compelling photographs of the episode, whose manifest purposelessness underlined its allegorical nature, have appeared in subsequent reviews, articles, and related press coverage: they feature aerial views, which silhouette the line of shoveling figures within the vast arid terrain. Since the participants are indistinguishable, and dressed alike in light shirts and dark trousers, and the context is shorn of all identifiable physical and temporal detail, these media representations abstract the event from its specific historical and geographical coordinates.

Characteristically, Alÿs has provided no definitive written record, though he has given a number of interviews. Discussion consequently circulates mostly via hearsay, as second- and third-hand rather than eyewitness accounts. A gratuitous utopian "beau geste" (to borrow the artist's terminology), this poetic "social allegory" brings to mind Joseph Beuys's proposal, made in the mid-1960s, to add ten centimeters to the height of the Berlin Wall. Beuys's gesture invites an ironizing reflection on the aestheticization of political activism as much as on the politicization of aesthetic praxis. Inserted into a highly charged sociopolitical context, Beuys's provocation depended on the historical specificity of that site at that moment. It consequently reverberates at the level of idea without the necessity of production. Alÿs's work, by contrast, not only gains from its enactment, it depends upon it. Only through its realization was the absurd pathos inherent in this futile action fully unleashed. Typologically, it invites comparison with such stereotypical events as the visit by Oscar Wilde in April 1882 to Leadville, Colorado, then at the height of its silver boom. After lecturing to the workmen on their renowned forebears, including such luminaries as Benvenuto Cellini, Wilde was fitted out in miner's gear and taken underground to open a new lode, which the miners named "The Oscar" in his honor. On his departure he was presented with the silver drill with which he had made the first incision in the earth. In spirit, *When Faith Moves Mountains* is far removed from the strangely charming mutual irony that must have infected the highly staged affair for both the literary celebrity and the Colorado miners alike.[18] Wielding shovels, the Peruvian volunteers who donated their labor to what was literally and symbolically a manifestly futile enterprise became the vehicles for a deliberately problematic if skeptical critique of the types of community-based, site-specific, service-oriented art practices that are the staple of recent biennale jamborees. Yet since it is addressed

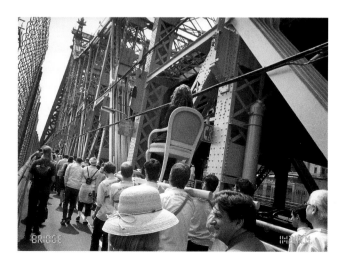

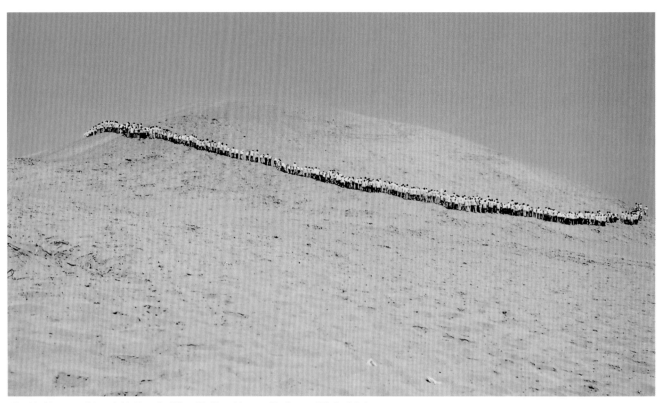

47–48. Above and top right: Francis Alÿs with Cuauhtemoc Medina and Rafael Ortega, *Cuando la fé mueve montañas* (*When Faith Moves Mountains*), Lima, Peru, April 11, 2002

principally ex post facto, via media representation, *When Faith Moves Mountains* has taken a potent posthumous life: it has assumed the form of a discursively determined site, one that is delineated as a field of intellectual exchange, conjecture, reminiscence, and rumor.

In Alÿs's practice, discourse does not provide a premise for the realization of the event: typically, the initial idea is no more than a seed or germ, "a three-line plot," in the words of the artist.[19] Whether the shoveling of sand or the moving of artworks, the event is the precondition from which the narrative burgeons as the "content" of the work. This content is verified by its convergence and circulation within a broader preexisting discursive formation. While in both of these carefully calibrated proposals Alÿs sought "to translate social tensions into narratives that in turn intervene in the imaginary landscape of a place," the epistemological challenge required relocating meaning from within the event to the contingencies of the ensuing conceptual context.[20] Significantly, Alÿs defined his governing strategy in textual terms: "If the script meets the expectations and

addresses the anxieties of that society at that time and place, it may become a story that survives the event itself. At that moment," he contends, "it has the potential to become a fable or an urban myth."[21] Despite their ostensibly very different thematics, these and related works in his oeuvre also engage "the narratives of art history, not to mention those of the art world."[22] The ultimate work in this vein may be his long-contemplated wish, which is perhaps manifested—or rather, coproduced—in the very fact of writing this essay (in conjunction with other retellings elsewhere), to create a work which takes the form of a rumor. In the recounting of his proposal the work will be realized, for it is not the content per se which makes a rumor but the mechanics and acts of its conveyance.[23] By definition, a rumor is unofficial, informal, time-sensitive, urgent, and topical. Forswearing accountability, it is part of a communications network that begins somewhere indeterminate and ends elsewhere. It marshals participants, recipients whose purpose is to convince their interlocutors, in turn, of the truth of their informants' hypotheses, speculations,

and revelations, irrespective of how unconfirmed, unfounded, or implausible they may appear. "The interpretations…needn't be accurate, but must be free to shape themselves along the way."[24] Offered with respect to the Lima project, Alÿs's salutary admonition extends a rare degree of intellectual license to those of us who wish to shape as we engage his discursive terrain.[25]

Lynne Cooke has been curator at the Dia Art Foundation, New York, since 1990. She is on the faculty of the Center for Curatorial Studies at Bard College and also teaches at Columbia University. She has written widely about contemporary art, including recent essays on Bridget Riley, Rodney Graham, and Jorge Pardo.

1. Reviewing the posthumously published anthology of Smithson's writings, Craig Owens wrote: "If this collection of Smithson's writings testifies to anything in our present culture, it is to the eruption of language into the field of the visual arts, and the subsequent decentering of that field—a decentering in which these texts themselves play a crucial part." ("Earthwords," *October*, no. 16, Fall 1979, p. 122.)

2. Smithson offered a more conventional complementary exposition of the genesis and realization of the work in an essay "The Spiral Jetty," in *Arts of the Environment*, Gyorgy Kepes, ed. (New York: George Braziller, 1972); reprinted in *The Writings of Robert Smithson: Essays with Illustrations*, Nancy Holt, ed. (New York: New York University Press, 1979), pp. 109-116. However, the after-life of *Jetty*, which is mostly submerged below the tomato soup–like surface of the water, and hence not only remote but invisible, has skewed reception of the film. It does double duty, as a quasi-documentary as well as a work in its own right.

3. Robert Hobbs, *Robert Smithson: Sculpture* (Ithaca: Cornell University Press, 1981), p. 201.

4. Hobbs, *op. cit.*, p. 202.

5. I am indebted for this information to Brad Spence's invaluable catalogue, *Bas Jan Ader* (Irvine, California: The Art Gallery, University of California, Irvine, 1999), and to its brilliant essay by Jan Tumlir, "Bas Jan Ader: Artist and Time Traveller."

6. Nicholas Tomalin and Ron Hall, *The Strange Last Voyage of Donald Crowhurst* (London: Stein and Day, 1970). The authors convincingly describe this as "one of the most extraordinary stories of human aspiration and human failing that, as journalists, we have ever had to record" (p. 12).

7. Note, however, that Bas Jan Ader made a performance work in 1972 in which he read every day in public—all the while genteelly sipping water—for the two-week duration of his exhibition at Art and Project Gallery, Amsterdam. What he read was a *Reader's Digest* story, "The Boy Who Fell Over Niagara Falls," an account of the miraculous rescue of a child, protected only by a lifejacket, who survived unharmed after being swept over the falls.

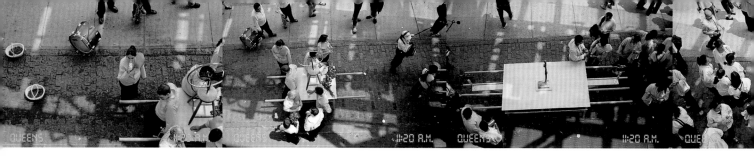

8. Had the event been widely announced as a performance artwork it would have solicited a different audience, whether in the role of participants or of observers, with very different expectations. Albeit loosely defined and implemented, the principal qualification for participation seemed to be the possession of institutional ties: the fact of being closely affected by the imminent relocation of the museum's celebrated collection, supplemented by personal affiliations.

9. Alÿs mostly relies on amateurs to provide visual representation. "I try to keep the documentation as neutral as possible, generally inviting friends—non-professionals always—to take a snapshot, in between evidence and memory…. In Venice for the peacock [piece] I invited people—through the postcard—to take photos of the ambassador and send them to me….The Lima piece…was somewhat exceptional since, because of the minimal nature of the piece and the extremely bare character of the location, we had to make sure we would not have cameramen or photographers running in the field of action or in the frame, which, as you can imagine, would have directly interfered with the quasi-ritualistic nature of the event itself and the narrative of the document…. In the case of *The Modern Procession* any document taken that day became a potential 'iconic image' to represent [the procession, ranging] from the ones taken by some official photographers commissioned by the Public Art Fund to more casual ones, from people who happened to be there and had a camera, starting from myself, my sister, friends, etc…." (E-mail to author, August 11, 2003.) Two short articles appeared in the next day's papers. Both, tellingly, were news stories; both involved a number of factual inaccuracies. (Reprinted in this book, figs. 43 and 44.) To date, there has been little coverage in art publications, with the exception of a double-page spread in *Artforum* in September 2002, which was accompanied only by a caption. There has, however, been considerable word-of-mouth discussion.

10. Although mostly he relies on informal modes of documentation, such as amateur snapshots, for this event "the cameras were quite present, and somewhat influential if not affecting the final shape of the event," Alÿs recalls; indeed, the camera's presence may be beneficial, since "in the case of large demonstrations it can also act as a stimulus to the participants, sometimes paradoxically making the event more "real." (E-mail to author, May 5, 2003.) In his dual-projection video piece *Re-enactments* (2000), Alÿs expressly addressed the nature and value of all forms of documentation in relation to the performance work. "In an age where documentation and video art have taken such a central place, what is left of the original role of performance as an immediate, risky (for example, Chris Burden), often anonymous act?" Alÿs asks. "How much of the development of the action will be conditioned by the expectation of its documentation? What is left of the original, capital importance of the immediacy of the experience for the actor and its witness respectively?" he asks. (E-mail to author, May 5, 2003.) Exceptionally, on this occasion, accident intervened to

shape the final format of the film. "The idea was to have a full real-time documentation of the whole procession in real time. The camera in front, looking back, [tracked] the leaving of Manhattan, and the camera in the back, looking forwards, the entering of Queens. Unfortunately," the artist confessed, "in the excitement of the arrival, one of the tapes was lost, precluding that scenario of a relatively neutral documentation of the whole journey." (E-mail to author, August 11, 2003.) The shortage of time separating the event from the exhibition opening—a mere three days—permitted only a review of the extensive footage and the outlining of a basic schema for a later and tighter edit. This schema was limned in the detailed storyboard, indicating key camera positions, plus certain close-ups, details, and individual shots, shown in his Projects exhibition. It was produced retrospectively, after reviewing the available footage, in the three days between the event and the opening of that exhibition. Although made under duress it remained the model for the edit some months later that resulted in the eleven-minute tape released in 2003.

11. Restrictions imposed by the museum in accordance with its mandate would have precluded shooting in these locations, had Alÿs so wished. But if this work may be read allegorically, as a metatext, rather than as an institutional critique addressed to a specific organization, the question is moot. (See interview with Robert Storr and Tom Eccles, pp. 79-97 for further discussion of the constraints under which the artist was operating.)

12. Homi K. Bhabha, "Double Visions," *Artforum*, 30 (January 1992), p. 88. Alÿs mocks himself here in that he typically places himself in the role of a pedestrian, using peripatetic methods as a vehicle in a series of signature solitary walks, as in *The Leak* (1995), or as a tourist as seen in *Narcotourism* (1996). Michel de Certeau has argued that such nomadic practices offer a fertile site for generating oral narrative: "What this walking exile produces is precisely the body of legends that is currently lacking in one's own vicinity. It is a fiction which, moreover, has the double characteristic, like dreams or pedestrian rhetoric, of being the effect of displacements and condensations….One can measure the importance of these signifying practices—to tell oneself legends," he concludes, "as practices that invent spaces." (Michel de Certeau, "The Practice of Everyday Life: Walking in the City," quoted in Bruce W. Ferguson, "Restless Production," in *Francis Alÿs: Walks / Paseos* (Guadalajara, Mexico: University of Guadalajara, n.d.), p. 61.

13. E-mail to the author, August 11, 2003.

14. In this, Alÿs's work differs significantly from that of a number of his contemporaries, such as Tacita Dean and Rodney Graham. Both Dean and Graham offer authored texts, which become verbal analogues to the visual component, as in the films *Disappearance at Sea I and II* (1996, 1997) or in *Phonokinetoscope* (2001). A more direct parallel may be found in the work of Christian Philipp Müller, evidenced, for example, in his *Hudson Valley Tastemakers*

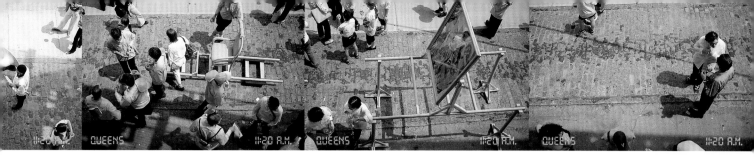

(2003), a multifaceted work involving the planting of crops, collecting of recipes, and commissioning of dinners by specialized chefs inter alia within the broader compass of agricultural issues and their social and economic infrastructures. For these four artists and many others of their generation indebted to Conceptual-art practices of the 1960s, these practices now appear less involved with the dematerialization of the art object per se than with the displacement and rethinking of materiality in favor of actions/events/language and mechanical reproduction. In this reading, Smithson becomes a canonical figure and Bas Jan Ader one of Conceptualism's most esteemed martyrs.

15. On the back of the card was printed the following: "Take a photograph of Mr. Peacock / Send it to this address / Receive a photo-souvenir by Francis Alÿs." Visually analogous to his use of such oral forms as hearsay and conjecture, Alÿs's dependence on casual and generic snapshots accords with what John Roberts refers to as the "valorization of the amateur" found in the art of Smithson, Ader, and their peers. They, too, eschewed the fetishism of the authored professional photograph in favor of such everyday anonymous practices as the snapshot, which, they also felt, could contest the supposed transparency of reportage. (See Michael Newman, "After Conceptual Art: Joe Scanlan's *Nesting Bookcases*, Duchamp, Design and the Impossibility of Disappearing," in *Rewriting Conceptual Art*, Michael Newman and Jon Bird, eds. (London: Reaktion Press, 1999), p.210.

16. "Fama, the swiftest traveler of all the ills on earth,
Thriving on movement, gathering strength as it goes; at the start
A small and cowardly thing, it soon puffs itself up,
And walking upon the ground, buries its head in the cloud-base.
...a swift-footed creature, a winged angel of ruin,
A terrible, grotesque monster, each feather upon whose body—
Incredible though it sounds—has a sleepless eye beneath it,
And for every eye she also has a tongue, a voice and a pricked ear."
Quoted in Hans-Joachim Neubauer, *The Rumor: A Cultural History* (London: Free Association, 1999), p.39.

17. Quoted in RoseLee Goldberg, in this book p. 102.

18. A delightful account of this episode is given by Joseph Masheck, "The Panama Canal and Some Other Works of Art," *Artforum*, 16 (May 1977), p.38.

19. "I try always to keep the plot simple enough so that these actions could be imagined without an obligatory reference or access to visuals...so that the story can be repeated (and memorized) as an anecdote, as something that can be stolen, or travel orally, and, in the best-case scenario, enter the land of minor urban myths," Alÿs states. That ideal, "of immediate imaginary apprehension...affects all the other lives of the project," he contends. (E-mail to author, May 5, 2003.)

20. I am indebted here, and elsewhere in this text, to the terms in which the theoretic premise and defining coordinates of a discursive field are elucidated in Miwon Kwon's seminal study, *One*

Place After Another: Site-Specific Art and Locational Identity (Cambridge: Massachusetts Institute of Technology, 2002).

21. Quoted in Saul Anton, "A Thousand Words: Francis Alÿs Talks about *When Faith Moves Mountains*," *Artforum*, 40 (Summer 2002), p.147.

22. *Ibid*.

23. In addition to Neubauer's *The Rumor, op. cit.*, see Jean-Noel Kapferer, *Rumors: Uses, Interpretations, and Images* (New Brunswick: Transaction Publishers, 1990).

24. "A Thousand Words," *op. cit.*, p.147.

25. I am aware, for example, that my postulation of an allegorical content in the video piece *The Modern Procession* (2002) runs counter to that of Alÿs's stated aims. For Alÿs, there is a liberating impulse in the temporary release of these icons from the precincts of the institution, a potential for a reengagement with the world beyond its sequestered, ideologically determined borders. A similar impulse—more persuasive, I believe—fuels *Walking a Painting* (fig. 51), a project that took place in Los Angeles, April 29-May 6th, 2002. Alÿs cites a quote from the *Los Angeles Times*, from April 30, 1992, as central to the genesis of this work: "Across South L.A., blacks, whites, Latinos and Asians are meeting in violent confrontations. The popular myth that Los Angeles was transforming itself into a harmonious multi-ethnic model city seems to waft away in the smoke billowing over the city." (E-mail to author, October 7, 2003.) In planning his solo show, which was to take place at the time of the tenth anniversary of the uprisings that had indelibly affected the city a decade earlier, Alÿs commissioned a painting depicting a large multiracial confrontation. Each morning for a week he removed the painting from the walls of the gallery and took it on an extended journey that included the very neighborhood in which the riots had erupted in 1992. Each night he returned it just before the gallery closed.

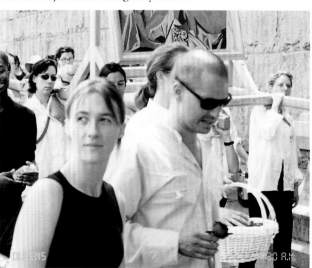

I don't know what I will do for the rest of my life. It can't get any better than this!

–KIKI SMITH, *at the end of the procession*
New York City, June 23, 2002

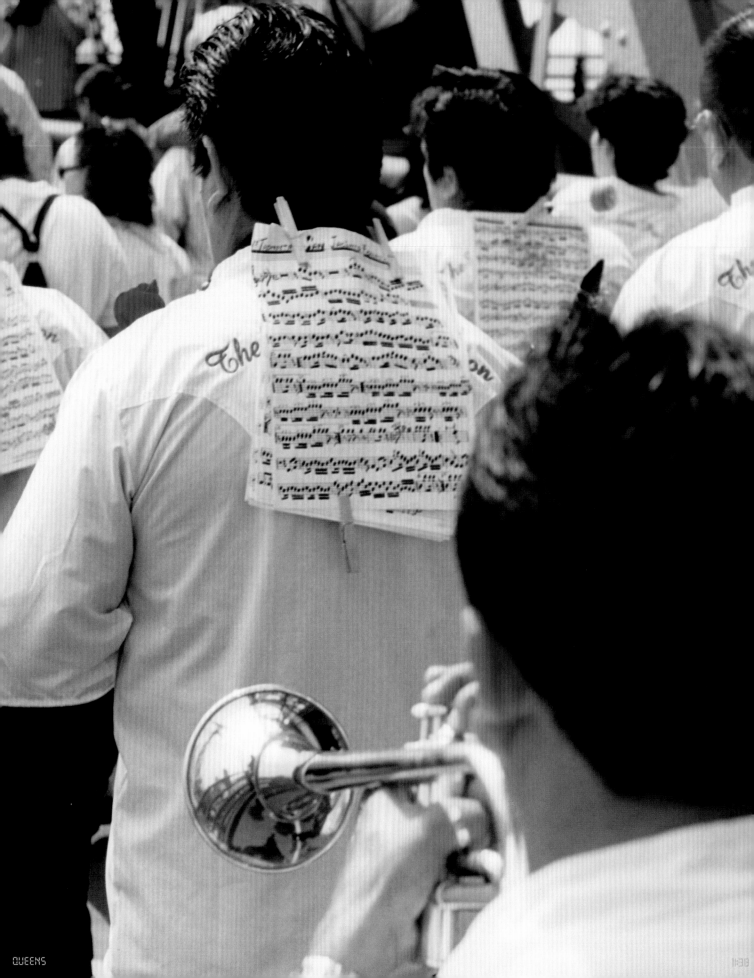

A MYTHOLOGIST AT WORK

Harper Montgomery

*"For they bring us pleasure, peace,
and sometimes redemption..."*
Francis Alÿs, New York City, May 2002

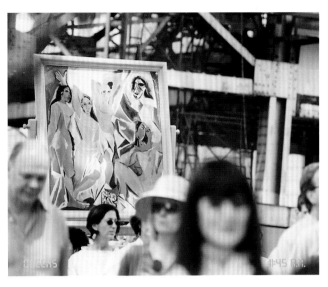

The story has been told before: how some two hundred people walked to Queens on a Sunday morning in late June, carrying palanquins with effigies of three master-pieces from The Museum of Modern Art's collection and a living icon in the person of the artist Kiki Smith. How they didn't think they'd be able to do it, carry ten to twenty pounds on their shoulders for close to three hours, through midtown and over the Queensboro Bridge. How, with their incredible journey completed, exhausted but exhilarated, transformed into unlikely pilgrims, they happily stood in line for watermelon and cantaloupe punch in the hot June sun in a parking lot on Queens Boulevard. Some saw their story on the six o'clock news that night: "Instead of using shipping trucks, the museum recruited volunteers—that's right—to form a procession carrying priceless works of art to the museum's temporary new home in Long Island City."

Elaborating on modern-day myths, Alÿs assumes the character of what Roland Barthes has called the mythologist. He creates new poetic myths out of the old, thereby exposing the cultural mechanisms involved in the semiotic construction of myth itself. Alÿs engineers "second-order myths"; he does this not with the goal of establishing an alternate ideological position but to confound ideology altogether by staging scenarios that are at turns lyrical, ambiguous, syncretic, political, and dialectical, announcing themselves as incomplete, unresolved, in constant flux. Integral to his mythologist inquiry is Alÿs's ongoing dialogue with the status of the art object, a discourse whose character is better defined by playful and open propositions than by direct critique.

He executes these propositions with a Duchampian levity and a lightness of meaning that encourages speculation. Rather than delineating their primary meaning, he opens up exponentially expanding concentric circles of significance. In several recent projects, including *Walking a Painting* and *The Modern Procession,* Alÿs has amplified his mythologist enterprise by circulating painting and sculpture in the urban realm, tapping into their mystical power and encouraging us to value them as icons that can offer us spiritual redemption. By walking these art objects through the streets of Los Angeles and New York, he injects them with subjectivity and agency, weaving a story around their journey and their chance encounters with random elements in the street.

In this spirit, Alÿs is fond of describing his open narratives as fictions, rumors, or fables. His work is first and foremost a process in the form of a journey or pilgrimage. It discourages the usual classifications of an artist's body of work, such as consistency of style and/or ideological message. Using a wide range of aesthetic strategies that encompass minimalism, baroque, surrealism, and conceptualism, and media that include painting, sculpture, drawing, video, performance, animation, and installation, his work can be encountered as a grand or intimate gesture. Chameleonlike, Alÿs at turns plays the part of the trickster or con artist, refuting easy categorization of his artistic production.

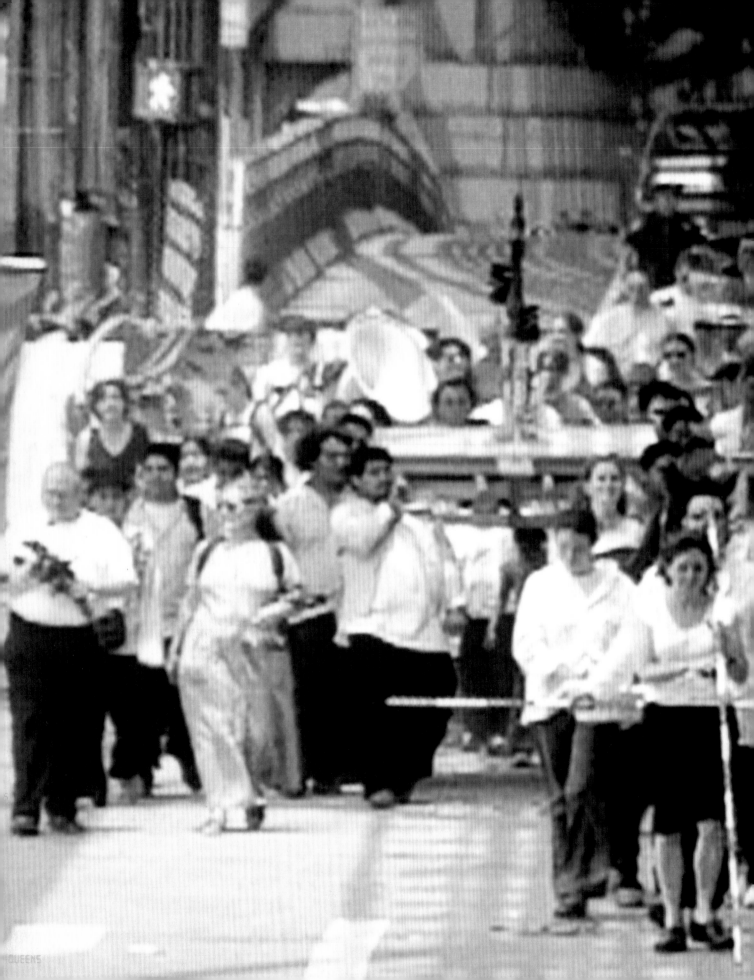

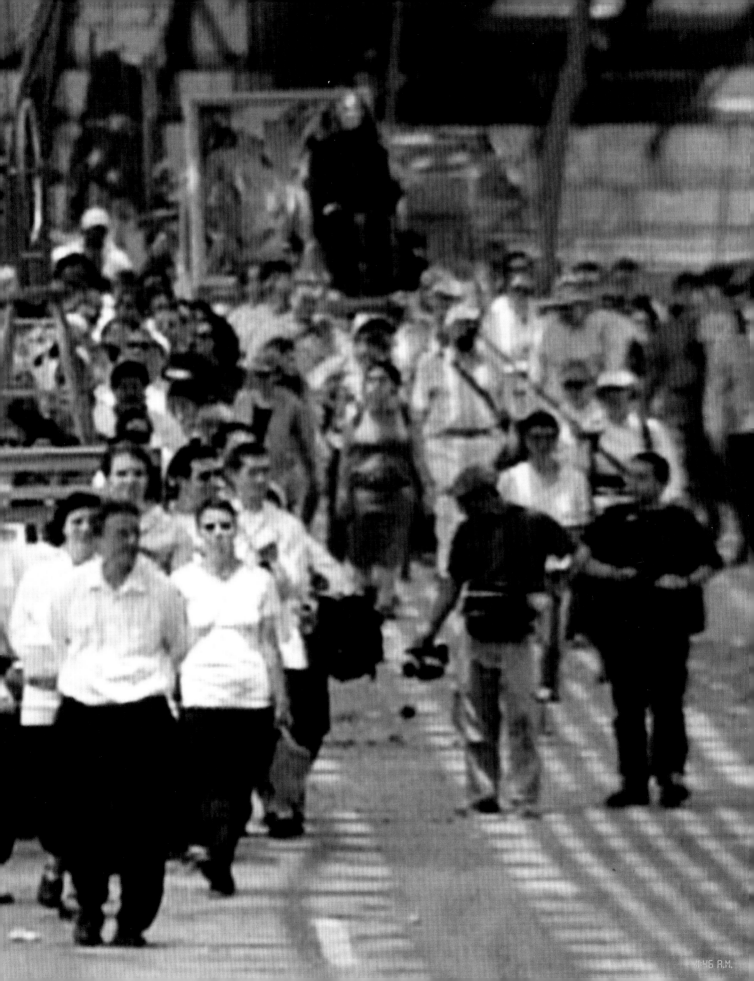

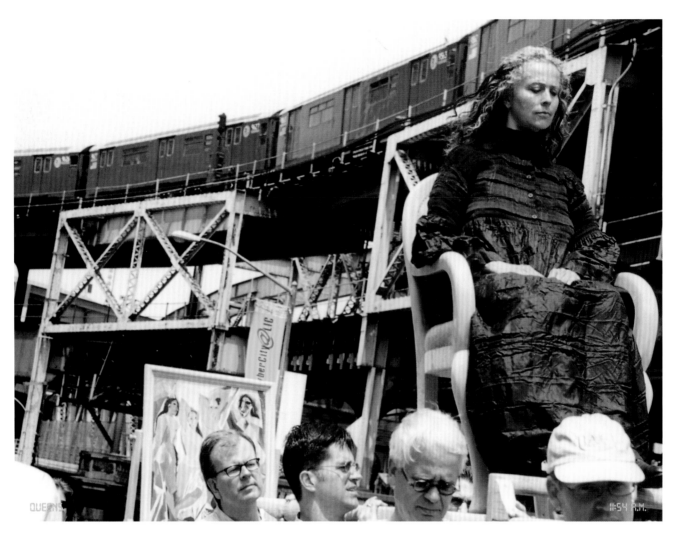

What makes his work compelling is that it always operates in a zone just a degree removed from our everyday behavior, a small but vital shift away from reality, operating side by side with the immediate everyday, wavering between harmony and disharmony like the pulse of street life. Never antagonistic, his interventions build on our established rituals and habits, tweaking our everyday experience in a humble but often profound way, discreetly dismantling our assumptions, deceiving our common expectations, and tapping into our ontological impulses.

The genesis of Alÿs's work was the series of walks he began taking in the early 1990s in Mexico City. He arrived there in 1987, when he was in his late 20s, and quickly turned away from his trained profession of architecture to begin an ongoing inquiry into how bodies negotiate the chaos of the urban entity by making pieces that addressed the conflictive and yet stimulating context of Mexico City. As he recalls, once he began living in Mexico City, architecture no longer made sense as an immediate tool of sociopolitical intervention. What started off as a dilettante's experiments in art-making became a full-time occupation in the early 1990s, a time in Mexico City when artists, curators, and critics were attempting to reorient the local practice, forging neo-conceptual strategies in response to the condition of living in the megalopolis of Mexico City.

Alÿs's first public walking action was *The Collector* (1991): for an open period of time, he would take a small toy dog on metal wheels out for a walk,

pulling it day after day through the streets of Mexico City (fig. 50). Its body, a wooden block embedded with magnets, attracted bits of scrap metal, and it gradually built a coat of the metal residues lying in its path, until its body was completely covered by metal scraps. Or, as Alÿs puts it, "until he was completely smothered by his trophies." In summer 2002, at P.S. 1 Contemporary Art Center's show "Mexico City: An Exhibition about the Exchange Rate of Bodies and Values," museum visitors could take this piece for a thirty-minute walk through the streets of Long Island City, reenacting the performance themselves.

This piece, like many of Alÿs's walks, is casual, in constant process, and endlessly repeatable. In another walk, called *Paradox of Praxis* (1997), Alÿs pushed a large block of ice through the streets of Mexico City for an entire day, until it melted completely (fig. 49). In the morning the ice formed a perfect minimalist cube, and as the day progressed it melted away to become a kickable fragment and, finally, a little puddle of water on the sidewalk. Reflecting on the ambivalence between poetic failure and the promise of success, with this work Alÿs enacted his assertion that "sometimes making something leads to nothing." As much about sculpture as performance, these works represented Alÿs's attempt to make sculptural objects whose raisons d'être were their own movement through and displacement in the streets. The

50. Francis Alÿs, *The Collector*, Mexico City, 1991

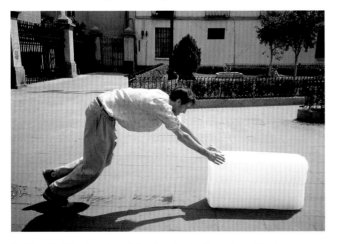

49. Francis Alÿs, *Paradox of Praxis – Part I: Sometimes Making Something Leads to Nothing,* Mexico City, 1997

reactions of the incidental passersby, the possibility of confrontation, of failure, or success continue to instigate most of his walks. For Alÿs, these social dynamics are inextricably linked to the physical qualities of the street, its role as a physical container for bodies, plus the stuff strewn around it, the traces of the lives that occurred there, the banal and ubiquitous, the quest for any particle that could potentially become poetic.

While the context of Mexico City has become a gigantic laboratory for Alÿs, he has since exported his walks to cities around the world, keenly sensitive to what John Tomlinson calls the "complex connectivity" that defines life in urban centers such as Mexico City, Havana, São Paulo, or New York. He always operates in the fringes of these locations, exploiting their capacity as sites for social inversion. He sees the streets as

51. Francis Alÿs, *Walking a Painting*, Los Angeles, 2002

communal, political, carnivalesque (in the Bakhtinian sense) territories. In more recent projects he has addressed the urban contexts of New York and Los Angeles, taking art into the streets to test the popular power of painting by framing the image and the object as icons, tapping into their potential as mystical objects through their dynamic clashing with the street, a context distinct from the white cube of the gallery.

Two months before staging *The Modern Procession* in New York, Alÿs performed a project in Los Angeles called *Walking a Painting* (2002). For the tenth anniversary of the Los Angeles riots he carried a painting through the streets. A large but hand-transportable canvas whose subject illustrated a quote from the April 30, 1992, *Los Angeles Times*: "Across South L.A., blacks, whites, Latinos and Asians are meeting in violent confrontations. The popular myth that Los Angeles was

transforming itself into a harmonious multiethnic model city seems to waft away in the smoke billowing over the city." He hung the painting downtown on a gallery wall, taking it off the wall every morning to walk through the city with it under his arm (fig. 51); as each day drew to a close, he brought the painting back to the gallery, hung it on the wall, and covered it with a curtain, putting the painting to "sleep." With this memorial act, Alÿs reminded Los Angeles residents of a painful recent historical episode, reopening a still living social wound that public officials have since attempted to discreetly suture, critiquing and literally exposing the myth of racial harmony.

In New York, Alÿs addressed the cold rationality of the city's grid, the relentless regularity of its block system in a project leading up to *The Modern Procession*. Walking and counting, in an endless series of walks, he

paced off block after block of the whole of Manhattan, charting off these spaces by precisely counting the meters traveled, mapping the city step by step.

In the gallery space, Alÿs presents the process and the evidence of his actions by way of drawings, videos, and photographs, and he publicizes them at the time of their happening by sending out postcards. The home-spun quality of these products—such as the off-register printing of the souvenir postcards, the handheld video footage, and the humble qualities of his drawings—add a patina of faraway manufacture, encouraging our unex-pectedly nostalgic and intimate encounter with them.

During the planning and production stages of *The Modern Procession*, Alÿs's detailed to-scale drawings of palanquins were copied for a carpenter's team in Mexico City and faxed to the registrar of The Museum of Modern Art in New York to determine shipping logis-tics, before finally being presented in the museum's gal-leries. While they are, in this sense, a technical record of his creative process, rather than the artist's touch or ges-ture, they also become the involuntary testimony of the progression of his story, tracking the germination of a narrative scenario, its characters, its plot, and route. They reveal discarded icons, like Giacometti's *Walking Man* or Brancusi's *Endless Column*, rendering the edit-ing and collaborative process visible. Often hurriedly photocopied and/or drawn over by Alÿs, faxed and refaxed during the long process of negotiation with MoMA and the New York City officials, these drawings acquired the status of blueprints and proposals. Like Duchamp's collection of notes and drawings in his *Green Box*, Alÿs's accumulation of drawings functions as neither illustration nor key to his actions. Instead, they allow us to speculate and ponder, emphasizing the inci-dental, the accidental, and the coincidental sidebars of the tale Alÿs has spun.

While he was elaborating *The Modern Procession*, Alÿs painted two small images he nick-named *Redemption*, both of which depict two figures submerged to their waists in a field of sea-foam green

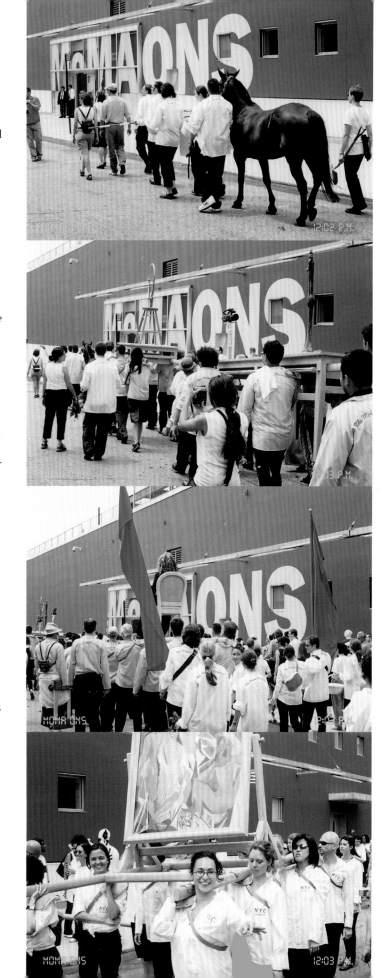

52. Francis Alÿs, *Untitled (Redemption)*, 2000-2002, oil and encaustic on canvas in two parts

water (fig. 52). In the first scene a white man seems to be writing on the back of a black man; in the second, the black man is writing on the white man's shoulders. Their gestures are also reminiscent of baptism in the tradition of holy roller–style full-body submersion. This diptych provides an important clue to Alÿs's recent interest in the spiritual salvation offered in images, in our ontological need for answers, and in how inextricably our collective religious rituals are engrained in our psyches. Alÿs is tapping into our ontological relationship with images, while also discreetly pointing to artificial myths, such as that of racial harmony in the States.

For The Museum of Modern Art, Alÿs's procession made visible a decisive moment of transition, calling attention to the potential for regeneration offered by the museum's move to Long Island City. Drawing on the evocative history of the procession, Alÿs inscribed icons signed by our masters of modern art into the museum's physical and logistical process of navigating its way to Queens, crossing the river to arrive in a distinct economic, demographic, architectural, social, ethnic, and cultural context. Although Alÿs's enterprise is dead serious, he executed the procession with a wink and nod, encouraging us to look both critically and fondly at our attachment to icons, reminding us of the quasi-religious status modern art can acquire, even in our contemporary New York lives.

Harper Montgomery, formerly an assistant curator in the Department of Prints and Illustrated Books at The Museum of Modern Art in New York, curated "Projects 76: Francis Alÿs." She recently co-organized the 2004 Trienal Poli/Gráfica de San Juan: América Latina y El Caribe.

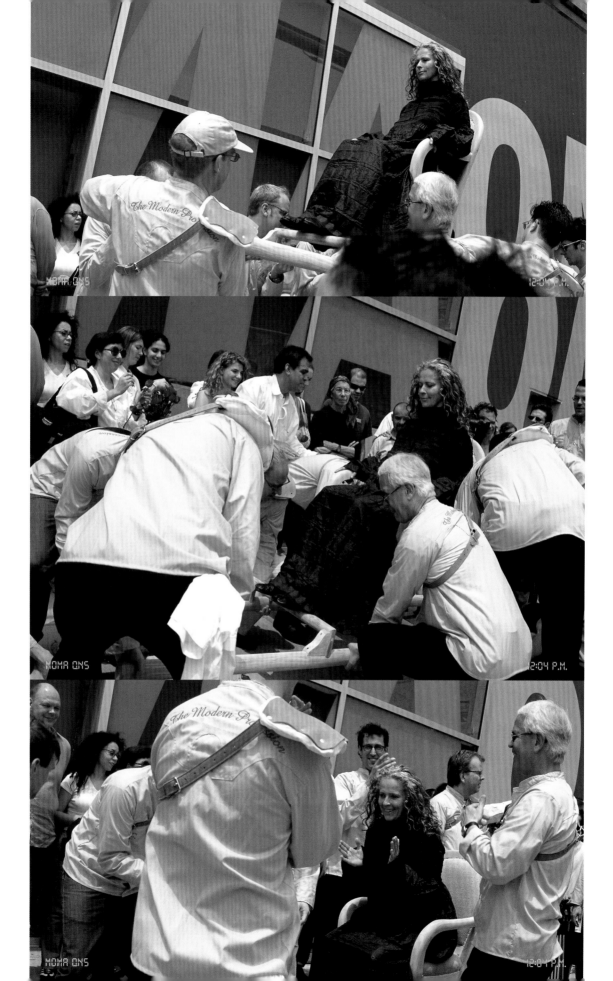

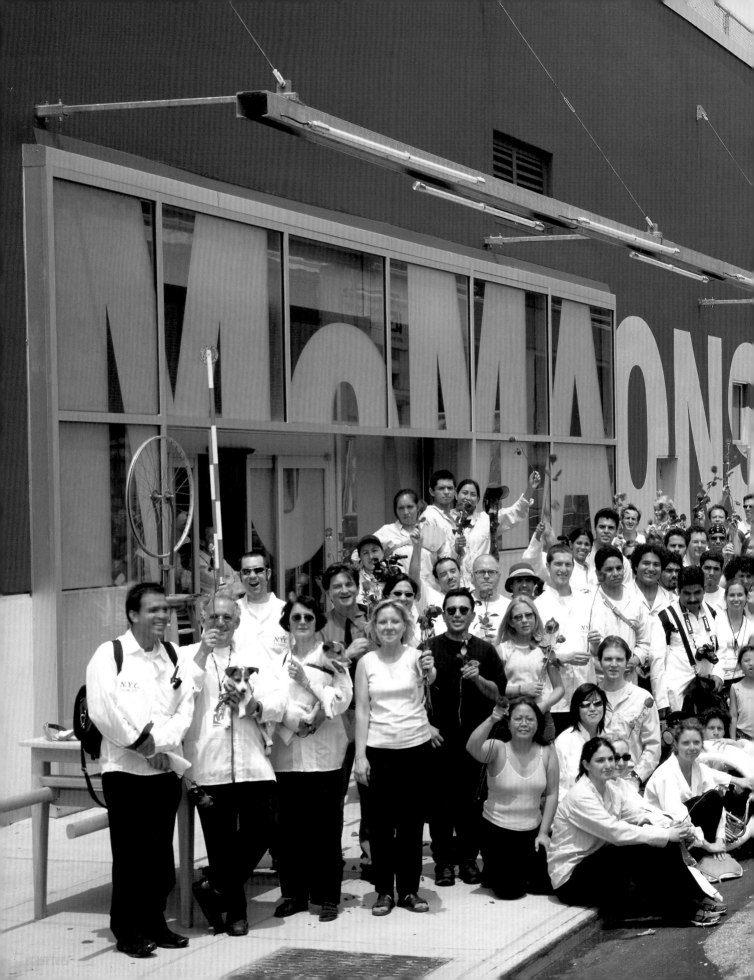

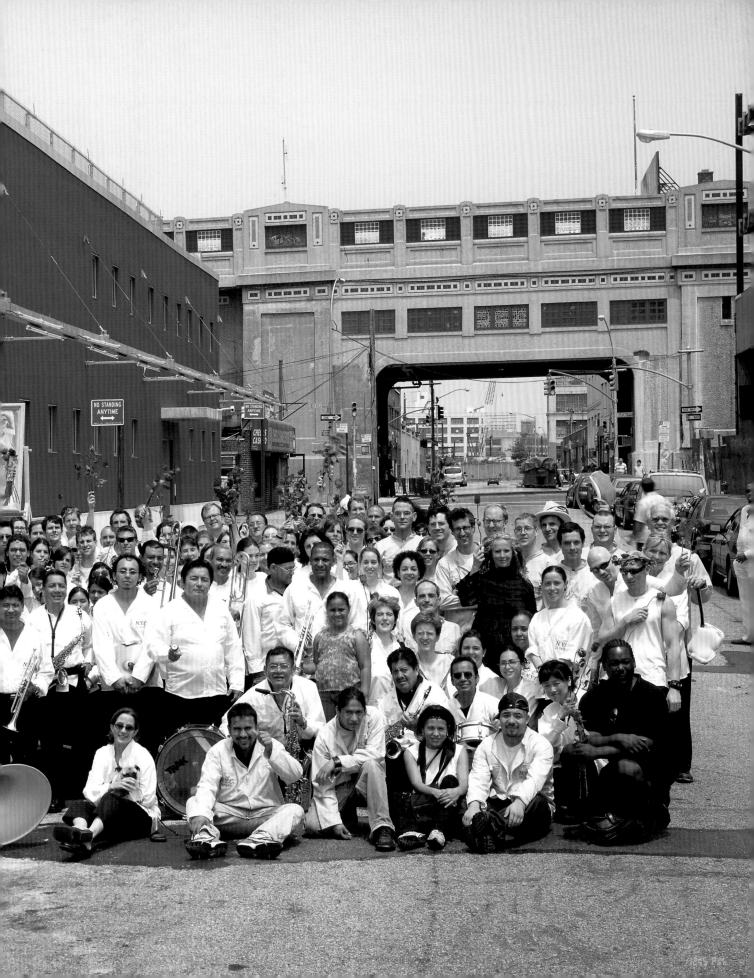

ON ART, MEXICO, FOOD, AND FRIENDS

An Interior Mexican-style Party for Francis Alÿs's *Modern Procession*

Alejandro Diaz

53. Alejandro Diaz, *AMOR*, cookie and frosting, 2002

I met Francis the late 1980s when a bunch of us from the United States and Europe had begun to merge and become part of the art scene in Mexico City. Like many of the artists at that time, I had an apartment in a crumbling early-19th-century, wedding cake of a building located downtown between the President's Palace and the Catedral Metropolitana. You could even look into the archbishop's garden through a giant crack in the wall of my bedroom, a result of the devastating 1985 earthquake.

After living there for about a year, I began to use the apartment for exhibitions and started to invite artist friends to do projects in the two front, salon-esque rooms. Francis was one of the first to show and he created a very simple and elegant work—a miniature bed which hung upside-down from the ceiling. The ceilings were so high that the bed was hardly visible, giving the room the appearance of being completely empty—very avant.

Now, nearly two decades later, I live in New York. Through distance and through the natural progression of time, I had lost touch with Francis and with many of the artists from the '80s Mexico City scene, and was pleasantly surprised when I received a call from Francis in April 2002. He explained his *Modern Procession* project to me and asked if I would organize, host, and style the party for the event. Because I usually have more fun at parties if I'm the host rather than the guest, I was thrilled to do it.

Since Francis's procession referenced the processionals of saints in Latin American countries and, in this instance, specifically Mexico, I decided that the food would have to be traditional interior Mexican—it would have to be colorful, earthy, and baroque. I then phoned my friend Dwight Hobart, who owns the Liberty Bar in San Antonio, and spent weeks consulting with him and with Liberty's chief cook, Oscar Trejo-Beltran from Mexico City, in deciding on a final menu.

> *Ensalada de Nopalitos (Cactus Salad)*
> *Betabeles con Limon y Petalos de Rosa*
> *(Beets w/ Lime and Rose Petals)*
> *Chiles Serranos en Escabeche*
> *(Pickled Serranos w/ Oregano and Ginger)*
> *Tostadas*
> *Salsa Ranchera*
> *(Red Tomato and Chile Sauce)*
> *Salsa Verde (Green Tomatillo Sauce)*
> *Tinga de Pollo*
> *(Chicken w/ Tomato and Chile Chipotle)*
> *Budin Azteca (Corn Soufflé)*
> *Frijoles Borrachos (Drunken Beans)*
> *Pasteles y Dulces Mexicanos*
> *(Colorful Mexican Pastries and Candies)*
> *Agua de Sandia (Watermelon Water)*
> *Tecate Beer*
> *Tequila*
> *Iced Coffee*

For the tables I created whimsical centerpieces using works of Mexican folk art, fruits, and flowers. Finally, to complement Francis's use of iconic works of art in his procession, I made 200 hand-size Brillo boxes, each containing a Robert Indiana–style LOVE cookie recast in Spanish: AMOR. Guests who were attending or participating in the event received one as a souvenir.

With all the distractions of New York daily life, I seldom stop to think of the time when I lived in Mexico. The sense of manifest destiny and community that existed among us has now been replaced by a solipsistic, market-driven experience—both in Mexico and in New York. But working again with Francis and working with Mexican materials (chiles, cakes, fruits, and flowers) brought back some of those Mexican memories, reminding me of the potentially humanistic role art can have when mixed with food and friends.

Alejandro Diaz is a New York–based artist.

TERRIER MIX

Laurence Kardish

Dogs are social creatures and eager to become part of a pack. A procession provides them with an excuse to join in, however temporarily. Anyone watching a parade knows that four moving legs are more interesting than two. Now, if a wagging tail is added to the event, the march becomes even more cinematic.

Dogs lend an element of comedy to the most solemn of occasions, and if a pilgrimage is religious in nature, the participation of dogs reminds us that it is also earthbound. So when Francis Alÿs provided The Museum of Modern Art's Projects committee with a proposal titled "The Modern Procession" to mark the migration of MoMA's collection across the Queensboro Bridge, he did so with a brilliant blueprint. Cursively and airily drawn were marchers, palanquins, some adored art objects, and, on the margins of the route (but not the paper!), a dog, perhaps barking, very much part of the whole. When first presented by Harper Montgomery, MoMA's organizing curator for the Alÿs project, the proposal stirred everyone's imagination and enthusiasm, and the Projects committee decided this *Modern Procession* must happen.

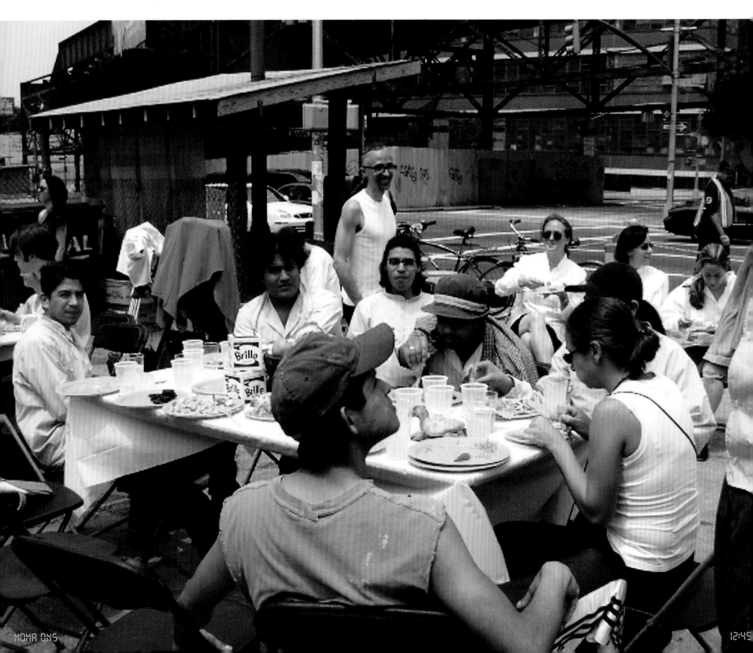

Inspired by festive processions in his native Belgium and ecclesiastical processions in his adopted Mexico, Alÿs envisioned that the venerated objects to be transported would be the actual works of art in MoMA's custody. That was the ideal but not the practicality. We all immediately understood that replicas would be substituted. After all, it is never the Virgin herself who is carried from church to church in Mexico but an icon bearing her image. It did take some negotiation to determine what would be carried across the East River: a Picasso poster, a readymade of a Duchamp readymade, and a copy of a Giacometti sculpture that looked very much like a piece MoMA owns. To add to the beauty and high drama of the event Alÿs was able to secure "a living icon" in the body of an American artist whose work is collected by MoMA—Kiki Smith, borne aloft. Alÿs and the Public Art Fund provided virtually all that the artist imagined in his original blueprint—from the brass band to the bubbles, flowers, and horse—and I provided two of the three dogs in the march. (The third, a pug named Chacho, belonged to the Public Art Fund's project coordinator.)

There are three dogs in our family. Our West Highland white terrier, Crispin, named after a saint of little repute, was too old to make the march, but our two Jack Russells cannot resist any action, and mileage does not tire their muscular bodies. Fiona, the three year-old, has had two litters and has seen some of her puppies die so I felt there was some connection between her participation and the biography of the Virgin. There was also a religious association to be made between nine-month-old Cyril and the idea of a procession. The connection was the concept of salvation: Cyril is a dog saved by a Jack Russell rescue society, one of whose members, listening to a Christian radio station in the northeast, had heard about a milkless dam and her starving litter.

We had to keep the dogs at a distance from the horse, which they would try to harass, but otherwise they became very much a part of Alÿs's work. They marched, they rested, they looked about, they sniffed,

they were given water and shade, they barked, and they reached our destination with the rest of us. They became the first dogs in the history of the universe to set paws in MoMA QNS.

Laurence Kardish is senior curator in the Department of Film and Video at The Museum of Modern Art, New York.

The nganga *is a cosmic receptacle venerated by Palo Monte, an Afro-Cuban religion of Congolese origin. A spirit is believed to dwell within it, a living religious entity, like the genie within Aladdin's lamp. Each practitioner of Palo Monte possesses a* nganga, *with which he or she is able to communicate.*

During the 1960s, one such believer, whose name I forget, became deeply involved in the revolutionary process in Cuba, and was invited to join the Communist Party. He accepted; however, at that time, no Party militant was allowed to follow a religion, and hence it would be impossible for him to keep on caring for his nganga.

Our man decided to approach the Guanabacoa Museum, which boasted a fine ethnographic collection. He said to the board, "I am about to enter the Party, and therefore I cannot keep my nganga. *I suggest that the museum take it over, but you will have to feed it." Indeed,* ngangas *are alive. They need to be fed with sacrificial blood, and to be kept happy by a complex range of ritual attentions. The museum agreed, and thus was sealed a pact unique in the history of world museography: the museum was acquiring not an object but a living deity, for which it faithfully performed the liturgies! The owner was free to pursue his Communist militancy, while the museum looked after his* nganga. *It amounted to a vicarious religious practice, mediated by the museum.*

—GERARDO MOSQUERA
Havana, September 2003

"mise en icône" ; mise en tombeau bet

à travers la sacralisation embrasses statut de avant garde
de la Procession iconique

 unveiling
 unveiling
Freud // jeu de bois ✗ rue
 ✗ original function of the de Bicyclette
 moment de définition
 rôle même.

museum / street / people / museum / reteurs de l'Exil Venu
 ? contemplatif ?
 ✗ TUBA or
 actif
 ✗ ICON
 IDOL
 reconnaissance publique.
 props mise en série
Symbole relics
 (replicas) de la
 mort de l'avant garde
Simbolo " Moderne "
 symbol
 ^ (tout en produisant une
 "performance"
 . morceaux de papier
 . apollinaire Schizo ...
 poème - Alcools Guernica
 des
 go after the
 animaux Status of icon
 fantastique but redondant
OUT of the white Cube → street

 TLALOC

AFTER THE MODERN PROCESSION

Francis Alÿs

Looking back at all my mails and notes written throughout the project, and thinking about the long course of actions and negotiations that led to *The Modern Procession*, the following scenario occurs to me:

From early on I had the impression that *The Modern Procession* embodied a tension between the Museum's contemplative wing (MoMA in its role as the guardian of a collective memory, the Museum preserving Great Art) and its more active wing (MoMA interacting with the contemporary art scene by commissioning new works by living artists).*

The Modern's move seemed to coincide with a moment of internal debate about the Museum's role as a public institution, oscillating between the past and the present. At least that's what I sensed when *The Modern Procession* entered the scene, as the project became the involuntary incarnation of that ongoing discussion.

When the "avant-garde" enters the Museum, this modern temple, it is consecrated and therefore historicized. This is the museological role of MoMA: archiving the relics of our art history. By parading MoMA's masterpieces in the streets of NYC under the guise of a traditional ceremony, *The Modern Procession* enacted a ritual of "reconnaissance publique" of this mode of cultural historicization, of the subsequent demolition of the avant-garde, which is also its deification. However, as the project took the form of a procession, an event that could be seen as street theater or public performance, *The Modern Procession* became an opportunity for MoMA to interact directly with the present, to perform in the immediate reality of a place. Yet it could never completely dissociate the institution from its historical role: even while the artworks were swaying on their palanquins, in harmony with the pace of the carriers, they were still portrayed as icons, or idols, if you like.

But in the heat of the action, the masterpieces also were more than mere props for a performance (or a film). For, happily, something simpler happened along the way: instead of having the usual situation of people going to the Museum to worship the artworks, *The Modern Procession* invited the artworks to leave the white cube and to pay a visit to the streets. Instead of people going to the museum, *The Modern Procession* took the museum to the people. And maybe then, for a few hours, the sculpture, the painting and the ready-made escaped their delegated status, mutating from raw matter to artworks to masterpieces to icons to idols to replicas and to props. For a walk in the city they turned themselves into works again. When, midway across the Queensboro Bridge, high up on its palanquin, the bicycle wheel started spinning again in the New York summer breeze, then, some 89 years after its conception, it might have remembered, if only for an instant, its original function: "I had a bicycle wheel in my studio in 1913. I thought of firewood. And I thought: when one turns this bicycle wheel, on its own, it recalls a motion, the motion of fire, of firewood....And I thought, I don't have a fireplace, [so] I will replace my fireplace with a turning wheel. So I placed my wheel on a stool and each time I passed by it, I turned it" (Marcel Duchamp in an interview with George Charbonnier, 1960).

* I hesitate to even mention two wings, as those two tendencies can sometimes be alternately expressed by one person at different moments in the same conversation.

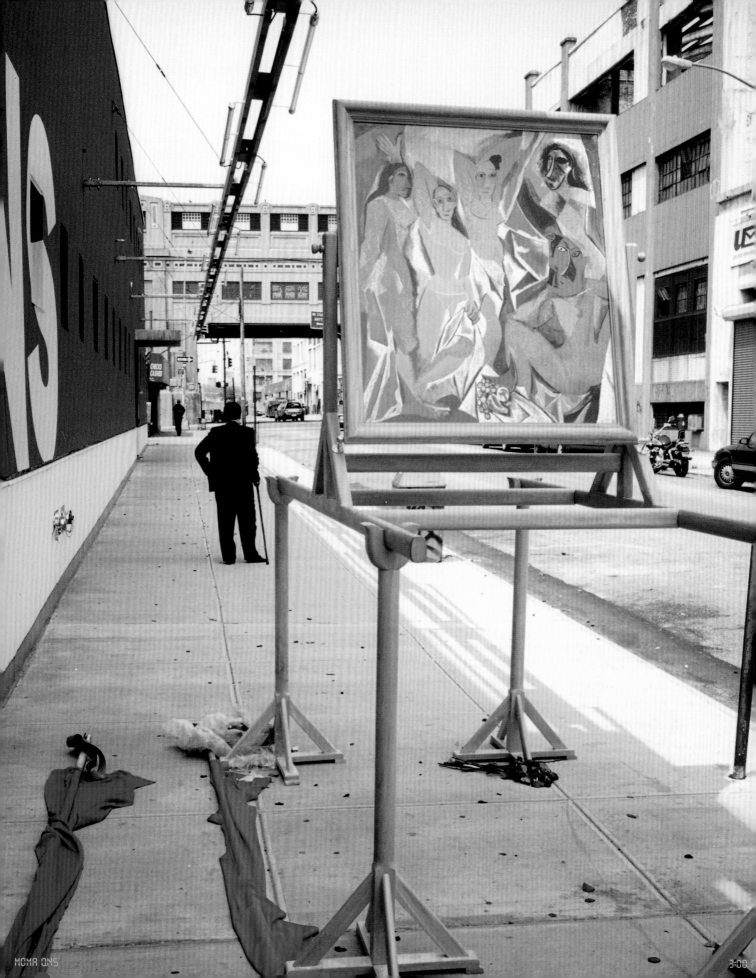

3:00

ACKNOWLEDGMENTS

Public Art Fund

BOARD OF DIRECTORS

Susan K. Freedman, President

Gerald A. Blitstein

Jenny Dixon

Joan Feeney

Barbara Joelson Fife

Sara Fitzmaurice

Lloyd Frank, Esq.

Matthew C. Harris

Ronald Jones

Richard Kahan

Marilynn Gelfman Karp

Abby Kinsley

Allen Kolkowitz

Holly Lipton

Ronay Menschel

Charles Short

Erana Stennett

Billie Tsien

David Wine

STAFF

Tom Eccles, Director

Malia Simonds, Development and
 Administrative Director

Richard Griggs, Project Director

Anne Wehr, Communications Director

Miki García, Project Coordinator

Jane Koh, Press and Archive Coordinator

Yayoi Sakurai, Installation Coordinator

Public Art Fund
One East 53rd Street
New York, NY 10022
www.publicartfund.org

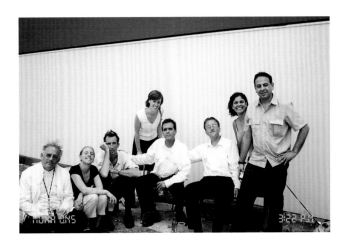

Francis Alÿs's The Modern Procession *was presented by the Public Art Fund in collaboration with* Projects 76: Francis Alÿs, *an exhibition of* The Museum of Modern Art, New York, *June 29 – November 11, 2002.*

This project was made possible through the cooperation of the Office of the Mayor of the City of New York, The Honorable Michael R. Bloomberg, Mayor, and the New York City Police Department.

Special thanks to Patricia E. Harris, Deputy Mayor for Administration; Kate Levin, Commissioner, Department of Cultural Affairs; Jonathan Greenspun, Commissioner, Community Assistance Unit; Raymond Kelly, Commissioner, Police Department; Officer Makowski, Midtown Precinct North, Manhattan; Officer Pelosi, Precinct 108, Queens; Sarah Knapp; and Joe Bonafede, Everybody's Place Parking.

Francis Alÿs would like to extend his thanks to the staff of the Public Art Fund and The Museum of Modern Art, and to the following individuals: Kiki Smith, Rafael Ortega, Diego Medina, Alejandro Diaz, Dwight Hobart, Asociación Tepeyac de New York, La Banda de Luis Cuevas, Cuauhtemoc Medina, Pip Day, Hans-Ulrich Obrist, Christian Haye, Kitty Scott, Peter Kilchmann, Nicholas Logsdail, Klaus Biesenbach, Katie Quillinan, Rizziero di Sabatino, Frederic de Smedt, Yvon Lambert, Michel Blancsube, Angel and Eladio Toxqui, Louise de Smedt, Suzanne Page, Ramis Barquet, Emilio Rivera, Francesco Pellizzi, Dario Gamboni, RoseLee Goldberg, Robert Storr, Lynne Cooke, *all of the photographers and videographers who documented* The Modern Procession, *and all the volunteers who participated in it, especially those who carried the palanquins. In particular he would like to thank the Freedman family and the Silverweed Foundation for donating the drawings and film of* The Modern Procession *to The Museum of Modern Art.*

First published 2004
Public Art Fund
One East 53rd St
New York, New York 10022
www.publicartfund.org

Publication copyright © 2004
Public Art Fund, the authors, and Francis Alÿs
ISBN 0-9608488-2-7

Distributed by
D.A.P./Distributed Art Publishers
155 Sixth Avenue, 2nd Floor
New York, NY 10013
Tel: (212) 627-1999
Fax: (212) 627-9484

This publication was coproduced
by Francis Alÿs and Public Art Fund
Edited by Francis Alÿs and Anne Wehr
Designed by Francis Alÿs and The Grenfell Press
Printed and bound by Trifolio in Verona, Italy